r before the
ill be

# The Art and Science of
# Screenwriting

## Philip Parker

**intellect**™

EXETER, ENGLAND

Second Edition published in Great Britain by
**Intellect Books**
School of Art and Design, Earl Richards Road North, Exeter EX2 6AS

First published 1998
Second edition published 1999

Publisher:              Robin Beecroft
Copy Editor:            Wendi Momen
Cover Design:           Sam Robinson
Cover Illustration:     Mark Mackie
Production:             Annegret Rösler

A catalogue record for this book is available from the British Library

ISBN 1-84150-000-3

Printed and bound in Great Britain by Cromwell Press, Wiltshire

# Contents

# Acknowledgements

First, I would like to thank all my past and present students at the London College of Printing and Birkbeck College, and the members of the Genre Group: without their interest and imagination the thinking behind *The Art and Science of Screenwriting* could not have been delivered.

I am also indebted to Troy Kennedy Martin, Judy Holland, Jeannie Farr and Janice Hart for their encouragement and comments.

Finally, a big 'thank you' to Robin Beecroft for insisting that I write the book, to Jane Anniken for insisting that I could write in the first place, and to Hilary – who makes every day special.

# Introduction

This is a tale of four coffees, two screenwriters and the mess we call life.

A young screenwriter strolls into a busy metropolitan café, the air full of animated languages discussing events, plans, love and the train home. The staff dart past him concentrating on one too many things. Looks are exchanged. Orders are barked. A plate is smashed.

It's only a moment's distraction. The hustle continues. The screenwriter's mind is full of meetings, films and encounters.

'What do you want?' A bright, overloaded manager, his face blank, detached, comes into focus.

'Two coffees, outside', is the reply.

```
EXT. CAFÉ - DAY

FRANK, expensive, casual, assured, sits alone, waiting and
watching. Frank has seen and heard it all, but life still
burns in every word and gesture.

                    DARREN(OC)
        Coffee'll be ten minutes. If we're lucky.

DARREN, sits down opposite Frank. Darren's casual, urban style
does not hide the intensity of his youthful eagerness.

                    FRANK
        How's the script?

                    DARREN
        Due on Friday. And life's not that organised.
        Yours?
```

Two scenes, two approaches to writing. The first is novelistic, the second has the beginnings of a screenplay. Both are based on an encounter I had last week. I decided to use them here to illustrate some of the key reasons why I decided to write this book and add to the already extensive collection of works on screenwriting.

The first reason is to attempt to differentiate screenwriting clearly from other forms of dramatic writing. Screenwriting has its own unique qualities and limitations and there is an art to using them. Writing for the screen is not

the same as writing a novel, for the radio or the theatre – though to judge from the places far too many producers and development personnel look for new screenwriters, you could be forgiven for thinking so.

The second reason is to capture the sense of pressure screenwriters feel given the industrial context within which screenplays are written and ultimately translated onto a screen. Deadlines are common in many walks of life but few expect your imagination and your ability to address millions of people to work to order in the same way.

The third reason is to state quite clearly that the incident described above was not how it happened, nor were these the exact words spoken. In the recent past far too many people have been heard to say 'fact is stranger than fiction', the implication being that we no longer need fiction. This misses the point. If life were understandable merely by watching it, there would be little point in fiction and especially drama. However, life is not that simple and the essence of drama is not to present something which is strange but to help us come to terms with the uncertainties of life and to gain some insight into them.

The opening scenes of this introduction were written not to capture what happened but to introduce you to two characters and their world. The coffees, by the way, did not come after ten minutes but we did manage to collar an unclaimed one after fifteen. Frank, not his real name, is an established screenwriter who has created seminal television series and written successful Hollywood movies. Our conversation was about the narrowing of the voices being heard and seen on television and in films. It was a conversation about people and their need to be validated and challenged in the form which has become the centre of late twentieth-century dramatic life, the screenwork. This is a dramatic form which is dependent on writers writing screenplays for large audiences; writers who have been marginalised in the new media conglomerates; and audiences who do not see their world being represented on the screen.

The café conversation was brief but it reminded me of other screenwriters and moments where the pain and the challenge of screenwriting has come into the public domain: when Jimmy McGovern wrote about the emotional turmoil in his own life, which was the backdrop to the creation of *Cracker*; when Linda La Plante, the creator of *Prime Suspect*, lambasted 'the suits' in the television industry for hiring 'Oxbridge' graduates with degrees in English as script editors; when a screenwriting student recently cried on recognising what their screenplay was really about and that they would now have to write with this knowledge to ensure the work achieved its full potential.

There was passion in those outpourings, a passion which lies at the heart of any creative process. It takes many forms – the passion to be recognised, the passion to communicate, the passion to tackle problems which others run away from, the passion to inspire, the passion to touch and be touched by human experiences. But perhaps the greatest passion of all is the passion to try and grasp some small part of this great mess we call life and make it understandable.

Screenwriters do this in the most industrialised form of dramatic writing we have yet invented. No one minds if a play is five minutes or an hour longer, or shorter, than another play. But someone will chop a sequence or a line of dialogue out of a screenplay if it is a second too long for its slot on television or prevents the cinema from fitting in another screening. On radio the sets and scope of action are limited only by imagination. On the screen a production accountant suggests restricting the locations and cast to save money. These may be mundane concerns but they can destroy a dramatic work if they are not dealt with properly.

Screenwriting as a form of writing has steadily evolved this century from a few notes to guide the shooting and editing to complex screenplays capable of playing with time and space and working with characters who may only be seen for a few seconds or watched for 20 years. However, this is a form of writing which, even in the late 1980s, was not taught in film and television schools in Europe. We still live in a culture where screenwriting is not recognised as a separate art and discipline by many of the key people who fund and make much of the television and films we watch, or choose not to, as the case may be. Yet it is the one area of contemporary writing which everyday transcends language and culture for millions of people, is used to tackle issues and concerns which would otherwise go unnoticed and acts as a reference point for many individuals' lives.

Some may say that screenwriters are the tribal storytellers of our century. However, the tribe has long since dispersed, there are no communal fires. The fear of what might be in the next valley has been replaced by a fear of what we might do to each other and the planet we inhabit. We live in a world of strangers, with more knowledge and an awareness of our own limitations. This is the world in which screenwriters create, not for a few friends and family in a known place, but for an audience of a million strangers in an ever-changing universe. The way in which each individual screenwriter tackles this situation is uniquely theirs. How screenwriters use the common language and conventions we have developed and understand is the essence of this book.

*The Art and Science of Screenwriting* is a practical handbook on screenwriting. However, I hope it will also provide an understanding of two other essential aspects of the screenwriting process. The first is a solid theoretical framework for understanding how screenplays work in their totality. Among the greatest dangers facing anyone teaching, discussing or starting to write screenplays in the current context are the various attempts to make one aspect of a screenplay the central, all important, aspect. I hope that the creative matrix will allow you to see how all the key elements which go to make up a screenplay are interdependent and as important as each other. The second is a recognition that screenwriting is a human creative process. No book, teacher, course or workshop can provide all the answers to writing a good screenplay. A screenwriter always brings their own self to the project and fills in all the empty spaces which the creative matrix provides, and in so doing writes their own unique screenplay.

In this context there is also no right or wrong way to go about writing a screenplay. I know several hundred successful screenwriters who have never read a book on screenwriting or attended a course. I also know that the new generation of successful screenwriters is dominated by those who have. This tells us more about the history of screenwriting courses than screenwriting. The writing itself will always be the key thing. To write you need some of that passion, some idea of what you are trying to say and some understanding of how to get it down on the page. The *Art and Science of Screenwriting* will be able to help you with the last two but the first is down to you.

The conversation outside the café moved on from the time we accepted the unclaimed coffee. Five minutes later we stopped a waiter and asked if there was any chance of a second coffee turning up. He rapidly disappeared inside full of apologies and determined to find our missing coffee. At this point another waiter appeared with two coffees. This was obviously our original order and we proceeded to drink the coffees. It was good coffee. We left the café a short time later, certain that a fourth coffee would appear at our table sometime within the next twenty minutes. Life is a mess full of such unpredictable moments and outcomes. Screenwriting is about using some of this mess to create something that can inspire, entertain and inform millions of strangers. It is a solitary activity which takes place in a collective industry for communal consumption.

*The Art and Science of Screenwriting* is an attempt to provide some frameworks for sorting the mess and an understanding why writing a great screenplay is so hard and yet so wonderful when it happens. There may be some people who on glancing through the book with all its neat lists and frameworks will see a prescriptive set of formulae for writing screenplays and fear the death of original screenwriting. This is the equivalent of saying that to learn what a sentence is means you cannot write an original sentence.

One of the major reasons I wanted to write this book was my frustration at the simplistic ways in which screenwriting has increasingly been discussed and an awareness of the destructive power of ignorance when it encounters a creative process. Far too often I have heard new screenwriters desperate to move on in their work being sent confusing messages by people who have not thought through the implications of what they are saying. Far too often I have seen good ideas mangled beyond recognition or dismissed out of hand by people who have no grasp of even the basics of screen language. I cannot hope that one book, or even a series of books, and a lifetime of teaching will stop such events happening. However, I hope that this one book will give some people enough insight and knowledge to proceed with more caution, and more courage, to create great screenworks.

In this sense, the book is a celebration of screenwriting in that by revealing its science, the things we all know and share, it reveals its art, the unique contribution each screenplay is capable of making to our lives. In order to do justice to all these various aspects of screenwriting I have divided *The Art and Science of Screenwriting* into three distinct parts.

The first part, Chapters 2 to 4, aims to remove some of the everyday confusion which exists owing to a lack of a coherent approach to screenplays as a whole, clearly understood working practices and what makes a good screen idea.

Chapter Two, 'A Creative Matrix' provides the theoretical framework and some new definitions with which to understand how the various elements which make up a screenplay actually operate. This chapter covers the essentials of what story, structure, plot, theme, genre and style are.

Chapter Three, 'Tools of the Trade' lays out the basic formats of screenwriting from ideas and proposals to screenplays and television format documents. It also highlights the problems of each type of format and the issues raised at each stage of the development of a screenplay.

Chapter Four, 'Developing a Screen Idea' provides you with the means to work from a source of inspiration right through to a finished screenplay. It covers what makes a good screen idea, how much research you need to do and how far you should take an idea before you write the screenplay or show it to someone else.

The second part, Chapters 5 to 7, provides a detailed approach to the creation of screenplays for film, television and other screenworks. This section concentrates on the key elements of the creative matrix.

Chapter Five, 'From Stories to Themes' looks at the ways in which the spectrum of relationships between story and theme underpin creative choices in different screenplays. It explores in detail the role of characters and the question 'What is this really about?'.

Chapter Six, 'Revealing Form and Plot' explains the different dramatic structures available to screenwriters and the role of active questions in shaping plots. This chapter also looks at the various building blocks of a screenplay from the shot to the sequence and the power of parallel editing.

Chapter Seven, 'Explorations of Genre and Style' takes apart these two, often intertwined, elements of the screenplay and looks at their separate roles in defining and unifying a screenwork. This analysis provides a working set of frameworks for understanding genre and the role of location, sound, editing and, crucially, tone in defining a screenplay's style.

The third part, Chapters 8 and 9, provides an overview of what happens after the first draft is written and some thoughts on the business side of screenwriting.

Chapter Eight, 'The Rewrite' details the various stages of the process of re-writing a screenplay and suggests ways to avoid some common mistakes.

Chapter Nine, 'Screen Business' looks at the ways in which screenwriters sell their work and the problems with current development structures within the film and television industries.

*The Art and Science of Screenwriting* is aimed at anyone who has an interest in screenwriting from first-time writers to experienced professionals, from directors and producers to media teachers. The combination of theory and practice, along

with my desire to reflect the ever-present uncertainties of writing, may on occasion conflict with a simple 'how to' approach. However, as the combination of emotions, rationality and shared experiences work to make a great screenplay, I hope the combination of the different aspects of theory and practice will allow you to grasp the essence of screenwriting as outlined in this introduction. The book may be read from cover to cover, but its real use will be in informing any work or discussion you undertake after reading it and as a tool in solving future screenwriting problems.

I hope you enjoy reading *The Art and Science of Screenwriting* and that in some way it helps you to understand what makes a great screenplay. However, before this is possible we need to clear up some creative confusions.

# 1. Creative Confusion

Every year powerful individuals in the film and television industries complain that 'there are not enough good screenplays'. Others repeat the oft-heard phrase 'You can make a bad film from a good script, but you cannot make a good film from a bad script.' The unspoken questions which follow are:

- If the first statement is true, why is it so – given the number of books, courses and screenwriters now working in the world?
- If the latter statement is so obvious, why do people still persist in proceeding with bad screenplays?

The simple answer to these questions is that this creative industry, like all human activity, is conducted with varying degrees of ignorance, insight, faith, habit, emotion, power and limited resources. The end result is a state of creative confusion which sometimes produces works of sheer wonder. However, these acts of wonder are not all accidents of fate.

Almost everyone has heard the story of the viewer who after watching a bad film or television drama has said, 'I can do better than that'. They then proceed to do considerably worse. How do we know this? Simply because there are thousands of screenplays being submitted to the industry every year which are so poor anyone reading this book, without any prior knowledge, would dismiss ninety-five percent of them on a first read.

The same problems – a lack of dramatic structure, cardboard characters, poor dialogue and a confused and/or boring plot – appear in nearly all of these screenplays. Even the ones which have tackled these problems still lack any reason to be made because they are either copies of existing films or television shows or the drama has nothing to say. In addition to these problems most new screenwriters do not know anyone in the industry so they end up sending their work to people who are not interested in making the type of screenplay they have written. Now you can begin to see why agents have become the gatekeepers, and why most people are reluctant to read screenplays on speculation. In contrast to this scenario, I know many screenwriters who have said exactly what all the above people have said and then proceeded to make careers as screenwriters. What are the fundamental differences between the group that continues to turn out unusable screenplays and the group of successful screenwriters?

The first difference is the desire to do it, and keep on doing it, even when the writing is not working. This is the passion for communicating and sharing a vision, which is one of the benchmarks of creative activity.

The second difference is an ability to learn from others. This can be achieved by study, taking feedback, discussion, or a combination of all three. The point is that it is an on-going process and each screenplay is aimed at being an improvement on the last.

The third difference is the acquisition of skills and their application in a rigorous and creative way.

The fourth is time. It takes time to write and it takes even more time to write well. It can take years to write well within the strict parameters of a screenplay.

The fifth is persistence. The film and television industries are always in a state of flux in terms of personnel and in terms of what is deemed to be a safe bet *vis-à-vis* production. A screenwriter has to be able to keep going with their ideas, and deal with the rejection and uncertainty of the whole affair.

Finally, and by no means the least, is the passion for the medium and the stories, characters and themes which are fundamental to any screenplay.

Screenwriting, like any creative process, is a mixture of skills, knowledge, experience, and luck. You can spend weeks, even years, trying to find a way of telling a particular story. Hours can be spent trying to improve one line of dialogue. Every writer has their own way of tackling these problems but none of them guarantees success. Success when it comes is often unbidden and sometimes only recognised with hindsight. In the light of this creative process and the personal struggle it involves, it is possibly not surprising that many writers fear discussing their process, or are defensive of their work once they have committed themselves on paper. For these reasons a number of myths and resentments have grown up around screenwriting and a great deal of confusion exists as to what makes a good screenplay.

Some of this confusion is inevitable for the writer. In creating a screenplay there are so many small and large choices to be made. A decision to change one line of dialogue may impact on the motivation of a character throughout a whole screenplay. The emergence of a particular theme may require changing several stories and characters to ensure it is fully realised in the finished piece. The original idea which sparked the screenplay in the first place may start to become lost in the process. Is this a good or bad thing? When will you know?

This level of creative confusion does not go away with experience. It is only resolved in relation to any particular screenwork at the point where the screenwriter finally realises what they are really writing about and all the characters are alive and living within the world of the screenplay. Creative confusion is also what makes writing a screenplay so difficult and so rewarding when the right choices are made. This confusion is inevitable. It is the writing process. No books, courses or development systems will be able to remove this aspect of film and television production.

This confusion having been accepted, there are other aspects of confusion which impact on the writing of screenplays that are not inevitable and which I hope this book will go some way towards resolving.

## Tackling Confusion

Two other major sources of confusion are the theoretical language used to describe aspects of the screenplay and the practical language which frames a screenplay's development. As screenwriting has been recognised and written about as a craft

there have been various attempts to find the key to writing a great screenplay. Almost everyone in the industry has their own view about everything from good dialogue and original characters to paradigms and structure.

The combined increase in the number of courses on screenwriting; the high fees paid to writers and script consultants and the slow but steadily increasing academic interest has created a confusing picture of what does make a good screenplay and how best to write one – a picture which any new screenwriter or student will recognise as they encounter people swearing by one person's system or hears an established writer dismiss everything as junk.

The desire to find the answer to what makes a good screenplay is an understandable one. However, the equally strong desire to make it simple is not the right approach. As I indicated above, some aspects of the screenwriting process are inevitably confusing. The question is, what can we know, or do, which is most likely to create a good screenplay? The simple answer to this question is to apply what we already know and see if it works. It is this basic principle I have applied to teaching screenwriting, which in turn has led to the creation of a creative matrix.

This simple and flexible structure seeks to place all the main elements of a screenplay in a recognizable set of relationships, which will help you solve problems within any one screen narrative. Unfortunately, this approach requires us to consider slightly redefining some words or clarifying their meaning within the context of screenwriting. However, I hope you will see that once the central relationships of the matrix are grasped, then you will be able to reduce some of the confusion implicit in the writing process.

The other area of confusion concerns the development of a screenplay through its various stages from an idea to a finished screenplay. This day-to-day aspect of screenwriting is especially frustrating when dealing with development personnel and others who share no common language with respect to the writer's work. The confusion here leads not only to writers delivering the wrong sort of treatment, but more importantly to people having the wrong expectations of what an outline or premise can deliver compared with the finished screenplay.

Reducing this area of confusion is, I believe, vital to ensuring the creation of better screenplays. It will also save many hundreds of thousands of pounds in development monies, to say nothing of production costs spent on screenplays which are not ready for shooting. In order to aid this process of clarification the chapter 'Tools of the Trade' seeks to define, in a simple and usable manner everything from a premise to a series format, from a step outline to a first draft. It contains suggestions on why certain aspects of a project cannot be effectively assessed at certain stages of its development and why a good selling document so often ends up as a bad screenplay.

## Avoiding Confusion

Here are two simple examples to illustrate why we need to redefine some commonly used terms.

*Example One*

The word *story* is often referred to when developing a screen project. It is commonly seen to be the same as narrative, so much so that some films / programmes are referred to as non-narrative, which is taken to mean without stories. In *The Art and Science of Screenwriting* 'narrative' as a term is completely separated from the term *story* and all screenplays and screenworks are seen as narratives. At the same time, stories are seen as motivational frameworks foe characters, which can be used in a number of different ways within a narrative.

*Example Two*

Much has been written and spoken about story structure being the same as narrative, or dramatic, structure. In *The Art and Science of Screenwriting* stories imply no particular dramatic structure, and as a result, dramatic structure is capable of several radically different but related forms.

Do we need to worry this much about defining words and terms when what we are engaged in is a creative human process where confusion is to some extent inevitable or even desirable? The answer has to be 'Yes' if:

- You wish to understand why a particular project is not working
- You want to hold a coherent conversation about a particular screenplay which does not rest at the level of 'I don't quite get this' or 'This is a load of crap'
- You want some answers when you are stuck
- You are fed up with rejection letters
- You love the idea, or characters, or theme, or visuals but have no idea how to develop the rest of the project, or
- You have any doubts or confusions about what makes a good screenplay.

## Confusing Definitions

In these opening paragraphs I have used two key words which have radically different meanings to different people. These are 'screenplay', and 'screenworks'. In this book a *screenplay* can be a television script, a commercial's script, a documentary script, a feature film screenplay or even notes on a possible set of images and sounds. A *screenwork* is any completed translation of a screenplay into a format which is watched / experienced on a screen. It could be a film, a sitcom, a promotional video, a personal essay, a video game or a home movie.

## Living with Confusion

All of the above problems are part of the reason why people so often remark that there are not enough good screenplays. Another major reason, is the failure on the part of many producers, directors and heads of development to engage fully with screenwriting and screenplays.

All the great directors (those who have produced a series of screenworks which have demonstrated consistently over time an ability to reach their audience) have recognised and openly stated that they are dependent on the screenplay. Yet far too often new directors still believe that the screenplay is something just to be

used as a jumping off point for their ideas. This attitude prevails in film and television schools, where it is still the case that it is the director's project which is made, not the best screenplay. Equally, producers uncertain of their own ability to recognise a good screenplay fall back on successful stage plays and books for adaptations. This situation denies audiences the chance to engage with contemporary ideas, as the majority of these works are historically based. Even where the material is contemporary it tends to be chosen from a narrow genre, in particular the thriller.

Of course, there are exceptions to these generalisations, but the overall confusion about what makes a good screenplay and people's inability to engage with the screenwriting process is undoubtedly undermining the potential of the medium to reach bigger and more diverse audiences. If to this is added a combination of the lack of opportunities for new original screenwriters, the restriction on development monies for solo screenwriters, and the screenwriters' own confusions, then disaster seems more than probable.

Clearly there is no simple answer to this scale of problems but I believe we have passed the time where solutions are merely a matter of opinions and where 'no one knows anything'. I hope by the time you have read *The Art and Science of Screenwriting* you will not only be able to understand how a screenplay works but also be in a position to hold an intelligent conversation about how one that is not working may be improved.

I also hope that those who want all the answers to all the questions, here and now, will find enough to keep them occupied. I recognise that one small book cannot tackle everything from writing short films to what are the options in an action sequence, but at least there are some clues here to reduce some of what is inevitably a creatively confusing process.

# 2. A Creative Matrix

What is a creative matrix and why is it a constructive means of analysing a screenplay and its development?

In nearly all discussions about films and television programmes people select an aspect which attracts them, or is easily identifiable, as the element which they feel made it good or bad. However, when a screenwriter sits down to write, they have to deal with all of these elements. There is no point in a screenwriter only being interested in one element of a screenplay, unless they wish to spend all their time re-writing other people's work.

Therefore, screenwriters need a frame of reference which not only highlights the elements which attract them to a project but also the other elements which they may not at first see or understand. Unfortunately, most of the discussions which the screenwriter has with other people, and often with other screenwriters, are still locked into the everyday terms and reasoning of liking or disliking one element of a screenwork.

At the heart of these discussions is the old chestnut of whether or not the screenplay is formulaic. This has been replaced, slightly, in the recent past by questions of whether or not it is structured properly or whether it is really a character piece.

The problem with all these approaches is they attempt to separate one or more elements from the work and make them central to creating a good screenplay. This may clarify some aspects of the process but it also fundamentally ignores the simple point that we do not watch a screenwork in parts. We experience it as a whole and the screenwriter has to create it as a whole. Therefore, we need to have a means of working and understanding the screenwork as a whole.

The concept of a creative matrix allows us to do just this. It provides a means of seeing the various elements which make up a screenplay in conjunction with each other, without allowing any one element a determining role over all others. In this way we can move away from seeing character, theme, dramatic structure, story, genre or style as being the singular, most important, concern of the screenwriter when creating a work.

Within the matrix, story, theme, form, plot, genre and style are seen to be the key reference points when writing a screenplay. Each of these elements will be shown to have a different weight in relation to each other, depending on which type of screenplay is being written.

However, though this approach may stop any over-simplification of the process of screenwriting, if a screenwriter is merely concerned with these narrative elements, they will miss half of the process. The other half is all the particular information, emotions and experience which the screenwriter puts into creating the unique screenplay which only they can write.

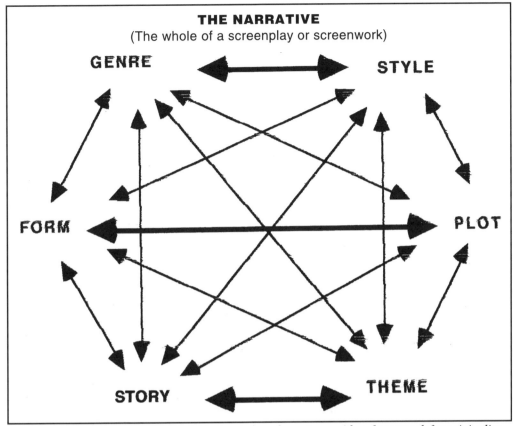

*Figure 1. The Creative Matrix, in which the six key elements provide a framework for originality.*

These personal choices and feelings are the elements of the creative process which cannot be addressed in a book, as they are unique to each and every screenwriter and to each and every screenplay. In the diagram, the space for these elements is expressed by the space in between the elements of the matrix and demonstrates why a matrix is the appropriate model for developing and understanding screenplays and ultimately screenworks.

The use of creative space demonstrates how a matrix allows for the art and science of screenwriting to be seen as a part of the same process. This process identifies where key relationships lie in terms of each of the narrative elements within a screenplay, including the screenwriter's own experience and feelings. Figure 1 illustrates the basic relationships between the various elements.

The key relationships are the pairs which form the horizontal aspect of the matrix. These are:

- *Story* and *Theme*
- *Form* and *Plot*
- *Genre* and *Style*.

These pairings are based upon the strength of their impact on each other with respect to the finished screenplay. The blank spaces between each of the elements, and within the rest of the narrative, symbolise the original elements which the writer brings to each screenplay.

In this chapter I will concentrate on defining each element and illustrating how each works with the others in the context of the matrix. The key thing to remember is that all the elements of a screenplay are important and all must work together if the screenplay and the screenwork based upon it are to realise their full potential.

Before we look at each of the elements in turn, I wish to spend some time re-defining the word 'narrative' so as to avoid any confusion later in the book.

In the illustration of the matrix, I have placed narrative in the defining position of identifying the space within which all the various elements of screenplay take place, including all the personal elements brought by the screenwriter. This is most easily understood if you think of the narrative space, which contains all the elements, as being a finished screenplay or screenwork.

Many people will not see this as problematic as many academic writers and screenwriting tutors will discuss narrative writing or narrative space in reference to screenplays or films. However, in the context of the matrix I wish to redefine slightly the use of the word narrative, so as to allow us to discuss the notion of a story separately from the notion of a narrative.

The word 'narrative' in the English language has become synonymous with story to such an extent that many films are discussed as non-narrative, meaning without story. I wish to suggest that this meaning of the word needs to be set aside if we are to discuss the screenplay and screenworks, as they are experienced, as a whole.

The reason for this is simple. We do not have a contemporary word for describing the totality of a screenplay or a screenwork and yet we need one if we are to see the similarities which apply to all screenplays and screenworks.

All screenworks tend to be described and analysed in isolation. Films are described and discussed differently from television, documentaries differently to dramas, and adverts differently from videos. This illustrates that the use of any of these descriptive, categorical words, such as film, make it all the more difficult to find a common term for describing the space within which the basic elements of all screenworks operate.

The power of the matrix is its ability to demonstrate how the various elements of screenwriting operate within all screenworks and to show that what appear to be totally different types of work actually share much common ground.

I therefore suggest the use of the term 'narrative' as a term which can be applied to all forms of screenwork and screenplays as they are finally represented to their audiences. 'Story', now separated from narrative, remains in its common usage. In this context a narrative is the version of a screenplay or screenwork which is shown to an audience. This audience may be several million people watching a

finished programme or film, or it may be one person reading a draft screenplay or a premise. In this sense, a narrative is not necessarily the final version of a screenplay or screenwork.

This use of the word narrative allows us not only to discuss the totality of the narrative separate from any one story or dramatic structure, but also incorporates thematically-based, as opposed to story-based, screenworks into our overall understanding of how to write screenplays and how screenworks work.

It also allows documentary, advertisement, video game, television series, feature film and all other screen narratives to be seen in the same light. This enables them to be discussed in terms of their use of narrative elements rather than as distinct entities which occasionally share some common ground.

For all these reasons I will use narrative to mean the totality of a work, as it is written in a screenplay, or as it is realised on a screen, no matter what stage of development it is at.

In order to avoid any confusion with this redefinition, here is how the word 'narrative' will be used. Remember the narrative is the totality of the screenplay or screenwork. This means that when you read 'narrative elements' this does not mean story elements: it means all the elements which make up the narrative – story, theme, form, plot, genre, style and the original elements the writer brings to the narrative. Equally, 'narrative information' is not story information but any information contained within the narrative. It could be about a character, the theme, a symbolic moment or just an establishing shot.

While we are looking at the totality of a narrative, it is perhaps worth noting a point that many writers and directors have made. This is the often heard statement that narratives are seldom finished but merely abandoned at the point where writers feel they can do no more to improve them. Leaving aside the very human desire to change something just to see if it is better, this expresses an aspect of this process which should never be forgotten. Screenwriting is an emotional as well as a practical activity. For narratives to work they must engage people's emotions.

It is the judgements of all the people involved in developing a screenplay and seeing it translated onto a screen which ultimately provide the power for the matrix to work. This inevitably involves an emotional reaction as well as various practical decisions. However, this does not mean that your emotional response to something should be your guide.

The power of screenwriting is its ability to provide a dramatic structure within which an emotional response is developed. Often when a screenplay is not working it is for lack of the correct support for the emotions, rather than the fact that the emotions are not part of the narrative.

The aim of *The Art and Science of Screenwriting* is to ensure the point at which any narrative is abandoned is where all the elements, including people's emotional responses, have been assessed and used to their full potential, and not before.

In order to make these assessments we need to understand the various narrative elements which make up the matrix.

## Story And Theme

Many conversations about a project start with 'What's the story?' Recently, even documentary discussions and proposal requests have tended to focus on 'What's the story?' instead of the older question of 'What is it about?'

This latter question has always been the fundamental question to apply to any screen drama, though it is usually phrased 'What is it really about?' This question is then generally taken to mean, 'What is the theme of the piece?'

It is the link between these two elements of the creative matrix, story and theme, which form the foundations of any successful screenwork. This link is essentially a spectrum of options which run from the narrative based upon a simple story, through to a narrative which is based upon a simple theme.

Story ‹—› Themed stories ‹—› Story-based themes ‹—› Theme

In between are numerous options which combine stories and themes in a plethora of ways. It is the choice involved in determining where along this spectrum a particular project lies that forms the first part of understanding how a screenplay works.

This is the spectrum which acts as the basis for audience engagement with a narrative. Its effectiveness rests upon reflecting human experience in its most simplified form. These experiences essentially make up the pattern of people's lives and arise from common problems and goals. For example, the awareness of loneliness brings about a desire in most human beings to find a way to avoid it. The most common way to alleviate loneliness is to find someone or something that meets this emotional need. This is the basis of all romance stories.

Equally, almost every human being has felt at some point in their life that they were wrongly judged by someone. This is the basis of the theme of injustice.

In order to understand how these general human experiences underpin narrative construction we need to be able to understand what a story and a theme are and how each of them works. separately and in conjunction with each other.

## Story

A story is a recognised pattern of events which when seen in their totality act as a frame of motivational reference for characters between the screenwriter and their audience.

To understand how this works we need to appreciate the fundamental relationship between a character and a story type. A character without a story is not a dramatic persona but merely a narrative presence. Therefore, you can develop the most fascinating character but until they do something we have no drama and, therefore, no basis for a screenplay.

A story without a character is a narrative device without a means of narrative engagement. Stating that a screenplay is a romance lets us understand its dramatic structure and theme, but without the character there is no means of making it original and interesting for its audience.

The idea that these two inextricably linked elements of a screen narrative can

be separated is clearly not workable as a means of developing a screenplay. However, it is the power of the character to engage the audience and turn the story into their story which makes a screen narrative compelling. This can only be achieved if the characterisation works within the parameters of the particular narrative and if the character's story is clearly revealed.

At the beginning of a project you may only have a character and not know what type of story they are about to become involved in. Similarly, you may have an incident or situation involving several characters and not know which one will provide the main story.

In this situation the first question is clearly whether you can see any indication of story type/s or themes which would point to story type. If you can, then select the type and take your character through this story and see where you end up.

Developing a character through story provides the quickest way to a narrative spine and, therefore, a potential main story. However, developing story through character will provide you with a clear understanding of the character's motivations and, therefore, a potential plot and ultimately a main story. Both routes work and both are regularly used by different writers to arrive at essentially the same position.

The danger with the first route is that the character remains shallow and confined by the story structure, as their motivational framework is already in place. The danger with the second route is that the character develops several story strands, the plot remains confused and no single story type, or theme, arises from the character's journey through the narrative. The degree to which any writer uses either route is dependent on where they are in developing the screenplay.

If you know you want to create an action adventure, various parameters involving the character/s and the main story will already be in place. By the same token if you are working with established characters, or subject matter, then the development of a story is all-important. However, to develop a story you need to know which story type you are trying to work with, as this will provide the motivational framework for the character.

To illustrate how this motivational framework is constructed, I have chosen one type of story, the romance story, and broken it down: For a romance story to be recognised as a romance story the following events have to be included within the narrative.

1. *A character is seen to be emotionally lacking/missing something/someone.*
2. *Something/someone is seen by the Character as a potential solution to this problem –the object of desire.*
3. *Barriers exist to stop the Character achieving a resolution with the object of desire.*
4. *The Character struggles to overcome these barriers.*
5. *The Character succeeds in overcoming some, if not all, of the barriers.*
6. *The story is complete when the Character is seen to have resolved their emotional problem and is united with the object of their desire.* Whether they stay united or part, and the form of any union, is up to the writer. Being united with the object of desire is the end of a romance story but not necessarily the end of a romantic narrative.

There are a number of points worth noting about this story. First, the Character has no distinctive characteristics other than the motivational ones of loss and a desire to change this condition. Therefore, it is perfectly possible to create a romance for a blue line in a white space, a piece of popcorn, any human being on the planet and any imaginative creature you can invent.

Second, the story does not require more than one character to be active. This highlights the fact that stories belong to their characters and are not dependent on other characters' actions to be understood. This is why in some very short narratives a character can interact with an inanimate object and we will still understand it as a romance.

Third, Characters' motivations are determined by the story they are involved in, not some external factor(s).

Fourth, the story does not determine dramatic structure. You can start a narrative with the ending of the story and then work back to the beginning. You can reveal different parts of the story in any order and in different ways. However, by the end of the narrative the whole of the story has to be present for the audience to grasp the type of story it is.

And fifth, the establishment of the story in the narrative brings about an expectation of its resolution. Once the notion of a character being involved in a type of story has been introduced into a narrative, the audience waits to see it develop and be resolved.

This last point is fundamentally why stories work as creative devices. It is also why stories have the power to confuse and disrupt narratives for an audience.

Stories are patterns audiences recognise which enables them to marshal all the disparate information the screenwriter places before them. Stories reflect in a basic way human experiences, which is why they work across cultures and languages and why audiences expect a certain pattern of development.

However, if having been established this pattern is not followed then the audience will become confused. When it does, it will stop taking in all the other information, which the screenwriter wishes it to engage with, as it struggles to understand what is motivating the characters to carry on. In essence, the audience will try to work out what the story really is and what it is therefore about.

Essentially, all stories work this way. They are very simple adaptable frameworks which allow the audience to grasp the fundamental motivational reasons driving a character and provide the screenwriter with the narrative space to develop their own concerns. The questions of how many stories there are and how they can be used when writing a screenplay are dealt with in Chapter 5.

## Theme

'What is this really about?' is the question which cuts through all the details of character, plot, style and who is prepared to become involved in it, and addresses the central issue of why will any human being be interested/affected by this narrative?

The difficulty for writers is that the theme of a project often emerges as a

project develops and, crucially, the ending of the narrative ultimately confirms or denies what the narrative is really about, not the beginning. However, as with stories there are some very broad basic concerns which encapsulate the range of reasons why people will be interested in or affected by a narrative. These work not at the rational level of understanding characters' motivations, as with stories, but at the emotional level of being engaged with the narrative as a whole, moment by moment. As illustrated above with the theme of injustice, this arises from the experience shared by most human beings of being wrongly judged at some point, or at several points, in their lives. This relationship with emotional experience is the power of theme, which holds an audience to a narrative and ultimately provides the emotional satisfaction at the end.

The broadness of such basic themes as injustice is their strength, but when you write a screenplay there will be a number of themes emerging within the work and all sorts of questions posed as to what this is really about. To answer this question in the final analysis you have to look at the main and secondary stories and see how they are dramatically resolved. In essence, it is the issues being addressed within the climax of the narrative which define what the particular form of injustice, or any other theme, any one screenplay is about.

As to how the narrative comments on this injustice, or any other theme, it is the outcome of the climax and the closure of the narrative which provide the conclusions on what the narrative is really about.

For a list of basic themes and how themes are developed within different dramatic forms and genres see Chapter 5.

## Stories and themes as structural devices within a narrative

As story provides the motivational framework and is illustrated by a development of events, so theme provides the emotional framework and value system of the narrative and is illustrated by the use of repetition.

The essential tool for creating the repetition within a narrative is the notion of the *strand*, i.e. having established in the narrative that something is important, we return to it on several occasions and on each occasion show it in a different light. This may be achieved literally by seeing it from a different angle, by creating a new sub-text for the image, statement or scene, or by juxtaposing it with different imagery.

The use of strands becomes extremely important within the construction of associational narratives where story is not evident. By making sure that various strands of images and/or references are established, developed and concluded within the narrative, an audience is able to follow a dramatic development through the narrative. The most obvious example of this in everyday life is the television advertisement which juxtaposes a series of images to give an impression of the subject of the advertisement. Therefore, theme is not revealed through story development but through the content of scenes and images.

The strand as a narrative device is possibly most easily seen when it is used to unite various episodes of a television series. This approach was most obviously

used in *Hill Street Blues*, but has been copied in numerous television drama series since. Other examples include *Heartbeat, Homicide* and *Roughnecks*.

It is in this context that the particular subject of any story is the key to the theme of the narrative.

In linear or episodic narratives it is how characters discuss or act in relation to this subject which reveals the theme. In associational narratives it is the juxtaposition of one image with several others, at different times in the narrative, which reveals its thematic significance.

Theme is also why you may select one story over another within a particular narrative, as it reflects another aspect of the theme of the main story. It is this reinforcing ability which is the fundamental aspect of the relationship between story and theme, and why I have placed them next to each other within the matrix. However, it is their fundamental status as the key underlying elements of any narrative which makes them distinct elements within the matrix. You will have to address these elements at some point within the development of a project if the full potential of the narrative is to be realised on the screen.

### The conjunction of story and theme

The underpinning choices with respect to stories and themes clearly have a major impact on character development and the use of one image or dramatic action over another. The range of options available to you if you are developing a screenplay are enormous and many of the vital decisions will be found in the empty spaces of the matrix where you will make your own personal choices about characters and events.

However, in order to illustrate how stories and theme work across a spectrum of narratives I have chosen to concentrate on the narrative options surrounding a concern with love. If we want to explore the value of love in contemporary society, then the most obvious choice is to choose a romance story. However, this simple story-based approach does not explore the value of love; it merely states it exists and is something we easily understand.

For the narrative to explore the value of love we will need other stories placed with it to illustrate the choices and the cost of love so that the character in the romance story can be seen to explore the value of love. These stories need to be thematically linked to bring out the pursuit of love and its value.

However, if we want to explore the value of love in more than one culture, then we need a narrative which will allow this. The answer then becomes a series of romance stories, taking place in different cultures within the same narrative and all clearly reflecting the pursuit of the love theme. Alternatively, if all we wanted to do was state that love is valued differently in different cultures, then we could choose a set of thematic images with no story elements at all and juxtapose these in such a way as to express this thematic statement.

This range of options is clearly dependent on the choice you, or any other writer, makes with respect to the issues raised. The central problem arises when a screenwriter does not confront the question of theme or understand what stories their characters are involved in.

The secondary problem is to make sure that all the stories are connected in some way thematically if they are to achieve the maximum narrative engagement. If you are working with a thematic narrative then the theme has to be explored in enough variety that the audience does not take the point of the narrative from the opening, making the rest of the narrative redundant.

The various ways in which the concern with love was tackled above points directly to the implications for dramatic form and plot. A narrative which seeks to combine several distinct stories at different times and in different places will clearly need a different dramatic form and plot from one which merely states that love exists.

## Form and Plot

Dramatic structure has been the major focus for debate and development in screenwriting over the last decade in the English-speaking world. It has led to various paradigms, metaphors and alternative structures; an attempted division between character-centred and story-centred narratives; and an attempted divide between Hollywood and European or world cinema.

At the same time it has largely ignored television's dramatic structures, issues of characterisation as opposed to character, the importance of sequences in narrative construction, the uses of genre, and the impact of style on narrative engagement.

The result has been a re-focusing on the screenplay as the basis of everyone's engagement with any eventual narrative; the beginnings of a common language among writers, directors and producers; and a great number of simplistic, formulaic screenplays which either do not work or which rely heavily on genre and style to overcome the limitations of the plot and characterisation.

In order to help reduce the simplicity of much of the past debate, and it is hoped to enhance the creative options facing screenwriters, I will identify the elements which make up a screen narratives' basic dramatic options and address the question of 'What is a plot?'

In this context form is the dramatic shape of the narrative while plot is the way the story and thematic elements are dramatically revealed within this dramatic shape.

## Form

There are three distinct parameters of form which determine the overall shape of a narrative. These are length, structure and time.

### 1. Length

Screen narratives can last a moment – literally all the time it takes for a human brain to register the fact that something has happened – or several years. An example of the former is *Buono Fortuna* which lasts seven seconds, while the latter is *Coronation Street*, a 'soap' which has been running for over thirty years. Length has an enormous impact on the number of stories which can be dealt with within a

narrative, the depth of thematic concerns, the types of characterisation possible and the plotting of the narrative.

## 2. Structure
There are four basic structures available within screen narratives:

### Linear
All the events of the narrative take place in chronological order, as if the camera had merely followed the action in real life, and the narrative was the edited highlights. This is the dominant form of screen narratives from *Fawlty Towers* to *The Lost World*, from *The Bicycle Thieves* to *Das Boot*. However, it has two distinct types.

The *simple linear narrative*, in which all stories run in parallel in the same time frame as the main narrative story, e.g. *Gandhi*, *Speed*.

The *complex linear narrative* in which a secondary story develops in a different time frame. This can be quite small in narrative time as in *Once Upon a Time in the West* or be a major part of the narrative as in *The English Patient*, and *The Terminator*.

### Episodic
A collection of discrete episodes form the narrative. Each episode can be viewed and understood on its own but its real narrative power rests on it being part of a series of episodes which form the narrative. This is the dominant form in television from *EastEnders* to *Heimat* but it is also present in feature films from *Kaos* to *Night on Earth*.

As with the linear narrative, there are two versions of the episodic narrative. The simple episodic narrative, in which each episode is told discretely and follows one after the other. Examples of this would be *The Bill*, *Columbo* or *Canterbury Tales*. It is possible within one narrative to have episodes which reflect on, or relate to, each other in some way but nonetheless are structured as discrete episodes, e.g. *Rashomon*.

The complex or the multi-stranded narrative, in which a combination of stories are woven into the narrative, some of which are contained within the episode, while others run across several episodes. Examples include *NYPD Blue*, *Northern Exposure*, *Boys From the Blackstuff*.

### Thematic
A series of discrete incidents which involve different characters linked by a similar problem, location or dramatic concern. These incidents may form episodes in feature film screenworks e.g. *Kaos* or *A Night on Earth*. Also it is significant within ensemble pieces e.g. *Secaucus Seven*, *The Big Chill* where disparate  characters and stories are used to explore and develop a theme.

The crucial aspect of this form is that the dramatic structure is driven by the theme which is the reason for the narrative's existence.

### Associational
Here the narrative is formed from a series of moments which are linked by common elements and do not rely on chronology or episodic relationships to produce their

meaning or effect. This is the dominant form in advertising, which promotes everything from cars to ecology. It is also evident in animation and short films e.g. *Sunsets*, *The Old Man and the Sea*. However, it has been used in longer narratives, e.g. *Koyaanisqatsi*, *Blue*.

**Circular**
Here the narrative is formed from repeated events. This has been used in one-off narratives such as *Groundhog Day* and the various episodes of *Road Runner*. However, its major contemporary use is in the form of interactive games from *Super Mario* to *Doom*.

Each structure can be used as the basis for narrative construction. They can also be used in conjunction with each other. However, in working with two structural forms you need to be sure which will dominate the narrative and which will play the role of adding variety to this dominant form. For example, *Pulp Fiction* is an episodic narrative with circular events adding a beginning and end and allowing references to elements of each separate episode to be made throughout the narrative.

The question which needs to be borne in mind here is not 'Is it possible to have a circular, associative structure within an episode of a linear narrative?' but 'What is the overall structure of the narrative and its impact on the plot, the number of stories, the development of theme, the characterisation and the style of the narrative?'

## 3. Time
Screen narratives work with four different types of time:

• *Real time*
The time it takes for the events which form the basis of the narrative to take place in our everyday reality. This is where our own experience of life plays a vital part in assessing the credibility of screen time.
• *Screen time*
This obviously relates to the length of the narrative itself, but also involves the ability of screenworks to play with real time literally before our eyes. Apart from the obvious distortions of using slow-motion, speeded-up action or pixillated movement, screen time can also be distorted by editing. The most obvious example of this is with extending the actual time it takes a character to walk towards danger. In real time it may take only a few seconds, but with cut aways to the form of the danger, to other people involved, even to separate stories, the amount of screen time can greatly distort this reality.
• *Emotional time*
The time revealed by the length of the shot, the angle of the shot and/or the juxtaposition of shots (discussed under Style and Plotting).
• *Narrative time*
Our ability to remember over time various narrative elements and use these in assessing and engaging with any narrative (discussed under Genre and Plotting).

The impact of real time on the form of a narrative relates to the credibility of action, and has a direct impact on plot and characterisation. This impact arises from two aspects of human knowledge. First is our knowledge of how long it takes for something to happen, e.g. for a person to search through files, to talking someone into doing something they do not want to do. Second is our knowledge of emotional responses to dramatic events.

If not enough real time is seen to have elapsed between one narrative event and another, then the credibility of the action evaporates. Equally, if a person's recovery from a dramatic event is perceived as too quick or too slow, the credibility of the character is undermined. Clearly the way each of these time problems is dealt with will vary from narrative to narrative. However, it is worth bearing in mind that the knowledge held by the audience does not have to be based upon direct experience; it is often based upon its perception of how long something takes.

The ellipsing of real time, i.e. editing it out of the narrative, and yet still retaining a credible time frame for characters and action to unfold is one of the judgement calls screenwriters always have to make.

## Plot

Plot answers the following question 'What is the most interesting way to tell the story/ies or explore this theme, within this narrative?' It is the means within the narrative by which the screenwriter engages the emotions of the audience from moment to moment throughout its involvement with the narrative. This is as true for *Un Chien Andalou* as it is for *Star Wars* and *Coronation Street*.

Unlike for form, there are no distinct parameters to plot, though the plot of any one narrative will be heavily influenced by genre. Instead, the driving force of plots is the establishment of a complex set of active questions. These active questions structure the narrative from moment to moment, from the beginning to the end of the narrative.

An *active question* is a question created by the narrative in the audience's mind, which intrigues and holds it to the narrative while an answer is sought.[1] Such questions can range from 'Where is the exit from this room?' to 'How will Tania avoid revealing the truth about Jo without upsetting Slimey and potentially destroying the whole universe before new forces arrive or the bomb explodes?'

Major active questions – ones which hold the whole narrative together – form the basis of framing plots. The following are examples of this type of active question.

- *The Romance* – Will the protagonists fall in love, and at what cost?
- *The Thriller* – Will the protagonist/s survive the threat of death?
- *The Investigation* – Will the missing element/s of a puzzle be found?
- *The Journey* –Will the protagonist/s complete their journey and why is it important?
- *The Revenge* –Will the debt be repaid and to whom?

© Polygram 1995

The Usual Suspects *(Best Screenplay, 1996 Academy Awards) illustrates the importance of choosing a point of view to determine plot.*

- *The Contest* –Who will ultimately win and when?
- *The Disaster* –Who will survive?

These large active questions work to hold the whole narrative together. They provide a framework within which all the various stories can be told. However, for a narrative actually to work, active questions are raised and answered from moment to moment, from scene to scene, from sequence to sequence throughout the narrative.

The key purpose of the plot as a whole though is to work at the emotional level in terms of engaging the audience in the narrative's development.

## Engagement

Engagement is achieved differently in different genre but is determined by the use of the following plot devices:

### 1. Thematic concerns.

The development of thematic concerns and how these are revealed through the combination of stories and images is dealt with above. However, clearly the interweaving of the stories and the development of the contrasts between them are totally dependent for their dramatic effect upon the plot of the narrative. It is the plot that reveals theme but it is the theme which makes a plot worth following.

## 2. The choice of a framing device.

This can vary from a character's story to a musical score or an editing scheme. The character-framing story will provide the plot spine in determining the overall shape of the narrative. This does not mean it will necessarily determine who the protagonist is for significant parts of the narrative. For example, the journalist in *Citizen Kane* provides the spine which reveals Citizen Kane's story, but it is Citizen Kane who is clearly the protagonist for the majority of the narrative. This highlights the point that the answer to what is the most interesting way to tell these stories/reveal this theme, is determined by asking the question –'From whose point of view are we going to reveal the story/theme?'

## 3. The choice of point of view.

Many narratives use the device of an omnipotent point of view i.e. the audience is placed in a superior position to the protagonist/s. This means the audience is often aware of information characters in the narrative do not have, a situation which lends itself well to the creation of suspense. This use of point of view dominates horror, action adventure, comedy and thrillers. However, often narrative information is revealed only as the protagonist encounters it. This approach enhances the element of surprise. It is often used in investigative, pursuit and quest narratives.

It is worth noting that the point of view can change within the narrative, i.e. for the majority of the narrative the narrative information is revealed by one character and then is revealed by another. This is most commonly used in argument-based narratives, e.g. court-room dramas, and dominates television documentaries. Examples where the storytelling possibilities of this choice are well illustrated are *The Usual Suspects*, *Rashomon*, and *Missing*.

## 4. Defining protagonists and antagonists

Who the protagonist will be within a narrative space is probably the key choice any screenwriter makes and it will determine not only the nature of the plot structure but the nature of the antagonist. The protagonist in this sense is defined by a character's link to the dramatic active question which dominates a narrative sequence. Therefore, a character's active question may be the one which dominates a whole narrative and that character is clearly the protagonist for this narrative.

In an episodic narrative one episode may have a completely different protagonist to the next. However, as in a multi-stranded episode, one character's active question will dominate one sequence and the next sequence will be formed around a completely different character's active question. In this case these characters are both clearly protagonists within this narrative. Equally, in an ensemble narrative a group may face a single active question as a whole but individual characters' active questions will form the dramatic core of separate sequences. In this light it is easier to see how a character can be the protagonist in one sequence and the antagonist in another.

Apart from very short narratives i.e. less then sixty seconds, there are normally two protagonists within any one narrative, and within soap operas up to thirty or more characters take on the role of protagonist over the course of a year. The antagonist is essentially the source/s of the dramatic conflict which provides the tension within the protagonist's story. Antagonists are characters with their own stories and can be characterised in any number of ways, but they are limited by the form, genre, style and the plotting of the narrative.

These four points provide a solid basis for understanding why a narrative is emotionally engaging but to stop it from being confusing we need to turn to one of the most written about and discussed dramatic ideas of the last decade of screenwriting.

### The Three-Act Structure

Unfortunately, or perhaps fortunately, there is not enough space within this book to go into all the different versions and stances taken on the importance or irrelevance of act structures in the creation of a screenplay. Instead, I will attempt to answer the basic question 'Is there such a thing as a three-, five-, seven-, (pick your favourite number) act structure?'

The simple answer to this is 'Yes and no'. 'Yes' in that there is a way of looking at narratives which is useful and uses a three-act notion of dramatic construction: 'No' in that there is not one single all-embracing act structure which runs for a certain number of pages or scenes and can be applied rigorously to all narrative construction.

The idea of the three-act structure has become a point of conflict, and security, for many people involved in screenwriting over the last decade. Its origins have been traced back to Aristotle and include notions of the well-made play developed by Eugine Scribe in the 1820s.[2] It has been challenged by the existence of narratives which do not have a simple linear plot, where the inciting incident, the climax or the closure moment are seen as separate acts; or a developing character is seen as the central dramatic core of the narrative.

However, the value of a three-act structure does not rest at these mechanistic levels where the debate is either about how many events make an act or whether act structure or character development dominates narrative choices. Instead, it rests at two levels of an audience's engagement with the narrative. Firstly, its engagement with the narrative as a whole, and secondly the development of individual characters' stories and thematic concerns.

In order to see how this works within narratives, I will describe the three acts as follows:

| Act 1 | Act 2 | Act 3 |
|:-----:|:-----:|:-----:|
| *Establish* | *Develop* | *Conclude* |

These three acts relate to the nature of how the audience perceives what the narrative is about.

At the beginning of any narrative you have to establish the parameters of the

narrative in the audience's mind. This is achieved by answering a number of simple questions ranging from 'where are we?' to 'what is this about?' However, once these initial questions have been satisfied in terms of defining the central concerns of the narrative, this establishment phase is over.

The second act is where you have to present the audience with reasons for not leaving the narrative at this point because they think it is all over or because the route to the end of the narrative is too obvious. This is the developmental part of the narrative, where you present a set of new active questions which build on the first set and present the possibility of different outcomes.

The third act is where you draw the narrative to its conclusion and provide a sense of closure. Closure in this sense means the audience is informed it is appropriate for this narrative to end at this point.

In terms of simple linear narratives, these aspects of the three-act structure can be seen very clearly. However, in episodic, associational and circular forms the same means of engagement apply.

In general terms the three-act structure operates as follows.

The first episode, the first set of images or the first events establish for the audience the basic concerns of these forms of narrative.

The second and subsequent episodes, sets of images or events reflect upon these established concerns and develop the possibility of other narrative conclusions.

The final episode, set of images or events provide a conclusion to the narrative which resolves the central concerns of the narrative up to the point of closure.

In this context, for example, in a four-episode narrative the three-act structure will work in the following way. Each individual episode will have its own establishment, development and conclusion. In addition, the first episode will act as the establishment for the whole narrative. The next two episodes will form the development section of the narrative and the fourth episode will form the conclusion of the narrative.

### The Three Acts in Stories or Themes

The three acts in relation to individual stories and thematic concerns work in terms of providing the audience with pointers as to which pieces of narrative information are important and which are incidental. The distinction which is being drawn here is between those elements of the narrative which the audience need to remember and focus on and those elements which merely provide a context within which these significant narrative events are taking place.

Therefore, you may in the opening sequence of a narrative represent a number of characters, events or images all of which will have equal weight, until one or more of them is repeated or dwelt upon for a longer time. This one then becomes significant but we do not know why. We know merely that it has more narrative presence than the others. It is only when an active question is raised in relation to it that the dramatic purpose of this is revealed and used. This is establishment, development and conclusion working at the moment-by moment-level of characters' stories or a theme's development within the narrative.

## How do form and plot work together?

The length of a narrative will heavily influence the number of active questions which can be raised and successfully answered. Equally, the more complex a plot, the greater the length of screen time required to reveal it.

This type of relationship also exists in terms of the number of significant characters and the thematic concerns of the narrative. The more characters, the greater the screen time required, and the more complex the use of active questions becomes. The more a narrative is being driven by thematic, as opposed to story, concerns, the more the use of the three-act structure to underpin the narrative becomes essential.

These three different aspects of the narrative – active questions, engagement and act structures – are the essence of *screen language*. They provide the means by which you can create dramatic and engaging narratives across a number of different forms, genres and styles.

## Genre

'Genre' is one of those words which everyone uses but few people can actually explain. We all know what we mean by saying we are going to watch a sci-fi movie or a new 'soap', but when asked to identify what makes it a sci-fi as opposed to a 'soap', we have trouble explaining. You only have to think of *Lost in Space*, or *Babylon Five* to start seeing the crossovers.

This level of confusion and lack of clarity is reflected in the absence of much genre description in screenwriting texts and in recent academic studies. Therefore, I will attempt, in the first instance, to provide a clear definition of what genres are, how they are constructed and how they can be used by a screenwriter in developing a screenplay.

Genres are sets of patterns, combinations of narrative elements, which screenwriters and the audiences recognise and use in interpreting the screenwork. They work because audiences build up a recognition of certain patterns over time and then use these when viewing new narratives. This memory of narrative patterns is in turn used by screenwriters and others to establish a set of expectations within the audience which are then built upon.[4]

Genres vary to some degree over time and can be combined in several different ways.

The difficulty with identifying genres is the flexibility of the various narrative elements, and the problem of shared elements within and across genres. In order to overcome this problem I wish to suggest that all genres have two distinct sets of elements. These are the primary elements, which separate them from other genre, and secondary elements, which when combined with the primary elements define the parameters of a particular type of thriller or romance, etc.

*Primary elements*. These work in much the same way as stories do, providing known points of reference for the audience which allow it to concentrate upon the particulars of the narrative.

*Secondary elements*. These differentiate one type of narrative from another within particular genre groups.

Genre groups are collections of narratives which share the same primary elements with each other but are different in their combination of secondary elements.

An individual genre does in some cases overlap with another individual genre from another group and in this way we can see the power of certain narrative elements at work in a number of different contexts. There is not enough space here for all the current genre groups to be explained and documented. Therefore, I will provide only two examples here and discuss other examples and their uses in Chapter 8.

## 1. The Situation Comedy

The primary elements of situation comedy are:
- *A half hour episodic dramatic form.*
- *A small core of characters.* These can range in number from one or two (*Steptoe and Son, Mr Bean*) up to eight or nine (*Cheers, Dad's Army*). The characters are all strong types. Within the core there is either one main character whose story dominates the narrative in each episode or a core relationship with a conflict which dominates the narrative. Note that the members in the core relationship can change in the large-cast shows and this becomes a necessity if the show has a long programme life.
- *The dramatic structure is based on stories with only a small thematic concern.* There are only one or two main stories in each episode.
- *One or two central locations.* This is often one building with adjoining rooms but can be two separate locations. Note that as a series becomes more successful so the number of locations tends to grow.
- *The dramatic conflict arises from the core characters responding to each other or from a single dramatic problem.*
- *The aim of the plot is to generate as many laughs as possible from the characters' attempts to deal with each other and their problems.*
- *Each episode is self-contained.* Therefore, the overall dramatic structure aims at returning the core characters to the position they were in when the episode opened. Note that the longer the series runs the greater the need for character development.
- *The plot is dialogue driven.* All the key dramatic problems are related to the audience via dialogue. There are only a few exceptions where action takes over from dialogue e.g. *Mr. Bean, Some Mothers Do Have 'Em.*

To these primary elements are then added particular secondary elements to form the basis of a particular type of situation comedy. Secondary elements define the following four types of situation comedy:

### a. The Romantic
- The core relationship centres on the possibility of the couple forming/ or maintaining a permanent relationship.
- The main story in each episode presents a problem which threatens the core relationship.

- The two central characters are opposite types but have equal narrative strength, i.e. it is never the case that one always triumphs over the other.
- Secondary characters take sides in the dispute between the main characters but each character is generally on the side of one character rather than the other.
- The use of a guest character is optional but not uncommon, i.e. a new character in each episode, who is the source of a problem for the main characters.

Examples of this genre group are *Watching, Cheers, Goodnight Sweetheart*.

**b. The Family**
- The central drama is about the maintenance of a family group. Note that the members of the group do not have to all be part of the same family, e.g. *The Golden Girls*.
- The main story focuses on one of the family threatening to leave, or break-up, the family or an external force threatening the family.
- The characters contain a generational age range.
- The characters are in familiar power relationships with each other, with one main character generally having the final say in all disputes.
- Secondary characters take sides in the dispute, or in attempting to solve the problem. Characters swap sides in disputes, but there are ongoing conflicts between them.

Examples of this genre group are *Frasier, Roseanne, Butterflies, The Cosby Show*

**c. The Institutional**
- An ensemble-based drama in which a group of people face a number of external problems. The central dramatic question is: 'Will the group survive, or solve, the problem facing them?'
- The group are united by institutional relationships, e.g. work, or team membership. There is a dominant character within the group, who determines the course of action. The main secondary character acts as the source of reason in the face of the main character's plans. The other secondary characters act as sources of comment, or additional problems, for the dominant character.
- An external force provides the basis of the main story each week.
- Character types are based upon their relationship to the institution, which binds them together.
- Guest characters are common.

Examples of this genre group are *Dad's Army, Fawlty Towers, Mash*, and *The Vicar of Dibley*.

**d. The Loner**
- One character attempts to survive in a very uncertain/threatening world.
- The main story is generated by the main character wanting to achieve something.
- The sources of conflict are secondary characters, and the forces which block the character achieving their goal.

- The dramatic conflict centres on the main characters inability to accept the world the way it is.
- A main secondary character often acts as a sounding board for the main character, but not always. Other secondary characters are merely there to present the main character with problems.
- Guest characters are common.

Examples of this genre group are *One Foot in the Grave*, *Mr Bean*, and *BlackAdder*

These groupings illustrate how by adding specific narrative elements to the primary core elements each type of situation comedy differentiates itself from the others.

## 2. The Romance
The Romance genre is unlike Situation Comedy, where the types arise from distinct, separate, groups of relationships. Romance operates as a spectrum along which various types merge with each other, but where three distinct types define either ends of the spectrum, and the mid-point. The primary elements of this romance spectrum are:
- *The narrative centres on a notion of love.*
- *The two central characters are both involved in romance stories.* If it is a triangular romance, then the third character is also involved in a romance story.
- *The central protagonists have an equal narrative weight in terms of narrative time spent with them, and the level of problems they have to overcome to realise their love.*
     The secondary elements which express the nature of the spectrum are outlined in three kinds of Romance:

### a. The Dramatic Romance
This is one end of the spectrum.
- The narrative centres on the value of love.
- The plot aims to establish the existence of love, and then place it in conflict with other human needs or sources of love.
- There are two or three central protagonists.
- The main motivation of the protagonists is to satisfy their sense of loss, but they have other equally pressing demands in their lives.
- A main secondary character is also involved in a romance story, which is used to illustrate a possible outcome for the main characters.
- All other secondary characters are merely to provide narrative information, additional dramatic problems, or illustrate the theme of the narrative.
- The narrative is dialogue driven, in that it is the psychological motivations of the characters, revealed in dialogue, which initiate action.
- The narrative remains with one or both of the central protagonists. The only exception being framing stories.
- A single location is common, although this could be a city or a community. It contains and illustrates the problems the central characters face to fulfil their love.

Examples of this type are *Ju Dou, sex, lies and videotape,, Brief Encounter*.

## b. The Romantic Comedy
This is at the mid-point of the spectrum.
- The value of love is taken as a given, and the purpose of the narrative is to illustrate how true love conquers all. As a result the plot is not about the inner struggle of the character to discover how much they love someone but a combination of external barriers, and the issue of commitment to the relationship.
- The two main protagonists face innumerable barriers to actually establishing a relationship, and recognising they are in love with each other. One of the protagonists normally believes they could be meant for each other early in the narrative, but the other resists this conclusion. However, neither character really develops through the narrative: it is merely 'Will they or won't they discover this is the person for them, and when will they both end up realising this?'
- Secondary characters provide the source of the main dramatic developments in the plot.
- The narrative is a combination of action-driven and dialogue-driven sequences. The balance is dependent on the style of the narrative.
- The aim of the plot is to provide as many comedic moments as possible between the two central protagonists, and their environment or other characters.
- Multiple locations are the norm.
- Secondary character's stories can dominate sequences within the narrative, but always with one of the protagonists present. This provides for a wider point of view than in the dramatic romance.

Examples of this type are *Four Weddings and a Funeral, Annie Hall, Sleepless in Seattle, Shooting Fish.*

## c. The Tragic Romance
This is at the other end of the spectrum from dramatic romance.
- The value of love is taken as a given for one of the protagonists. However, the other protagonist has substituted something, normally money or power, as the object of desire, and is, therefore, ultimately not capable of sharing the love of the first protagonist.
- The two protagonists are involved in a romance, but it is a tragic one as their very natures mean it must end in one, or both, being destroyed. Note that this is not about tragic endings. Some of the most memorable Dramatic Romances end in tragedy, but this not implicit in the characters' relationships with love. It arises from the circumstances surrounding the romance. While in the tragic romance it arises from the nature of the characters themselves.
- Secondary characters reveal the true nature and intentions of the protagonists.
- The plot aims to provide as many surprises and twists as possible in terms of what is the real motivation of the person, who has substituted something for the love of another. Therefore, it is crucial that we believe a character may be truly in love with the person who is in love with them, but at the end we realise this is not true.
- The narrative is dialogue driven but action provides the main revelations in the plot.

- Secondary characters' stories can dominate some sequences but always with one of the protagonists present.
- Sex, or sexual attraction, plays a significant part in the motivation of the love-oriented protagonist.

Examples of this type are *Body Heat, Double Indemnity, The Last Seduction, Dangerous Liaisons* and *Un Coeur en Hiver.*

Situation Comedy and Romance both illustrate the different ways in which screenwriters group narrative elements together to create a cohesive bond between a particular screenplay and its audience.

### Genre, Time and Place

As I stated in the introduction to this section genres work as a framework across a number of narratives, and with different audiences at different times. Does this mean that the genre framework remains the same across time and with all audiences?

In their basic form, with all the primary elements in place and the secondary elements reflecting the essential qualities of any one genre this would appear to be the case. This is why *Jurassic Park* – a horror genre piece – worked well in most cultural contexts and why the investigative thriller is one cinema genre that is often made.

In terms of a wider sense of genre, though, it is clear that certain genre only really work within certain cultures, with only a curiosity or cineaste appeal at a wider level. One example of this is the gangster genre, which has flourished in American, Italian and Japanese film but has only a few rare examples in British, Swedish and Russian cultures. The reason for this is fairly obvious in that the first three cultures have all experienced major periods within cinema's short history when gangsters played a major part in the country's everyday life.

It is notable that one of the most successful gangster films to work outside its own culture was *The Godfather*, which apart from using the spectacle of cinema, centred on a personal drama, the destruction of Michael Corleone, and not just the gangsters as gangsters.

Equally important for some genres is not just an historically shared experience within the audience but some culturally specific traditions. Therefore, the combination of martial arts and Chinese theatre provides the backdrop for the Hong Kong martial arts films, while the documentary movement and the existence of the BBC supported personal dramas within the UK.

Another aspect of genre usage is the development of new genres. These often arise from new forms of media, e.g. the soap in response to television; or from social changes, e.g. the dance movie in response to the participation of the audience in dancing rather than just watching others perform.

All these different aspects of genre point to its dynamic nature but also highlight something which many screenwriters and other creators of screenwork forget. Having a genre framework does not guarantee a successful narrative, nor

does attempting to avoid a genre mean you are being original. You are just as likely to end up being confusing.

The art of using genre is to realise its strengths and limitations and bring to them your own original characters, situations and story-telling abilities.

# Style

'Style is the most misused word since love', according to Sidney Lumet,[5] and in terms of screenwriting it is certainly one of the least understood. There is a confusion between a writer's style, i.e. how they use words on a page, and screen style, i.e. how the style impacts on the other elements of a screen narrative. However, it is also an area of screenwriting, which has all too often been seen as exclusively the director's territory.

## *The importance of style*

When creating a 'soap' in a contemporary setting the question of style seems almost redundant. It is assumed that it would be shot in the naturalist style which dominates most contemporary English-language television drama. However, if you compare the visualisation of *EastEnders* with *Neighbours*, the differences are not just about one being set in London and the other in Sydney. The choice of setting, its lack of 'gloss', or its emphasis, are directly linked to the type of characters and plots the soap will include.

Does this mean that style arises from the other elements in the narrative? In many screenworks this clearly is the case but there are times when style is the single most important factor in determining how the narrative develops. For instance, when adapting a well-known, if not too well-known, text to the screen, style often becomes the most important part of defining the originality of the screenwork, e.g. Baz Luhrmann's approach to *William Shakespeare's Romeo and Juliet*.

This is equally true when dealing with a complex episodic narrative which needs a singular point of view imposed on it, e.g. *Trainspotting*; or when the characters, or the setting, require it, e.g. *Star Wars*, *Nightmare on Elm Street* or *Doctor Zhivago*. Style in this sense is a set or pattern of narrative devices which when used together form a unifying bond between the disparate elements of the narrative and the audience.

However, the single most important characteristic which underlies all the aspects of style is tone. The big question is whether a narrative is comedic, tragic or dramatic in tone. Then within these three types of tone, which particular style is being used? For example, within the comedic spectrum the choice ranges from parody through slapstick to wit.

Each particular tone is expressed through the style of the narrative in terms of characterisation, visuals, action, dialogue, pacing and dramatic structure.

For example *Airplane* is a parody of the disaster-movie genre. As it is a parody of a particular plot, i.e. the disaster; its character types are derived from the original but the characterisation is parody, which means the characters have to be ludicrous.

As they are ludicrous there is little character range to be expressed, which in

turn means a substantial number of incidents or people are needed for the key protagonists to encounter. This is the only way the narrative will not become predictable and boring.

Equally, the reactions to these incidents/people must be ludicrous. This points to a slapstick style of visual comedy and an absurdist style of dialogue, rather than realistic responses and simple witticisms. This leads to fast-pacing, set-piece action sequences, a non-realist approach to violence and physical locations which in some respects defy the laws of time and space.

In thi way tone affects various elements of the narrative and provides a unifying factor between them. The basic definitions of tone are as follows:

• *Dramatic*. Where the style of the narrative reflects the theme directly within the narrative action and climaxes in an affirmation of the values being questioned.

• *Comedic*. Where the style of the narrative reflects the theme throgh a comic prism with a climax which can be either positive or negative with respect to the subject or value system being addressed within the narrative.

• *Tragic*. Where the style of the narrative reflects the theme directly within the narrative action but the climax challenges the contemporary values at the heart of the narrative.

So how is all of this expressed in the screenplay?

## Style tools

### Location
This is dealt with not only in terms of where the action of the narrative takes place but also what is specifically used in the location to complement and enhance the style of the narrative For example, it is far easier to generate suspense at night than in daylight. The setting for the final confrontation/revelation can provide not only elements for action in the scene but also atmosphere and symbolic support for the emotions in the scene. The visuals of the opening scene or sequence will indicate the genre to the audience.

### Characterisation
This will apply not only to the physical characteristics of characters but also their way of expressing emotions and the range of emotions contained within the narrative.

### Dialogue
Dialogue can be used in a number of different ways and is clearly one of the strongest elements of characterisation. However, dialogue is not just about character. It also about exposition, the context of the action and the emotion of the narrative.

### The balance of dialogue with action
Each genre strikes a balance between action and dialogue. Ths is reflected in the overall style of the narrative.

## Editing

The editing style adopted for a narrative has an enormous impact on the length of scenes and sequences, the pace of narrative information, the point of view taken and the development of active questions.

## Point of view

Deciding from what point of view the narrative will be seen and how this will be represented on the screen is a crucial style decision. However, it is also important in terms of shots. Placing the audience close to the action or far from it, placing a character alone in a big or small space or lost in a crowd – all have a huge impact on the emotion of thismoment. Note that this does not mean littering a screenplay with camera shots. It means describing the image required in such a way as to make the choice of camera position obvious.

## Colour

The overall feel of a narrative is often determined by the dominant colour scheme adopted for key sequences or emotional moments. A few key words in the description can capture this in the screenplay.

## Sound

Screenwriters tend to ignore the soundtrack other than for the obvious, e.g. dialogue, gunshots and car crashes. However, the range of options from ambient sound and silence through to songs and background music are part of a screenwriter's way of adding to the style of the narrative. Note that if you want to refer to specific music do not assume the reader knows the same music as you, so describe the feel of the music as well as its title.

## Special Effects

These range from simple optical moments, e.g. following a frisbee through the air, to full-blown fantasy worlds. With this range of options the impact on style is equally variable but it is important always to describe, succinctly, what we will see on the screen, not what is happening all around or in a character's mind. Note that it is important when dealing with fantasy or un-real characters and phenomena that not only their representation on the screen is worked out but also their limitations. It is through these limitations that we derive the drama and credibility of unreal events.

Given the three tones and the numerous options derived from combining the devices listed above, I have chosen *naturalism* as the one style to illustrate how this will impact on the other elements of a narrative. This is the dominant style of contemporary screen narratives. The aim of it is to use the credibility of everyday reality without adherence to everyday events or actions, within the parameters of genre and plot.

- Genre rules apply to the look and realisation of reality in the narrative. For example, sit-com homes are bigger, cleaner and less cluttered than real flats,

houses or apartments. Similarly, 'mean streets' are full of rubbish, dark and moody and everyone looks threatening.
- Dialogue reflects the tone of the narrative.
- Events adhere to the needs of the form and the plot.
- The editing style reflects the dramatic needs of the plot.
- Characters and characterisation reflect the needs of the genre, the dramatic form and the theme.
- Sound and music are used to enhance dramatic moments

Examples of this style reflect a diverse range of narratives and illustrate why naturalism is such a flexible style, e.g. *Only Fools and Horses, Friends, Tilia, Sunday in the Country, Pride and Prejudice, Goldeneye.*

This example illustrates the means by which a style produces the unifying quality which is the look and feel of the narrative. Understanding and using style are essential in the successful creation of any screenwork. They are also essential in the creation of any successful screenplay.

The degree to which the writer has to be aware of them and has any choice over them will depend on the project. There is a huge difference between addressing the style questions on an original television serial or feature film, and writing the one hundred and thirty-fifth episode of an on-going series.

The important thing about style is that it is a unifying force within a narrative, and once established in the audience's mind, will be very difficult to shake off as the narrative progresses.

Unlike genre, which isolates one type of narrative from another, style can be and is used across all types of narrative. It is also the one element of the creative matrix which sees aspects of its presence being developed in one type of narrative then another all the time.

An example of this is the flash insert of what a person is thinking. This was developed and extensively used in pop promos and is now being used in mainstream feature films. It is this flexible aspect of style which makes it so distinctive and one of the first things an audience notices.

However, it is only in the short form that style can sustain narrative interest. In screenwriting it is definitely the case that style must reflect the content or the whole project will be undermined.

## Conclusion

This chapter has attempted to provide a brief summary of the key narrative elements which make up the creative matrix. However, it must be remembered that the matrix is also about the spaces left by these elements which have to be filled by the screenwriter. It is these creative spaces which when supported by the six elements – story, theme, form, plot, genre and style – provide the unique and original qualities of a screenplay.

The individual screenwriter brings to the matrix their own concerns, experience, desires and passion. It is these qualities which ultimately make the

screenplay engage and inspire its audience. In order to grasp just how these qualities are brought to the bear on the elements of the matrix, it is probably easiest to express them as a set of questions:

- What is the theme and how will it be expressed in this particular narrative?
- What dramatic form will the narrative take?
- What are the main stories and from whose point of view will they be told?
- What combination of genre/s and style/s will this narrative be written in?
- What is the tone of the narrative?
- Who will be the main characters and what form of characterisation will they be given?
- What are the active questions, where are they planted and where are they answered?
- How will all the narrative elements be formed into an engaging plot?
- What will make this narrative distinctive and original?

In addition, there is a broader question which is always worth asking when developing any idea and writing the screenplay. 'What is this narrative really about and why do I want to write it?'

This group of questions is not the whole picture but if you find some answers they will help you fill in the matrix in your own distinctive way. You will then be applying the combined power of the art and the science of screenwriting to create a strong and distinctive screenplay.

This is the end of the outline for the theoretical framework which underpins the practical advice at the core of this book. The following two chapters are about the practical aspects of developing screenplays. They will cover in detail how to write everything from a premise to a screenplay and how to develop an idea to the point where you are able to assess whether or not it is a good idea.

If you wish to look further into how the various elements of the matrix operate with each other, then please turn to Chapters 6 to 8.

## Notes

1. I first came across the idea of the active question in Iain Heggie's essay 'Structuring Your Story' in *Debut on Two* (Giles & Licorice(eds.)).
2. Aristotle's ideas on dramatic structure can be found in *Aristotle's Poetics: Translated by J.Hutton.* W.W.Norton & Co, 1982. It is developed with reference to screenwriting in *Screenplay* (Syd Field). Dell, 1982. A critique of three-act structure, and the reference to the well-made play are found in *Alternative Screenwriting.* (Dancyger and Rush). Focal Press, 1991.
3. Dancyger and Rush, *Alternative Scriptwriting.* Focal Press, 1991.
4. For a review of the history of Genre writing up to 1986 refer to *The Gangster Film* (Tom Ryall). British Film Institute, 1987.
5. Sidney Lumet, *Making Movies.* Bloomsbury, 1996, p.49.

# 3. Tools of the Trade

One of the fundamental problems faced by anyone discussing, writing about or working on a screenplay is that several commonly used words have different meanings.

For instance, in a meeting or more usually in a submission document, someone may ask you for an outline. This could mean anything from a paragraph of prose which occupies half a side of paper to an eighty-page document involving every scene of an intended screen narrative.

The simple way forward would appear to be to ring up the person who asked for the outline. You will usually discover the desired length from this approach but unfortunately not always the nature of the outline's content.

The reason is that the word 'outline' is used in different contexts without precise definitions. It is a word commonly used by development personnel without any agreement about what the content of such a document should or might be outside of their own production company. More importantly that definition takes little or no account of the role of an outline in the writer's development of a screen idea.

Within this slightly frustrating context I will seek to define all the essential words, from outline to format, which you may encounter in the development of a screen project. I will then attempt to use them consistently throughout the rest of this book to avoid any further confusion, creative or otherwise.

For simplicity and ease of explanation I will follow the development process of a lengthy screenwork, i.e. a feature film or television serial. In the course of working through this process I will cover the following terms and documents:

- *Premise* – idea or proposal
- *Outline*
- *Treatment*
- *Step Outline*
- *Screenplay Layout*
- *Series Formats*

Each one will be dealt with in turn, defined and reviewed in terms of their relevance to writing a screenplay. This process will also highlight some of the contradictions and problems encountered when having meetings and discussions with script editors or other development personnel.

## I Have a Good Idea

Let us start at the beginning of a screenplay project with the sort of things requested from a writer who is about to start developing a project. The following is a list of common terms or phrases encountered: an idea, the premise, the proposal, what it's about, what is the story. Even here we have a range of options and two fundamental differences of approach to the development of a project.

The first three options – the idea, the premise, the proposal – are about summarizing the essence of the project. I will deal with these in some detail in this chapter.

The latter two – what's it about and what is the story – are seeking an understanding of how the narrative will develop and/or what the writer really wants to write about. These two quite separate concerns are dealt with in the next chapter.

## The Premise

For ease of understanding I will use the word *premise* to incorporate the notion of 'an idea' and 'a proposal'.

A premise is a short, one to three sentence statement, which captures the essential elements of the screenplay.

The aims of a premise are to assure the reader that this idea has definite screen potential, that there are some familiar and original elements in the project and that an intriguing enough question has been posed to launch a narrative. It also suggests its probable length.

The premise should contain the following information:

- *The genre of screenplay* – e.g. thriller, docu-drama, romance – *and its qualifying phrase*. For example, action, psychological, conspiracy, comedy, romantic could all be possible additions to the type 'thriller'. To this may be added a comparison with other screenworks e.g. It's *Dances with Wolves* set in China.
- *The form* – e.g. episodic, multi-stranded, circular, associational. These terms are only relevant if you are working outside of the linear form, which is what most people will assume you are using unless you state otherwise.
- *A description of the characters*. These should include:
  - *their names*. Using generic names such as 'A Detective' really weakens the emotional identification with the character;
  - *their central roles in the action of the story* – e.g. unemployed adventurer, inquisitive nurse or hardened soldier; and
  - *their essential problems*. These are the problems which bring them into conflict with the antagonistic force.
- *A description of the dominant antagonistic force* – e.g. a calculating tomb-robber, a corrupt administrator, an earthquake, a character's own doubt or lack of skill.
- *A reference to location and time*. The assumption is that the screenwork will be contemporary unless you state otherwise. However, stating the basic location is essential. The idea of the drama taking place in a setting not seen before or an old setting seen in a different light is intriguing, compared with the familiar.
- *An active question which arises from the conflict outlined between the central dramatic forces*. This should provide enough of a hook for the reader to want to hear or read how the premise will be developed.

### Assessing a Premise

When writing or reading a premise, ask yourself:

- Who or what is the narrative about? What is the dramatic problem? And why can't it be solved?
- What type of story is it?
- Where is the dramatic conflict coming from? What/who is the antagonistic force?
- What form and genre of screenplay does this idea appear to belong to?
- What is original about it? What is familiar?
- Why will an audience be interested in it?

Some of these questions will only be answered in the development of the idea but it is always worth asking the fundamental questions throughout a project's development. The answers will be changed in the writing process and it is easy to lose sight of the central idea and its originality.

### Do any premises vary from this basic format?

The largest variation is writing the premise for an existing television series. Here the form, genre and style of the narrative, the characters, the antagonistic forces and often the location, are already established. So 'all' you generally have to do is provide the problem for one or other of the central characters and the active questions which arise from it.

However, this 'all' has confounded many writers and should not be under-estimated in its difficulty. The degree of established elements into which the premise is being fitted, e.g. a multi-stranded police series set in Paris with four central characters, will determine the degree to which you have to add the additional elements. For any completely new film or programme then clearly the premise will require all the elements discussed above.

### The difference between a premise and a pitch

A *pitch* is primarily a verbal approach to stating the premise. However, it is often reduced to one sentence and is much more about the appeal to a given audience than the nature of the screenplay. This is why a good pitch does not even imply a good screen idea, leave alone a good screenplay.

A pitch will concentrate on the type of film or programme, its known selling points, e.g. established stars who may appear in it, and its audience appeal, e.g. true story, topical subject matter, universal theme, attraction for a particular age group.

If the pitch involves a producer it will almost certainly contain a sense of the budget. This will initially be phrased in general terms, e.g. low, medium, budget range.

For more detail on this aspect of screenplay development consult chapter 9, 'Screen business'.

## Outlines

The next major document in the writing process is the outline, synopsis or treatment. In general terms, outline and synopsis mean a short prose version of the

screen narrative. However, the word treatment has been used for this short version as well as for a longer prose version. Given the common usage of treatment for the longer version, for which there is no alternative word, I will use it to mean the longer version only.

An *outline*, incorporating the notion of a synopsis, is a present-tense, prose version of the intended screen narrative.

It concentrates on the main narrative story, the central protagonist/s and antagonist/s, their motivations and the essential active questions.

The length of an outline depends on the scale of a project. For a ten-minute film it will be about half a page. For a half-hour television programme it will probably be a half to a full page. For a feature film it will be about four pages. The aims of an outline are to establish:

- engaging characters with strong motivation
- a clear dramatic structure
- the essential narrative events, including the resolution of the main story, or stories
- the style of the narrative.

An outline should provide the following information in addition to the points raised in the premise:

- *A clear reason or set of reasons as to why the central characters are engaging.* This could be their situation, classically an undeserved misfortune, or their use of power, etc.
- *Characters' motivations need to move beyond the simple central problem established in a premise.* How does their motivation change as the narrative unfolds?
- *The dramatic structure which relates how the essential story information will be revealed.* Holding back on key story information to create suspense, surprises and reversals is as essential at this stage as in the finished screenplay.
- *The central dramatic question which forms the climax of the narrative and ultimately forms the basis on which an audience will be engaged with the work.*

If using a complex structure, e.g. multi-stranded, episodic with a serial strand, it is probably best to set each of the stories out separately in the outline, rather than trying to weave them into a complex narrative. However, the order and a general identification of the major stories is important.

If working with an associational approach, the shifts in the theme/narrative focus should be clear in the outline and provide a clear three-act dramatic development.

- *The development of the narrative should provide a resolution/conclusion to the central active questions posed.* However, it is often useful to leave a small part of the narrative unresolved in the outline. This not only intrigues the reader but helps the writer feel there is still some unresolved business.
- *The style of the eventual narrative should be reflected in the style of the writing.* This is extremely difficult, if not impossible, within an outline and is a major problem at this stage of development.

## *The Outline Style Problem*

You may have a very clear sense of the comedic style, the surreal moments, the witty dialogue, the mind-boggling special effects or the power of the characterisation, but managing to convey this while also spelling out the other narrative elements in such a short form is extremely difficult.

The reason this is a problem for you as a screenwriter is that often, especially when submitting ideas to existing television series or applying for development money, this one-page outline is all people will read.

This problem has led to three radically different approaches from screenwriters.

One is to refuse to write outlines. This is not unreasonable given the high expectations far too many readers have of what an outline can deliver, and a rejection can destroy a writer's faith in an idea before it has really had time to be developed.

The second approach is to add a small paragraph on style and approach at the end of the outline. Essentially, this is a statement of your intentions about how this screen narrative will look and feel, what you believe will make it work on the screen.

This paragraph should clearly indicate the visual style/s of the narrative, any comparable films or television programmes, any special visual aspects and any relationships with key elements of the project which will help with the development or production, e.g. actors, locations.

However, the scale of the problem represented by the question of style should not be under-estimated. On numerous occasions this problem has meant that good ideas have not been seen for their potential. This has led many writers to adopt a third totally different approach to outlines.

In essence they write an outline where the style of the narrative dominates over other narrative elements. This approach seeks to sell the idea and energy of the project without spelling out the dramatic structure.

This form of outline will usually state the following very clearly:

- What genre of narrative it is
- The central active question at the start of the narrative
- Who the central characters are, with good vivid descriptions, and
- A skeletal description of how the narrative develops, until posing the big dramatic question underlying the climax.

This approach often excludes any resolution of the main active question on the basis that the reader is left wanting more, i.e. a meeting to discuss the project or to see a treatment.

This form of outline is very good at catching the attention of readers. However, it leaves a lot of questions unanswered.

The difficulty with this solution to the problem of outline style is that it lacks any clear narrative structure and many screenwriters have been left floundering trying to write a treatment or screenplay on the basis of what is essentially a selling document, not a writer's developmental tool.

Therefore, when writing an outline for consumption by anyone in the industry, as opposed to a writing tool for yourself, the golden rule must be: first find out what sort of outline is expected.

### Assessing Outlines

If you are reading or working with an outline, the following questions should help you focus on what you need:
- Is there a clear story/stories and/or theme?
- What dramatic structure is being used?
- Do the climaxes/surprises/reversals relate to the dramatic structure?
- Are the characters original enough, and are they clearly and believably motivated?
- Does the style of the writing reflect the style of the proposed screen narrative?
- Which elements need careful development towards the next stage?
- What is original and what is familiar about the project?

The major variation on this approach is where the storyline is typical/well-known, e.g. super-hero confronts and defeats super-villains, or children present problems for parents in a sit-com.

In these circumstances the outline should concentrate on the unique qualities of, and the combination of conflicts generated by, the original characters and the situation, which you are bringing to the project.

## Treatments

The next stage of development is the *treatment*. Many writers avoid treatments as they feel they undermine the creative energy of the potential screenplay, they find them difficult to write, or they just do not believe they work as a means of expressing the project's potential.

However, treatments have become an essential part of many series and film deals and in some cases the initial funds may not be able to be raised without them.

A treatment is a semi-dramatised, present tense, preliminary structuring of the screenplay.

It follows the dramatic structure of the intended narrative. It concentrates on the main stories and conveys all the story information necessary to understand the motivations, stories and/or the central active questions and themes.

Generally it contains minimal, if any, dialogue. However, when writing a comedy treatment, inserting some funny lines and characteristic phrases may be essential to convey the style of the humour.

The additional elements which should be found in the treatment, but would be less evident in an outline, are:
- *The dominant impressions and motivations of all the main characters and how these change during the course of the narrative*. The change in each character obviously varies in scale depending on the nature of their story, the importance of their role and the type of narrative.
- *All the major dramatic scenes*. These should contain an indication of location, the action of the scene and the motivations of the characters within the scene.

- *A strong sense of the plot and its dramatic impact on the narrative.* The surprises and reversals should all be in the positions you intend them to be in the final narrative. Therefore, it should be easy to establish the dramatic structure and its related climaxes.
- *A real sense of the style.* A treatment is the first time within the development process that the visual style, the atmosphere of particular scenes/sequences, the pace and the tone of the narrative are really given enough space to be reasonably expressed.

### How do you write a treatment?

Every writer has their own approach to creating a good treatment. The following steps are just a guide to what you need to concentrate on and how to avoid a plot-driven document which has lost all the initial energy of the creative process.

- *Make sure the idea has been properly developed.* See Chapter 4.
- *Do not plan to use the first thing you write.* Re-writing is as essential now as it will be with the finished screenplay.
- *Identify the emotional elements in the story and the scenes where these come to the fore.*
- *Write these scenes.* This will bring you closer to the characters and ensure the strongest dramatic moments are given enough narrative space.
- *Write your opening scene – the visual, the hook, the first laugh.* You need to engage the reader/s as much as you will the final audience with a strong indicative opening.
- *Describe your characters in as distinctive and original a way as possible.*
- *Write the treatment in the present tense using an active style, pictorial nouns and plenty of adverbs.*
- *Re-write emphasising the motivations, the major changes in active questions and the emotional aspects of the narrative.*
- *Re-write in the style of the screenwork which you wish to write.* If it is comedic, increase the humour; if it is a thriller, ensure there is enough suspense; if it is an adventure, ensure the danger and action are graphically captured.
- *Re-write the treatment to ensure it reads smoothly and leaves a reader wanting more.* The 'more' is not about leaving the ending off. It is about wanting to hear the characters, see the action sequences and experience the surprises and the atmosphere of the complete screenwork.

### What are the problems with treatments?

Clearly, not achieving all the above. But there are problems other than just making the treatment a good indicator of the narrative you wish ultimately to write.

Treatments by their very nature are plot heavy if they are going to provide any sense of what will actually appear on the screen. However, they can also obscure character's motivations, as they develop in relation to the action. This is especially true for secondary characters and secondary stories. However, writing all of this out in full turns the treatment into a small novel or short story and loses some of the screen narrative feel of the idea. Treatments can also lose the dramatic shape of

the narrative. Owing to the need to setup all the main protagonist/s and antagonist/s, the setting and the central active questions at the start of the narrative, the treatment can feel top heavy, i.e. too much time spent on the beginning in relation to the other parts of the narrative. The is also true of the ending. This can obscure the fact that the middle is under-developed. Treatments can also leave character/s relationships not fully spelt out; therefore, part of the motivational framework is missing.

Writing good treatments is hard, especially when many development personnel have unrealistic expectations of them. However, they are a good tool for screenwriters who want to work up their secondary stories, are dealing with a complex dramatic structure, or are still working out the essential theme of the narrative.

## Step Outlines

An equally useful tool is the step outline. The aim of a step outline is to provide a clear indication of all the major scenes and how they build into successful sequences.

Step outlines come in two distinct forms. To illustrate how these two forms look I have taken a short paragraph from a treatment, and then used it to create the two distinct forms of outline.

### The Treatment

JENNI, mid-thirties, divorced and with a lot to prove to herself and the world, thrives on the frenetic activity of an American photo agency in Paris where she works. When news of a bomb scare two blocks away arrives, she needs no second word. In a flash she heads for the door with instructions from her calculating boss, GERRY, not to return unless she has a snap of the new bomb squad 'robot'.

### The Step Outline – Writer's Notes

1. Bomb taken into a large city store.
2. Amy arrives for an interview with JT at the photo agency. She is desperate for the job.
3. Bomb left in the store.
4. The agency receives a tip-off about the bomb but has no one to send except Amy. She accepts the challenge.

You will have noticed that the main character's name has changed and that she is no longer working for the agency but trying to get a job. This is a writing process not a paint- by-numbers and fill-in-the-empty-spaces exercise. Changes are inevitable at every stage of a screenplay's development and writers need to make them for all sorts of reasons. The only valid question is, does the new version work, and if not, why not?

This writer's notes version of the step outline is often written out on cards, long sheets of paper or numerous interchangeable sheets each concerned with a particular sequence of the narrative. The aim of the writer's-notes version of the

step outline is to allow you to see the dramatic moments in isolation and move them around in relation to each other to create a solid dramatic structure.

These notes are, however, very difficult for anyone other than a writer to interpret, as all the narrative elements are essentially being dealt with in shorthand. This leads on to the following version, which is the sort of style and approach needed when you are intending to show this level of development to someone else.

### Step Outline – The Complete Version

```
1. EXT A&B BUILDING - DAY

A singular leather knapsack is carried, by an unseen person,
into the store.

2. INT OUTER OFFICE: PHOTO AGENCY - DAY

CHRISTINA, a young French receptionist directs AMY, 30s,
smart, casual, toward her appointment with Jerry Thompson - JT
- the agency's picture editor.

3. INT A&B BUILDING - DAY

The knapsack is carried towards an escalator.

4. INT JERRY'S OFFICE - DAY

JT, in shirt-sleeves and with an air of studied cynicism,
invites Amy to justify why they should hire her. Amy begins to
win him over by overtly complimenting the agency and thus him.

5. INT A&B BUILDING - DAY

The knapsack is left in the store.

6. INT JERRY'S OFFICE - DAY

JT is about to let Amy go with a less than encouraging
response when the phone goes. A bomb alert at A&B and there is
no one in the office to cover it but Amy. JT tells her she
gets a job, provided she snaps the new police bomb-detecting
'robot' at the store.
```

This form of step outline is clearly well on the way to being a screenplay. However, the addition of dialogue, and specific shots should not be under-

estimated. This type of step outline reveals the plot in great detail and focuses the reader on the main stories, the characters and the development of active questions.

It also provides a solid basis on which to write the screenplay and ensures that all the essential plot and character developments are in place.

However, it is not a screenplay. Even with all of these scenes worked out, once the characters start talking and the creative process of writing scenes and sequences takes over, much of what appeared essential will fall away and a new version of the screenplay will emerge.

## The Screenplay

I have noted above that things changed between the treatment, the writer's notes and the complete version of the step outline. This process of change and development continues throughout the life of a screenplay.

This is in part because scenes or whole sequences may become redundant or have to be changed before the screenplay is completed. Certain shots will make some scenes redundant, the impact of a sequence may not be clear, new narrative ideas change active questions, etc.

However just as big an impact on the changes in a screenplay is the writer's own development through the work. When you start writing a project you may have all sorts of information, ideas and thoughts about what this screenplay will be like and what it is about. The simple truth is that you cannot know what it is really about until it is written.

Arthur Miller is reported to have said that only on finishing the first draft of a play did he discover what the play was really about – its theme. He then typed this theme statement up and placed it in front of him as he went back over the whole script, and re-wrote, bearing this statement in mind.

You may discover on reading a first draft that this is not the best way to tell the story or tackle the theme. This could and should mean a major re-write. The details of re-writing are found in Chapter 8.

Finally, it is important for the screenwriter, and all those who are working with them, to remember all of the key elements of the creative matrix and not to throw away a project until it has been thoroughly examined for solutions as well as problems.

## The Writer's Choice

In developing a project a screenwriter faces a number of choices and not all of them are creative ones. The choice of which stage of development to use next and when to start on the screenplay are all important choices which will affect the first draft of the screenplay.

Step outlines are sometimes part of the development deal on a project, in which case the second version of the step outline would be the appropriate model to follow. However, it is the writer's notes version, in my experience, which continues to be of the greatest use to screenwriters in their development of projects.

In this context it is worth noting that not all projects go through all these

development stages. The shorter the narrative, the less need for elaborate step outlines or treatments.

The availability of development finance often determines in which version the writer first delivers the narrative. Whatever the contractual situation over a project, the importance of good solid development cannot be underestimated. It will save you an enormous amount of writing and probably lead to a better first draft in a shorter time.

Leaving all this to one side for a moment, a first draft can be achieved by another route.

This is the route of just writing the screenplay. By this I mean starting with an idea, a few scenes, and proceeding straight to a full-length screenplay. This approach to developing a project is used by many writers and does work. If you feel this is the only way you are going to tackle this scale of project, then just do it.

The major risk in taking this route is discovering the narrative approach you have taken is not the right one or that it ends up not saying the things you wanted to say. This latter point is a very common problem and is reflected in a certain type of screenplay.

The structure of this type of screenplay reads roughly as follows:

- *Pages 1–10*. A big incident involving a central protagonist.
- *Pages 11–60*. Numerous other incidents introducing several other characters and their stories. All are given roughly equal weight and the central protagonist either changes or becomes lost in the plotting.
- *Pages 61–70*. Another major incident which is seen to set up the climax.
- *Pages 71–95*. A race to the climax in which all the minor characters are forgotten about and one single story suddenly takes over the narrative.
- *Pages 96–100*. The climax in which someone achieves something but we are not quite sure what it is, other than probably killing the antagonist or walking into the sunset with the one they love.

This clearly will not work as the basis of a feature film. However, it is perfectly acceptable as a working tool, which you are then prepared to abandon and use as the starting point of a new draft of the narrative.

This means you have to be prepared to throw away the whole of the first-draft screenplay and possibly the whole of other drafts until you reach the point where you have a draft which is coherent and says what you want it to say.

If it works, great. If it does not work, then the questions posed at each stage of the development process outlined here will, I hope, help you sort out some answers.

The screenplay is the point at which all this narrative work finally takes on a realisable form and the final screenwork is in sight. The detail of what makes a screenplay work and the balancing of all the various narrative elements, is covered in Chapters 5 to 7.

In this section I will concentrate on the more practical aspect – layouts.

There are three fundamentally different types of layout currently in use in screenwriting.

### 1. Film layout

This is essentially a standard feature film layout which has evolved in English-language speaking production. It emphasises the equal weight of visuals and dialogue and is easily broken down for shooting schedules and continuity purposes. It is also the easiest to read.

### 2. Television layout

This is the drama television layout which evolved in the era of live television, where camera notes had to be written next to action or dialogue. It emphasises dialogue owing to the limited locations and shot options, in live studios.

### 3. Documentary/Corporate layout

This two-column layout evolved to accommodate the use of post-production voiceover and the use of monologues rather than dialogues in the development of the narrative. It emphasises dialogue as this is the major structural device within the majority of documentaries.

Note carefully that all these examples are based upon an English–language tradition. Layouts can vary radically when working with languages which are read from right to left, or up and down a page. Therefore, if you are not working in English, check for layout guidelines with production companies or writers working in your language. In addition it is worth noting that layouts are a developing form. Therefore, many screenplays vary from the layout shown here. However if you use these layouts, most people will be able to understand what you are trying to do. Also be careful about following layouts in published screenplays as these have usually been modified by the book publisher.

### Film Layout

The page number is placed 1 inch from top of the page.

Then there is a line space before a line of text indicates whether the scene is Exterior or Interior, what is the specific location and (if necessary) the general location, and whether the scene takes place in Day or Night.

Then there is another line space before the description of what we see on the screen. This description runs from the left margin (1.25 inches from left) to the right margin (7.25 inches from left). Characters are introduced in UPPER CASE but then written in lower case from then on. Action, etc. remains in lower case. *All* camera directions are in UPPER CASE. Sound over direction is *identified* in UPPER CASE, but the sound itself is *described* in lower case.

Then there is another line space before the name of the character that is about to speak is given. This name appears in UPPER CASE  (The name is indented 4 inches).

On the next line, any dialogue directions, if necessary, follow.

On the next line, dialogue itself starts (3 inches in from left and runs across to

15. INT. PRINTING PRESSES - DAY

A hand flicks a switch. SOUND OVER: the deafening noise of the
rolling presses.

A bundle of papers hits the floor. The front page is clearly
visible, with a general shot of the bomb scene and the
headline 'NEW TERROR'.

16. INT. PICTURE DESK: CHRONICLE OFFICES - NIGHT

ANNE slumped in a chair, nursing her camera bag and copy of
the paper with the terror headline. PULL BACK to reveal TONY,
a tired, cynical hack, at his desk. He looks up at the empty
newsroom and spots Anne.

                          TONY
          Go home. They're great snaps.

                          ANNE
          It was luck.

                          TONY
                       (smiling)
          That's the difference between good and great.

*Figure 1. Film Layout example.*

6 inches in from left before returning. There is no space between dialogue and
character's name, if there is no need for dialogue directions.

The example in Figure 1 only gives a general idea of the dimensions given
above as the page of this book does not have the width of either A4 or US Letter.
Note that a page in this layout lasts approximately one minute of screen time. All
margins are based on a sheet of A4 paper.

### Television Layout

The page number is placed 1 inch from top of page. There is a 3.5 inch margin
from the left of the page and the text runs across the next 4 inches.

The time of day when the scene takes place is commonly placed in the scene
heading. Scene description is given in UPPER CASE and runs across the whole
column.

The script is double-spaced throughout. Dialogue is indented 0.5 inch.

```
1. INT PLATFORM DAY(16.40)

(JUDY, 30S, TIRED AND STRUGGLING WITH A LARGE

SHOULDER BAG, LAP-TOP AND A WAYWARD TRILBY,

WALKS BRISKLY THROUGH THE CROWD OF COMMUTERS.

SAM, HER DISHEVELED TEENAGE SON, IN TORN JEANS

AND FADED OVERCOAT, STRIDES ALONG BESIDE HER.)

        SAM: Why don't you believe me?

        JUDY: What do you expect? I'm your

        mother.

(SAM STOPS)

        SAM: And I'm serious.
```

*Figure 2. Television Drama Layout example.*

When identifying speakers, the characters' names are given in UPPER CASE and underlined. All scenes are numbered in sequence from beginning to end.

An example is given in Figure 2.

Each new scene starts on a new page. Therefore, a half-hour screenplay can run from fifty to over a hundred pages. Text finishes 1 inch from the bottom of the page.

Note that a full page in this layout lasts approximately 25-35 seconds of screen time. All margins are based on a sheet of A4 paper. Also television scripts follow this general format, but each show may vary the margins slightly, or the convention on brackets and underlining. Therefore, obtain a sample copy of the individual programme's format if submitting a 'spec' screenplay. Also, many television dramas are now shot on film and use the film format for their screenplays.

### The Documentary/Corporate Layout

This is shown in Figure 3. The left-hand column here contains an indication of the images envisaged on the screen. These can range from specific images to a general indication of a sequence. Beside this, the right-hand column contains references to the use of sound. These can range from a general indication of VOX POP to a draft commentary. It is also used to indicate music, ambient sound, and sync. or non-sync. sound.

| IMAGE | SOUND |
| --- | --- |
| Images of countryside | VO: Comments about stress of living here. |
| Interview: J.Amfit. Industrial Consultant | J.Amfit talking about the problems people face in a modern city.<br>- competition for space<br>- unhealthy environment<br>- spiraling cost of living |
| Images of people moving house/ driving in countryside/small town life | Music |
| Maureen Sly working | VO: Maureen Sly talking about why she moved. |

*Figure 3. Documentary/Corporate Video Layout example.*

This form is used in the early stages of scripting a documentary, or corporate work. It is also used in some animation studios. This layout is sometimes used throughout the development process, but can be replaced by storyboards, and a more elaborate shooting script, as individual shots are finalised.

## Television Series Format
The only other major tool in developing an idea is the Television Series Format document. This contains the essential elements which form the basis of the series. They vary in length from five to twenty or more pages depending on the scale of the project, whether or not illustrations or sample scenes are included, and how much background on the writer and other people is seen to be necessary.

These documents are used extensively in series and serials, including situation comedy, for television. It is impossible to provide a specific example as each series is different, but the following package provides a guide to the information most formats contain.

### 1. The Introduction
This is essentially a selling statement written to intrigue the reader and provide the absolute basics of what the series is. Therefore, it will refer to genre, e.g. mystery, or children's adventure; a central protagonist or subject; and a good active question which the series will answer. This is written as a very short statement, or set of questions, and seldom exceeds a couple of paragraphs.

## 2. The Characters
Profiles of the characters provide a strong sense of who they are, what their main active question is, their relationships, and what makes them distinctive. Profiles can range from a few lines for regular secondary characters to one or two pages for major characters. However, the average length is half a page.

## 3. The story outlines
These include at least three to six, fully, written-up, outlines for episodes of the series, plus a number of suggestions for other episodes. The length of an outline depends on the length of the episode, but it must contain all the key dramatic points in the two main stories. The suggestions for other episodes can be no more than a sentence or two, but they must clearly relate to the central characters, or subject of the series, and pose a good active question for an episode.

## 4. A statement of intent
Here are the reasons why this series will be distinctive, why you feel it is significant, and what contemporary experience it reflects, exposes, engages with, or addresses. This statement also addresses the nature of the audience, and why they would want to watch it. This could include what other screen narratives it is similar to, the nature of the lead characters and what makes them engaging, or background information on why this type of series is right for now.

Obviously in addressing these types of question there is no formula for writing this sort of statement, but there is a very strong point to be made about the ending of it. The final statement should reveal a confidence about what the project is, and/ or what it means to a contemporary audience.

### Problems with Formats
a. *They only give the briefest idea of what the series will be like in its finished form.* However, they do provide a sense of whether or not this is a situation, subject, or group of characters, which will appeal to a broadcaster.
b. *Character profiles are too short to really expose the potential for on-going dramatic conflict between characters.* Therefore, there is a tendency to rely on types, or even stereotypes, to make the conflict obvious. This can work well when dealing with comedy, but is extremely difficult, and to some extent defeats the object of creating a character-driven, dramatic series.
c. *The story outlines may work for six episodes, but for a series to be successful it needs to run for more than six episodes.* The question of 'Has the idea got legs?' is too easily ignored with so few story line examples.
d. *The intention of the series may look clear, but this is only an intention.* The realisation of grand plans is difficult, and will certainly take time. The question is: Does the series or serial need an elaborate structure or level of reasoning? If so, how will this be conveyed on screen?

Series formats are large writing projects in themselves and generally will not be commissioned other than from established writers. If you are submitting a new

series idea then a format document will need to be accompanied by a sample screenplay, in most cases.

### Final Notes on Development

As I stated at the beginning of this chapter this process has been following the development of a major screeenplay. Therefore, if you are developing a short screenwork you would normally proceed from an outline straight to a screenplay. If you are developing a promotional video then the premise would quickly be followed by a storyboard, which is the equivalent of a step outline. While if you were developing a series you would probably write the format document prior to any screenplay development.

Whatever the length or scale of the work the most important thing to remember is that these tools of the trade are just that, tools. They are there to be used in helping everyone involved in the development of screenplays. They provide a practical means of developing an initial idea to a completed screenplay.

However, it should never be forgotten that this is a human creative process and tools do not provide the solutions, merely the means to achieve them.

In this respect it is important that screenwriters and everyone who seeks to help them write a screenplay recognise the inevitable changes which will occur in development. It is equally important that writers learn to use the tools well, and allow their emotion to be the human engine, which brings the various elements together into an effective dramatic screenplay.

# 4. Developing a Screen Idea

Developing new ideas is the first essential part of working as a screenwriter. Most professional screenwriters have upwards of seven projects in various stages of development at any one time. A writer submitting storylines to an existing television series will be expected to arrive with a minimum of five ideas and may well work through fifteen before one is accepted for the series.

It is fairly clear from these scenarios that working up ideas to the point where you can assess them and present them to someone else is a major part of a screenwriter's life. The aim of this chapter is to outline how to do this and to provide a quick guide to assessing an idea once you have reached the premise stage.

In setting out on the journey of finding an idea I have assumed you are starting with nothing and have no particular programme or type of film in mind. However, the core of the chapter – sources, the research programme and thedevelopment frameworks – will help you even if you have a specific idea with which you already want to proceed.

Let us start at the beginning. *What are we after?*

Is it a premise? An interesting situation? A character? Some action? A dilemma? A social issue? An artistic expression? A post-modernist interpretation of angst or a large cheque?

The first, simple, answer is: it could be all of these and many more besides. However, in essence the start of a screenplay's development is an idea which the writer believes in.

The parameters of the idea will vary from project to project, and radically from an original feature film to a tertiary story in a television series which is in its seventh year of production.

In the first instance, one of the perennial problems encountered in developing and discussing ideas is that many people have no clear sense of what a screen idea is. For example, it is not uncommon for people to describe a character they know, a situation they have thought up or been involved in, an image which fascinates them, or a programme or film they want to emulate or avoid and say that this is the idea for a screenwork.

All of these suggestions are in essence sources of inspiration; none of them is a solid screen idea, which in and of itself meets even the basic criteria for assessing whether or not it will generate an interesting screen narrative.

So what do we need to know to confirm that we have a screen idea? In the first instance we need a clear sense of the story / subject and / or thematic concerns and its dramatic potential. These elements apply as much to documentary, non-fiction works as to dramatic fiction. They also apply to novels, stage plays and radio plays.

The additional elements which turn a basic dramatic idea into a definite screen

idea are a sense of the genre, the style and its dramatic structure. All this points to the major problem of finding good screen ideas: You have to undertake a fair amount of work before you are in a clear position really to assess any idea's potential.

This in turn highlights one of the basic mistakes that far too many screenwriters, script-editors, development personnel, directors, producers and financiers make: committing to or rejecting a project too early in its development.

How do you develop an idea and where do ideas come from? If you have ever attended a public seminar with a writer or director on the stage, sooner or later someone will ask the inevitable question: 'where do your ideas come from?'

Then, depending on who is on the stage, the answer will come back either in terms of a specific source or incident for a particular project, or an anecdote about chance meetings, dreams, memories or life in general.

This illustrates, probably better than any textbook, the obvious but often forgotten point that specific ideas arise not from some learned rules or prescribed formula but from the life of the creator, their experiences and their choices.

However, there are a number of sources which can be identified which constantly provide ideas for screenworks and often for other forms of writing. Screenwriters will always find these sources useful but in their own terms they have limitations and in some cases need serious health warnings.

The following is a brief rundown of these sources, with a few guidelines on how to use them and the pitfalls to avoid.

## Sources

### 1. Adaptation
Adaptation is essentially, changing the medium being used from one form to another, in this case to a screenwork. Novels and short stories continue to be the source of the majority of adaptations. However, comic books, video games, cartoons, poetry, biographies, songs and graphic novels have all been used on more than one occasion.

The most important things to discover before you embark on an adaptation are: who owns the rights and are they available for adaptation to the screen? Undertaking an adaptation without clearing the rights has proved to be a very frustrating experience for many new writers. It can also prove very expensive for producers.

A detailed discussion of how to undertake an adaptation is beyond the scope of this book. However, the process of creating the finished screenplay is the same as if you were starting with an original idea. It is not a bad idea to take note of the opinion of many adaptors: that you have to start afresh using the original material as source material and then create a new original screenplay from it.[1]

### 2. Contemporary True Stories
These are the basis of many television films and serials, with whole strands of television drama being dominated by them on occasion.

The question of rights applies equally here, though instead of resting with the creators of work they rest with participants in, and in some cases, journalists who have reported, the events.

The key issue here is how much of the material you wish to use in your screenplay is in the public domain? The 'public domain' means that material is available to the general public. This may include newspaper and magazine articles, court records, some government records.

Many true life stories have been written for the screen based upon public domain material without any permissions being granted by the people involved. However, it is advisable if you are writing about actual events to obtain a written option on people's stories or accounts of events prior to committing to writing the screenplay. In making documentaries a waiver is normally signed by participants to ensure the documentary-maker can use any material they record.

The form of an option deal or waiver can be obtained from a producer's organisation, a good media lawyer, or in some standard books on film or television production or legal aspects of journalism.[2] What needs to be remembered is that just fictionalising a story may not protect you from being sued if you are seen to have defamed someone or invaded their privacy. However, the laws on these areas vary from country to country and you need to consult with a lawyer to ensure you are operating within the appropriate legal framework.

### 3. Historical Events

History is, in common, everyday terms, everything which happened before today. However, in screen terms it is a moving dateline, which creeps ever forward, and is generally determined by the availability, or lack of, contemporary locations and costumes.

So, for instance a screenwork set in 1990 will not generally be seen as historical in 1998 since finding locations and costumes for this period is not difficult – yet. However, setting a screenwork in 1970 – though possible, depending on where it was set – might prove more difficult and would therefore be generally be seen as an historical piece.

Why does this matter to a screenwriter? In terms of writing a great screenplay, it does not. In terms of seeing this screenplay realised it has enormous implications. Historical screenworks cost more money to make. Therefore, you need more power to realise the screenwork. This has proved to be a difficult task even for established film-makers, e.g. Richard Attenborough with *Gandhi*.

The answer to this problem may be to approach the material from a low-budget perspective, e.g. *Edward II*, or *I, The Worst of All*. This solution allows you the chance to see the drama realised but requires a very distinct, and often dialogue-based, solution to the narrative problems imposed by cost.

### 4. Future Events

The predicting of what might happen in the future has always been a source of stories for screenwriters. This often results in a major piece of creative work with whole worlds and people having to be invented for the screenwork, e.g. *Star Wars*.

However, a significant number of science fiction screenworks have been set in the near future, e.g. *Jurassic Park, Alphaville,* or have brought something from far away into our contemporary life, e.g. *V* or *Close Encounters of the Third Kind.* The same issue of cost that is present in the historically based screenwork applies here. The low-budget option is represented by such works as *Dark Star* or *Red Dwarf.*

These first four sources potentially bring with them huge amounts of information and certainly indicate avenues of research and a strong basis for narrative development. The following sources are really about starting with nothing and finding inspiration for new screenworks.

### 5. Existing Screen Material

We have all seen sequels, Part One to whatever number the producer could finance. The problem for the screenwriter is generally that they are being hired to write this material to someone else's requirements and the compromises may well not fit the dramatic inclinations of the writer. Thus this approach is not about a source of inspiration but more one of perspiration.

However, apart from the sequel, existing screenworks can provide ideas for new original screenworks. What you are looking for in existing screenworks are stories/characters/events which may be part of a documentary, a news item or even another drama, which acts as a source for a new story or theme to be explored.

### 6. Headlines

Headlines in newspapers, magazines or journals are short, sharp phrases, sometimes only one word, which grab your attention and may suggest stories, or situations, worth developing.

*Exercise One*: Take a collection of words or headings from magazines, webzines, newspapers. Then set aside a specific period of time, say ten minutes or an hour, and without reference to the articles or their original context see what your imagination comes up with.

The aim of this is to create a character with a dramatic problem or an active question which could be developed into a story.

### 7. Visual Material

Given the significance of visuals to this medium it is hardly surprising that visual material is often a good starting point for ideas.

*Exercise Two*: Collect any pictures, photographs, illustrations, even colours which strike you as interesting. As with the headlines set aside a specific period of time and just let your mind come up with stories, characters and dramatic situations.

### 8. Dreams

Many writers have started their projects on the basis of dreams, both those remembered from sleep and day-dreams, when imaginary scenarios suddenly fill

your mind.  The trick here is to have a notebook close at hand at all times, especially first thing after waking up, and to note down everything you can remember.

## 9. The 'What If?' Scenario

This is the 'wet week staring into space', or 'being stranded at a railway or bus station' solution to finding ideas.

> *Exercise Three:* Just ask yourself what if such-and-such happened. It can be anything from 'what if blue were green' to 'what if an asteroid hit me'. Then write down the first things that come into your head.

The point about the above five sources is to let them be inspirational. Do not censure your imagination at this stage. You are just seeking the basis of an idea, not committing yourself to doing anything with it.

## 10. Your Own Life

One of the most often used phrases from established writers and teachers is, 'Write what you know.' This phrase should in my view carry a major warning: *This does not mean just write up some aspect of your own lif*e. Anyone who has ever worked in development or sat through screenings of people's first films or videos quickly realises that one of the first mistakes most people make is to create a screenwork or screenplay based upon a series of episodic moments in their life. These outpourings generally fail dramatically but they also fail because the source material is flawed.

Life does not, in most people's experience of it, have neat dramatic structures, nor do we understand why everyone does what they do or even why things happen. If we did, then we would lose one of the most significant appeals of drama – its ability to provide some means of working out why some aspects of life are as they are. In addition to this, most writers are too emotionally involved in their own life experiences to be able to amend them or change them for the sake of a dramatic story or character development.

Finally, we experience people from one perspective – our own. Yet a screenwriter needs to be able to encapsulate numerous different perspectives if they are to bring a rich and varied array of characters to the screen. This is much harder to achieve when all the characters you are writing about are people you know and, rightly or wrongly, you feel obligated to portray in certain ways.

So when writers and teachers say 'write what you know' are they disingenuous, or plain dishonest? I think not. However, what does appear to be the case is that the notion of 'what you know' is not being adequately explained, and hence the thousands of very poor autobiographical screenplays. There are three distinct aspects of 'write what you know' which are fundamental to screenwriting.

• *Knowing the nature of particular types of screenwork.*
If you want to write an action thriller, a family sit-com, an investigative documentary or any other type of screenplay, you need to understand the basic

parameters of this particular type of screenwork as it is currently used and work with them. Far too many screenwriters attempt works without having grasped even the basic conventions of the type of screenwork which they claim to be writing.

• *Knowing the emotions with which you are working.*
We watch films or television programmes and expect to have emotional responses. These vary enormously from being intrigued and surprised to being thrilled and scared. We may smile, laugh, cry, become angry or bored. However, to read most screenplays you would think that emotion was the last thing the writer ever intended to engage with, and that boredom or confusion were the major aims of most screenworks. Any screenplay must use emotion to be effective and engage a reader and ultimately an audience – not only in terms of what the characters are experiencing but also as a means of engaging and keeping the audience involved with the narrative.

• *Knowing the subject matter.*
One of the major criticisms of many screenplays is that they are 'thin'. By this people mean there may well be a theme, a story and characters developing through the narrative, but how it develops, what they talk about and what happens is unoriginal, repetitive or just strung out for far too long. The major reason for this is undoubtedly the lack of knowledge the writer has of the world of the narrative.

The simple answer to this is *research*. The biggest problem with this solution is that it can become more fascinating than writing the screenplay and can very easily become an unending task. For this reason it should carry a significant warning – research is not writing and it can take over your life.

However, research is so fundamental to the development of a good screenplay and the working up of a good idea that I have decided at this point to lay out a basic framework for research with respect to screenwriting. It is worth noting that this is different in its emphasis and in some of its practices from academic and journalistic research.

The following basic framework for research will, I hope, help you avoid the charge of writing a 'thin' screenplay.

## Research

The starting point for any research is to find out what you need to know to complete the screenwork and avoid the mistakes listed above. The following is a brief guide to this area of development and to relevant sources.

1. To avoid the problem of not knowing the current production parameters, you need to know:
• *Existing narratives.* Past productions are listed in video and film guides; current or planned productions are listed in the trade magazines or on the Web under 'screenwriting'.
• *Existing forms.* Some of the screenwriting handbooks carry good guides to the different types of television and screen narratives. Chapter 7 contains the basic information you will need on genre: also see Appendix A – 'Some Useful Books'.

It is equally important to watch and analyse screenworks you feel are relevant or similar, to your own project.

2. To avoid not using emotion effectively, you need to know:
- *Your Characters*. See the detailed approach in Chapter 5.
- *Genre conventions*. See the detailed approach in Chapter 7.
- *Dialogue/Language*. See the oral archives, observation and interviews below.

3. To avoid not knowing enough about the subject, characters and dramatic situations, you need to know:
- *Historical period*. Standard history texts, newspapers, novels, published and unpublished journals, oral archives
- *Historical events*. Published chronicles of the period; newspapers and personal accounts, government records
- *Working practices*. Museums, oral archives, professional or craft associations, unions and people who have worked, or currently work, in the job.
- *Locations*. Visiting a location cannot really be bettered but photographs, documentaries, travel books and illustrations are all better than nothing.

## Conducting Research
Having decided to undertake some research, how do you proceed?

Here are six basic questions which will provide you with a framework to guide you through the maze of sources and options which will inevitably open up as you start your search.

### 1. What is the purpose of the research?
Knowing what you need to know before you start will stop this process going on forever and you being swamped by interesting, but ultimately irrelevant material.

The options are fairly obvious.
a. *Specific information*, e.g. when something happened or how something is achieved.
b. *Character information*, e.g. jargon, lifestyle, careers, anecdotal stories, backstory, shared experiences and family context.
c. *The context of your story*, e.g. its historical period, contemporary value systems, economic and political circumstances and societal differences.

While *a* and *c* are often satisfied by paper research, *b* is best achieved through interviews, unpublished material or oral history archives.

### 2. What is the topic?
The key to effective trawls of large resources – for example, in a major newspaper library or copyright library, e.g. the British Library – is to have a list of key words, dates or topics which you can use to select your material.

### 3. How much do you know already?
To avoid wasting time it is a good idea to make a note of all the things you already know about the topic. Search through your own files, books and notes for any

information which may be relevant before you start on any other collection. If you have access to the Internet then a basic search will often produce numerous references but most are available from other sources.

### 4. How much does the audience know already?

One of the many pitfalls of research is either over- (or under-) estimating what an audience knows about a situation or topic.

There are two problems here. The first is that as you research the material you become a specialist and yet when you write the screenplay you have to be capable of seeing the material as would an average person in your audience. The second is assuming your audience knows what you know when often they do not.

There are no guaranteed solutions to these problems. However, being aware they are problems should stop you from just ploughing on regardless. This is one of the major reasons why you need to discuss your work with other people.

### 5. What do you want the audience to understand by the end of the film/programme?

This is the flip side of the previous problem. Research will present you with piles of interesting, diverting and sometimes compelling information. However, you do not need all of it for your screenplay and the question is, what do you leave out?

The simple answer is to ask the question, 'How much does the audience need to know to understand what is happening?'

This is not just about following the plot but also being able to work out the basis of any actions or motivations on the part of characters. For example, if you are writing about industrial espionage which involves database tapping, then you need a good sense of how much detail the audience requires to understand what is going on. This will vary enormously from a screenplay about a character who does this sort of work for a living to a screenplay in which it is merely an incident in a contemporary action adventure.

Once you have answered this question, the rest of the information is for your archives and/or another screenplay.

### 6. Technical Advisors?

Nearly all major television series have a technical advisor attached. Sometimes this is the person who devised the programme but more often than not it is the person whose life experiences are being reflected in the drama. For example, *Casualty* has a number of doctors and nurses as advisors. What they provide is someone with whom the writer can talk, to check the credibility of procedures, attitudes and actions.

Do you need one for your screenplay? The simple answer is 'Yes'. Why? Because they will save you hours of frustrated research, give you great anecdotal information and provide you with a veracity which is difficult to achieve if you have not lived through the experiences yourself.

This obviously points to the possibility of you being your own technical

advisor, a position many television writers have found themselves in. The point here is, I think, even if you have lived in the environment of your drama, you still need to find someone else who knows the subject well. They will not only provide you with other dramatic options but also stop you being too close to the material. The point I made about personal experience above should be borne very closely in mind here.

How can one know who will be the best technical advisor? Unfortunately, many writers do not have much choice. Many experts are literally the only, if not the best, informed person on the subject. A person may own the rights to an archive which you need to use. There may be only one person who is prepared to help you or set aside the time for the price you are prepared/able to pay. There may be only one person who you can manage to see face-to-face in the time you have available. Therefore, make the best use of whoever is available.

When do you need to conduct all this research? The simple answer is you do not have to complete all of it at all and certainly not all at once. If you are looking for ideas to develop, then clearly all you need to research are characters, stories or incidents which inspire you to develop an idea further. If you have an idea, then all the essential story details and character information needs to be researched to some degree. However, I would advise strongly against a full literature search or extensive interviews at this stage.

If you are committed to developing an idea to a treatment or screenplay, then a full paper search followed by observation and interviews become essential. *A paper search* is a review of all published and written material you can find, while *observation* includes:

- Watching as many different examples of the type of screenwork you are about to write as you can afford to see.
- Spending time at locations just noting what happens, the atmosphere, conversations, visually interesting aspects and any ideas which come to you.
- Spending time with people who are doing the things characters in your narrative will be doing.

*Interviews* are detailed discussions with experts, practitioners, witnesses, journalists, other writers. Why conduct interviews? The reasons are simple.

- To provide quick routes to specialist information.
- To provide direct access to relevant locations.
- To provide an opportunity to listen and learn the distinct jargon and language of potential characters.
- To provide a series of anecdotal stories and life experiences which are beyond your own experience.
- To build a network of contacts and potential technical advisors.

## Interviews

The prospect of interviewing strangers often terrifies new writers and yet in most people's experience, if you are well prepared, this is one of the most satisfying and rewarding parts of developing a new screenwork.

The thing to remember is that most people would love the chance to just talk

about themselves and what they do to someone who is really listening. This is why most people when given the chance to talk *will* talk, and will give you far more than you probably ever imagined.

**Setting up an interview**

Before you approach anyone for an interview do some research first.

Find out who specifically you want to interview. Just contacting someone or an organisation to ask who is the best person to talk to about a subject will often provide a much better response than a standard letter asking for basic information.

Find out more about the person you are going to interview, their job title, what they have said or written on the subject so far, their background.

Be clear about why you want to talk with them, and devise a list of no more than ten questions which will cover the essential information you need. This will help you structure the interview and ensure you have covered all the essential points.

Then follow this simple procedure if you do not already know the person, have a personal contact, or feel uncomfortable with a 'cold' phone call, i.e. just ringing up and asking for an interview. Write a brief letter typed, preferably on one side only, making several clear statements.

*Who you are, in terms of your writing credentials.* Do not panic if you are not an established writer yet or that no one is paying you to develop your screenplay. You are a writer the minute you commit yourself to this project and all that matters is that you conduct the interview well and have valid reasons to talk with the person. Therefore, just explain what type of screenwork you are intending to write and who you intend to show it to.

*Why you need the information for the development of a screenplay about this subject.* This is the subject this person knows something about.

*Why you have chosen to interview this person.* Use a specific reference in terms of job, what they have done in the past or something they have commented on/contributed to.

*What areas of their life/work/knowledge you are interested in.*

Be clear and state that you do not expect the interview to last for more than half an hour. Finally, keep control of the process by stating you will call the person to arrange a time. This is crucial. You want to proceed with the project and cannot afford to wait for a complete stranger, who does not know you, to get around to replying to a request out of the blue.

An e-mail option may solve some basic information exchanges but it completely defeats the wider purpose of conducting the interview. The follow-up telephone call should be within a week of sending the letter and is aimed at making initial arrangements for the interview. Have your ten questions ready in case the person is unable to give you a face-to-face interview. Also be prepared to be recommended to someone else and ask the person to help you arrange this interview.

Close to the agreed interview date, phone to check whether it is still convenient. No matter who you speak to, be it the receptionist, assistant or the actual interviewer, be friendly and show you are not going to waste their time by being brief.

Remember you are asking for a favour here, even if your interviewer is a public official; they are not paid to help writers develop ideas.

## Conducting the interview

- *Have your questions written down on a pad*. Remember them, but have them for reference.
- *Arrive slightly early*. There is no point in keeping someone waiting in this situation.
- *Tape the interview*. Check the machine is working before going into the interview and know how long the tape will last, so you are not left wondering how it will pan out.
- *Ask if taping is OK at the start.*
- *If the person asks to go off the record at any moment, allow it immediately*. This is not an investigative situation where corroborated information is essential.

Do remember that if you are conducting an interview with someone who you may want to film later, it is worth recording the initial interview on professional standard equipment. The reason is that some interviewees talk better first time, without the camera present, and this material can then be used as voice over.

- *Ask if any obvious noise in the room can be reduced.*
- *If the person does not want to be taped, write the key points of the interview down in note form*. You do not need a verbatim transcript – you are seeking information.
- *If there is a particular phrase or saying which you want to capture, ask the person to repeat it for you*. But do not break their flow – wait for an appropriate moment.
- *Shorthand is obviously useful in this situation but it is not essential.*
- *Check if the person is all right for time at the point you said the interview would end*. Note that most interviews run over half an hour but a bad one will have gone on long enough at thirty minutes.
- *Remember body language, yours as well as the interviewee*. You need to look interested. They will look bored or defensive if your questioning is stopping their flow.

## Finishing the interview

- *Ask if there is anyone they recommend you speak to, or any books, articles they can recommend*. This is often the most productive part of the interview.
- *If the session has gone well the interviewee will often recommend other people you will find useful*. They will even go to the trouble of introducing you or setting up the interview. All of this makes your life easier.

However, heed this major warning. *The process may never end*. There is always going to be that person you have not spoken to yet. Therefore, you must set a time limit on the initial research and if a person has not been seen, then they will have to wait until later or be abandoned on this project.

### Following up the interview

- *Ensure you have covered all the points.* If not, ask for the missing details in the thank you letter.
- *Always write a thank you letter, even if the person has not been that helpful.* You do not know when you might want to contact them again for some other project, possibly ten years from now.
- *Write up a description of the person and the location as soon after the interview as possible.* Specific short-term memories fade fast and little details like posters on walls or an overheard saying will often be quickly forgotten.
- *File everything – names, addresses, references, dates and subjects.* This ensures you are able to find all this information again quickly when you need it.[3]

At the end of the first research period you should have enough material to start the first assessment of your idea.

## What makes a good screen idea?

You have delved into your sources of inspiration and discovered and discarded several possibilities, but what do you actually need to move on with an idea? At this point you should be able to write a premise, which you can then compare with a series of parameters to see where the idea naturally fits. If you then want to develop the idea in any particular way, to address a particular audience, you are in a position to see what the next stage of development should be.

These comparisons should be made before you set up any interviews, or undertake major research, unless the source of the idea is a person, a printed book or something similar. A crucial part of this comparative process is to see whether the idea clearly belongs in the cinema or on television.

### Cinema or Television?

The reason this question remains important for screenwriters is that many writers in the UK and Europe as a whole are struggling to find narratives which clearly engage cinematic audiences but are often accused of only writing television dramas.

The situation has been made all the more confusing by the ability of many films, which have limited audiences, to be hyped and give the impression that there is no fundamental difference between these two media, only one of intention on the part of the film-makers.

So the question remains – is there a fundamental difference between writing for cinema as opposed to television? In the first instance, most people agree on a number of key differences which in some respects mark the two ends of a spectrum.

Television narratives are more dialogue driven, the scale of events is smaller: TV is contemporary and the dramatic situations more domestic, involving fewer characters. This is exemplified by 'soaps', 'Cop and Doc' shows, and issue-based documentaries.

In contrast, cinema narratives rely heavily on action; big events are the norm, any contemporary aspect is secondary to the genre parameters, and the dramatic

situations are broad – involving several characters and institutions. This is exemplified by disaster movies, action thrillers and horror films.

However, such a simple break-down fails when you consider the television serial with its often epic scope, broad sweep, numerous characters and lack of contemporariness. Examples of this include *Lonesome Dove, The Octopus, The Kingdom,* and *Edge of Darkness.*

So what are the fundamental differences, if any? The difference is clearly not about stories or themes as every film and television culture appears to be able to create a version of all the basic stories and tackle the essential themes. The use of certain stories and themes is heavily influenced by the culture of specific countries but there appears to be no obvious link between culture and favouring cinematic or televisual narrative creation, other than methods of distribution.

This brings us to the question of form and, in particular, the length of narratives. A one-off feature length work has radically different dramatic parameters than an episode of an on-going series, which in turn is different from the several episode serial. These different parameters point to one of the fundamental differences between the two formats.

In both the series and the serial there are other episodes, and character/s have to be seen again to sustain narrative interest. This means that any *dramatic changes in a character* have to take place over time, not within one single episode. Compare this with the feature film where, if the character's change is not completed or significant, it will not be seen by an audience.

In addition, *the scale of emotional change* and danger a character can withstand is far more in a one-off than in the returning character of a series. In a serial the character's range may be as significant as within a feature film but it takes place over a longer narrative time. Therefore, the change is gradual and does not need major events to make it credible.

Another dramatic parameter is *the number of significant characters* and the amount of narrative time available to tell their stories. The feature film is extremely limited in this respect, with a balance having to be struck between characterisation, story development and narrative time. The result is that even if the narrative is two hours in length, it will struggle to work effectively with seven significant characters. Compare this with the television formats which seldom work with fewer than ten significant characters over a series and can accommodate six or seven comfortably within a half-hour format.

Genre clearly plays a significant part in defining most screenworks. However, though there are specific genre which can only be used on television, this is more about the length of a narrative and its impact on characterisation than a question of subject or particular types of story and style combinations.

Therefore, what may be a romantic sit-com will be translated to a feature film as a romantic comedy. The changes are dependent more on the needs of the dramatic form than on the romantic aspects of the genre requirements.

In contrast to this, style has a large part to play in defining the quality of

cinema as opposed to television. This arises from *the importance of scale* to the experience of watching either format. Television is a small screen, favouring intimate moments and simple visuals. The cinema screen is huge and can accommodate large visual spectacles, moments of wonder based upon the scale of the image, and requires highly detailed visuals to hold the attention.

These elements combined demonstrate that the real differences between the two formats is one of scale: the scale of characters' emotions, the number of characters, the dramatic range of the characterisation and the scale of the visuals. All these contribute to the reasons for making the choice of going to a cinema rather than just switching channels.

The final point to remember, though, is that this is also about the scale of emotion the audience expects to experience in a cinema compared with watching television. There have been and always will be great powerful television narratives which capture a sense of wonder or overwhelm with their emotional impact. However, these are not essential to television narratives working, while in the cinema if a large emotional impact is not delivered, then the film will have failed and probably in a major way.

Assuming you have some idea of whether or not the idea is going to work on the small or large screen, you then need some sort of framework in which to place the premise for further development.

## Development Frameworks

What follows is a set of development frameworks which will provide you with the means of assessing your idea and also direct you to what you need to develop, change or abandon at this stage.[4] Each framework addresses the basic questions and will help you assess the potential of the idea with reference to particular screenworks.

It is important to remember that an idea may not match up with all the criteria listed or may fail in its current form to meet them. This does not mean the idea should necessarily be abandoned. However, it does mean you should look to see what changes will be necessary for it to work in the narrative you have chosen for it. One of the most common mistakes is to attempt to force an idea into the wrong length or genre of narrative. It is at the ideas stage that this sort of problem can easily be identified and resolved before major work has been undertaken.

### An Idea for Short Fiction Video or Film

- *What are the characters stories?*
Know how many there are and know them as main characters, antagonists and essential others. Who are they, what problem do they have to solve and why are they in dramatic conflict?
- *What theme, if any, is present in the initial collection of stories?* Do they complement each other?
- *What genre of narrative is it?*

- *What is its dramatic structure?* What are the twists and surprises?
- *What is the style of the narrative?*
- *What is original and what is familiar? Is it original enough?*
- *Are the characters' stories or the thematic subject matter realisable in the length of short being envisaged?*

This is the most difficult question to answer but also the crunch question determining whether or not the idea really will work as a narrative at this length. Unfortunately, there is not enough space in this book adequately to provide a definitive framework to answer this question.

However, the three fundamental distinctions in shorts, which have an impact on narrative content, are:

1. The short short.

A narrative under five minutes in length. In essence, a joke or a visual and aural experience which does not seek to convey a sense of story but an engagement with subject/theme.

Characters and characterisation are dependent on strong types, often stereotypes, owing to the extremely short amount of narrative time.

2. The medium short.

Approximately five to twelve minutes in length. This is a narrative which can support two stories or a series of episodic moments and requires dramatic development to sustain interest.

Characters need to be seen to make a dramatic journey. Characterisation is very simple owing to the limited screen time, but it can be idiosyncratic. This is because there is time to establish and develop characters, but not enough time to question their credibility.

3. The long short.

From twelve to thirty minutes in length. Secondary stories are necessary at this length. However, the total number of stories is probably no more than five, and even then one or more of these will be extremely simple.

Characterisation and character development need to be more complex to sustain interest. If the plot is simple, then style elements will have to compensate in terms of emotional engagement.

Note that one of the most distinctive aspects of the explosion in short film and video narratives in recent years has been the popularity of shorts which are either comic and/or have a very simple plot but are heavily dependent on style.

## An Idea for a TV Fiction Series

- *Clarify the main characters.*

Discover the source of the on-going conflict between the main character/s and other characters. Is this conflict sustainable and for how long?

- *Identify the element/s of the dramatic situation which will generate stories.*

How many are there? Do they have equal or varying dramatic weight?

- *Identify the basic dramatic structure of each episode.*

Does the series have any serial elements? If so, what aspect of the drama is developed within the serial part of the narratives.

- *Know what genre it is*
- *Know what style it is*
- *Identify a number of premises for episodes.*
- *Identify secondary characters.*

Who will appear in most episodes? How distinctive are they, what dramatic potential do they have?

- *Know what makes it familiar and what makes it original.*

Originality in television series is a difficult problem. Broadcasters and advertising executives are wary of moving away from proven formulae. This situation has opened an era where every known version of a police detective or doctor appears to have been used. This has led to the more original work being undertaken in comedy and serials. However, the ability of a series to be original and define its audience is a challenge you need to address if you wish to break into this area of television writing.

- *Know its commercial limitations and its potential in the marketplace.*

Crucially, who are its primary and secondary audiences?

## An Idea for a Feature Film

- *What are the characters' stories?*

Know how many there are and know them as main characters, antagonists and essential others. Who are they, what problem do they have to solve and why are they in dramatic conflict?

- *What type of stories are they?*
- *What theme, if any, is there present in the initial stories?*
- *What form of narrative is it?*

Linear? Episodic? Associational? Circular?

- *What genre of narrative is it?*
- *What is its dramatic structure?*

What are the twists and surprises? What are its dramatic parameters?

- *What is original and what is familiar about the idea?*
- *Does it have a high concept and/or a compelling pitch?*

The former is not essential. The latter will be in selling the project and it helps if the writer is able to express it in words.

- *Does it need another strong story?*

A common mistake is to think that films are essentially one story, when inevitably they are at least two. Therefore, finding the second story is an essential aspect of assessing an idea. In developing the screenplay there will be at least three significant stories, and up to twelve or fifteen secondary stories, depending on the length and dramatic form being used.

- *Is it a cinema or television narrative?*
- *What are its commercial limitations/potential?*

Which cinema or television audience is the film ideally suited for and how could its appeal be widened?

### An Idea for a TV Serial

The framework is essentially the same as the feature film with the following crucial differences:

- *What is the overall length and the episode length?*
- *Are each of the characters' stories sufficiently developed to sustain the narrative?*

Do we need more or fewer characters to sustain the length?

- *What are the dramatic developments which will sustain climaxes at the end of each episode?*

These frameworks provide a sound basis for developing ideas, but there are still three fundamental questions which must be asked before too much other work or writing takes place on a project.

## Before The Treatment

When you have developed an idea and you are at the point where you want to commit to writing the treatment or the screenplay, it is crucial you ask of the intended work and yourself the following questions.

### 1. What makes it familiar and what makes it original?

No screenwork is wholly original, by definition. For it to be so it would have to re-invent screen language, then provide a means of interpreting it and finally find an audience prepared to engage with this new experience.

In the light of this reality, it is extremely important to understand which familiar aspects of screen narratives each project is bringing to an audience. These provide a framework within and around which the original elements of the project are placed and therefore made accessible, and it is hoped, understandable to the audience. In this context, familiarity is fundamentally provided by stories, form and genre. Originality arises mainly from subject/theme, character, plot and style.

What makes this balance so crucial to the further development of an idea? Without significant original elements the project will appear to just be a poor copy of something we have already seen. However, without the familiar elements of the framework the original characters or premise are likely to remain merely interesting and not dramatic enough to sustain a screen narrative.

Some ideas are very dependent on their plotting or characterisation. If this is the case, then developing the project further is probably the only way in which it is going to be possible to assess whether or not it really is a good idea, i.e. if it will provide the basis of a good screenwork.

Developing an idea and writing a treatment, etc. will change a project. Therefore, the question of the balance between the original and the familiar elements will always be something to keep in mind. However, it is the originality which will attract people's attention and ultimately make the piece worth watching.

## 2. What are its commercial limitations/potential?

If a writer is commissioned to develop an idea from a pitch, or a premise, then initially it clearly is a commercial idea. However, this does not mean, unfortunately, that it is a good idea. This realisation has dawned on many a writer, script-editor and development executive and led to the commission being abandoned, or to a major re-think.

The important relationship between commercial realities and ideas, from the writer's perspective, is the degree to which the idea can be realised as a screenwork by the writer if they complete the screenplay. This will obviously vary enormously from a short capable of being shot on a camcorder to an all-action special-effects blockbuster. Therefore, it is important to recognise the commercial implications of the idea and what you hope will happen to the screenplay when it is finished.

## 3. Why do you want to write or develop this screenplay?

All the above criteria aside, or fulfilled, there has to be a substantial reason why a particular screen project will be developed and not another. This has to relate to your need to write this screenplay. This may range from financial considerations to a long-held passion, from a fascination with a subject to an impending deadline.

However, all of these are nothing if you do not in some way own the project and your emotional commitment is not strong enough to sustain you through the process. As a writer you have to believe in what you are writing about in some way for you to be able to accommodate all the set-backs, the re-writing, the rejections and the diversions which will beset the writing of a good screenplay. Therefore, it is important to ask whether you are prepared to take this idea and commit the time and energy to write this screenplay now. If not, abandon it. Develop another idea instead as this one will always be here waiting for you to come back to.

## The next step

The problem with most ideas is that they do not work, or you become bored with them, or there is no one who is prepared to make this project now. The beauty of ideas is that they do not die. You can always come back to an idea and develop it at a later date or when someone is interested in trying to get it made. Creating a file of ideas alongside the articles, headlines and images will always serve you well when you need inspiration or when you are panicking prior to a pitching session.

Assuming you have your idea and you are committed to it, then you can proceed to write the outline, treatment, step outline or screenplay, depending on how you wish to proceed. This brings me to the end of the basic framework of screenwriting. The creative matrix provides the theoretical basis, the tools of the trade provide the means for writing within a screen context and this chapter has provided a context for developing screen ideas.

The next three chapters look at the work of the creative matrix in more detail and how to use it to write a screenplay – from plotting and structure to dialogue and capturing a shot on the page.

# Notes

1.  Adaptation is discussed and illustrated well in William Goldman, *Adventures in the Screen Trade*. Futura, 1990. A comprehensive overview of adaptation can be found in Kenneth Portnoy, *Screen Adaptation*. Focal Press, 1991. There is also an interesting article by Jeanette Winterson in Giles & Licorice (eds), Debut on Two. BBC, 1990.

2.  A model option form can be found on pp. 201-203 of Linda Seger, *The Art of Adaptation: Turning Fact to Fiction into Film*. Henry Holt, 1992.

3.  For a lengthier discussion on research consult Ann Hoffman, *Research for Writers*. A & C Black, 1979.

4.  These frameworks were developed by myself with various student groups as part of a workshop programme at various teaching establishments in London.

# 5. From Stories to Themes

In developing an idea from a simple premise through to the finished screenplay the role of theme and stories is clearly crucial. This is true not only in terms of providing the audience with a means of understanding the character/s' actions but also for the writer to develop their theme and raise the questions which make a screenplay relevant emotionally and rationally to an audience.

The creative matrix provides a means of seeing the link between stories and themes and how they underpin much of what the screenplay delivers in terms of human experience. In this chapter I will look at the stories and common themes which can be found time and time again within screenworks. In addition I will provide a framework for developing original characters and illustrate how their characterisation affects the plotting and is influenced by the style of a narrative.

Having established the parameters of story and theme it is then important to see how you can use different stories to structure a plot, and work within different dramatic forms. However, before we can do this we need to know what stories are available to us.

## How Many Stories are There?

In almost any discussion on films or dramas the phrase 'There are only six/seven/ten stories' will sooner or later crop up. So, how many are there? This question was partially answered in a newspaper column by Rory Johnson in reference to his father's analysis of plays. Denis Johnson, Rory's father, believed there were eight plots in playwrighting.[1]

The eight plots according to Johnson are:

1. *Cinderella* – or unrecognised virtue at last recognised.
2. *Achilles* – the fatal flaw.
3. *Faust* – the debt that must be paid.
4. *Tristan* – the standard triangular romance.
5. *Circe* – the spider and the fly.
6. *Romeo and Juliet* – boy meets girl, boy loses girl, then they get together again.
7. *Orpheus* – the gift taken away.
8. *The hero who cannot be kept down.*

Having considered these eight basic plots – which to all intents and purposes are the basic stories – and discussed them with several groups of students and writers, I believe there are in fact ten stories. I think the triangle romance, in Johnson's list, is merely a version of the romance story. I would add rites of passage, the wanderer and the quest as additional story types which are commonly found within screen narratives.

# The Ten Story Types

## 1. The Romance

- A Character is seen to be emotionally lacking / missing something / someone.
- Something / someone is seen by the Character as a potential solution to this problem – the object of desire;
- Barriers exist to stop the Character achieving a resolution with the object of desire.
- The Character struggles to overcome these barriers.
- The Character succeeds in overcoming some, if not all, of the barriers.
- The story is complete when the Character is seen to have resolved their emotional problem and unites with the object of desire.

Whether or not they stay united, and the form of this union, is up to the writer. The character becoming united with the object of desire is the end of a romance story but not necessarily the end of a romance narrative.

This is illustrated by Romeo in *William Shakespeare's Romeo and Juliet*, Niles in *Frasier* and Wallace in *A Close Shave*.

## 2. The Unrecognised Virtue

- The Character with a virtue becomes part of someone else's world.
- The Character falls in love with a powerful character in this world.
- The Character seeks to prove that they are desirable to this powerful character but the power relationship undermines this.
- The Character ultimately attempts to solve a problem for the powerful character.
- In attempting to solve the problem, the Character's virtue is finally seen by the powerful character (Note that whether the problem is solved or not, whether or not the Character is united with the powerful character at the end of the narrative, is up to the writer).

This is the story of the prostitute in *Pretty Woman* and servant in *Scent of Green Papaya*.

## 3. The Fatal Flaw

- The Character is seen to have a quality that brings success.
- With this success they gain opportunities denied to other characters.
- They use the opportunities for their own gain, at the expense of other characters.
- They recognise the damage they have done to others and set themselves a new challenge.
- The quality which brought them success leads to their failure in the face of the new challenge.

Note that it is worth assessing how 'fatal' is 'fatal'. In one-off narratives, then it is often literally fatal. In episodic television, where the character has to return next week, the fatal ending is usually avoided by turning it into failure yet again.

Examples include Dracula in *Dracula, Prince of Darkness* and Dr. Ross in *ER*.

### 4. The Debt that must be Re-Paid

- The Character wants something / someone.
- The Character becomes aware that someone / something is available which will possibly give them what they want, at a price.
- The Character agrees to pay the price, later.
- The Character pursues their original desire.
- The Character attempts to avoid paying the debt.
- The Character runs from the debtor.
- The Character is finally confronted by the debtor.
- The debt is re-paid.

The success in pursuing the original desire and the final outcome of the repayment are up to the writer.

Examples include the soldier in *Angel Heart*; The embezzler in *Midnight Run*; Del Boy in *Only Fools and Horses*.

### 5. The Spider And The Fly

- The Character wishes to make another character do their bidding, but they have no power to force them to do so.
- The Character devises a plan to trap the other character into doing their bidding.
- The Character executes the plan. It works.
- The Character achieves their initial goal.
- The Character faces a new future in the aftermath of the plan.

Note that the final outcome is determined by the writer.

This is demonstrated by the title character in *The Politician's Wife*; Valmont in *Dangerous Liaisons*.

### 6. The Gift Taken Away

- The Character is seen to have a gift.
- The Character loses it.
- The Character seeks to regain it.
- The Character becomes reconciled to a new situation which they discover in pursuit of the gift.

Note that they may or may not regain the gift.

Examples include the mother in *Little Man Tate*, the husband in *Solaris*, the father in *Paris Texas* and the female police inspector in *Prime Suspect*.

### 7. The Quest

- The Character is set a task to find someone / something.
- The Character accepts the challenge.

- The Character searches for the someone / something.
- The Character finds the someone / something.
- The Character is rewarded, or not, for their success in the quest.

Note that this is the basic quest story. The epic version is essentially a plot which combines this story with other stories to produce a particular plot.[2]

   This is illustrated by the title character in *Jason and the Argonauts*, Luke in *Star Wars*; Mulder and Scully in many of the *X-Files* episodes.

### 8. The Rites Of Passage

- The Character becomes aware of the next 'age' in their life.
- The Character attempts to learn what they need to know to live in this new age.
- The Character attempts to act, as if they have learnt what they need to know to live in the new age, and they fail.
- The Character encounters a challenge which requires them to reach beyond what they have already achieved.
- The Character succeeds in meeting the challenge.
- The Character enters the new age.

This is illustrated by the teenage boys in *Stand by Me*, the thirtysomethings in *The Big Chill* and Muriel in *Muriel's Wedding*.

### 9. The Wanderer

- The Character arrives in a new place.
- The Character discovers a problem associated with this new place.
- In facing the problem the Character reveals why they left the last place, before they arrived at the current situation.
- The Character attempts to move on again.

The question of whether the problem is actually resolved or whether the character moves on is up to the writer.

   This is illustrated by Thelma in *Thelma and Louise*, the title characters in both *Shane* and the television series, *The Fugitive*.

### 10. The Character who cannot be Put Down

- The Character demonstrates their prowess.
- The Character faces a new challenge with even bigger forces ranged against them.
- The Character accepts the challenge.
- The Character faces a range of the antagonistic forces.
- The Character overcomes all the antagonistic forces.
- The Character succeeds in accomplishing the challenge.

This is illustrated by Conan in *Conan the Barbarian*, Spade in *The Maltese Falcon* and the FBI agent in *The Rock*.

As was discussed in the chapter on the creative matrix, these definitions of story are very basic and they can be used in numerous ways and combined in any grouping within any one narrative.

On the one hand, the power of any one story is enhanced if the concerns revealed by the story reflect a theme which is expressed in other stories within the same narrative. However, before these thematic factors come to bear, the question remains of how to use this simple framework of character motivation when developing a screenplay.

## How are Stories Developed?

Having found an idea or subject you want to turn into a screen narrative, the next major question is usually finding the story. The questions are not only 'What type of story is it?' but also 'How are you going to develop it?'

There are four distinct levels of stories within narrative dramatic structures and each level determines the level of development of any one particular story in relation to the narrative.

1. *Main Stories*
These are stories which run throughout the whole dramatic structure and dominate the narrative space in terms of the time dedicated to them.
2. *Secondary Stories*
These also run the whole length of the dramatic structure but do not occupy as much narrative time and are, therefore, simpler in their telling.
3. *Tertiary Stories*
These are stories which do not run throughout the whole dramatic structure. They may last a few scenes or a sequence. They are present throughout the dramatic structure but they never dominate it.
4. *Fillers*
These are stories which last only one or two scenes.

The position of any one story within the plot will determine which of the above four options is appropriate to the story you wish to develop. For instance, if you are developing a character who merely supplies key information to an antagonist and has no further role within the narrative, then this is a filler story. On the other hand, if the character is the partner of a main character and is expected to appear in most scenes with them, then this becomes a main story and will require as much development as the main character's story.

## How Many Stories Do You Need to Make a Narrative?

Given the number of options and the number of characters necessary to tell any one story, how many stories do you need to make an effective screen narrative?

Given that each character has a story, it would appear at first that you need to find three or four to make a short, a dozen or more to create a feature length film, and thirty or more to plan a television series.

Simply put, this is true. However, if you start off just looking for a collection of stories to form a narrative you will almost certainly end up with a very confused narrative.

The starting point is to decide either what the narrative is really about – it's particular theme – or what the main story is. The thematic approach is dealt with later in this chapter. At this point let us concentrate on the question of the main story.

The *main story* is the one which will form the dramatic spine of the narrative. The way the main story operates as the spine varies from form to form. In a simple linear narrative it provides the focus for all the major dramatic action within the narrative. In an episode of an on-going series it will provide the central dramatic moments around which other stories, involving different characters, will be spun.

In a serial it will be the story which we return to every time a significant episode involving other characters has been resolved. In this form it is possible that the main story will hardly feature in one episode of the serial's narrative.

What makes a story the main story in narrative terms?

- *It provides the narrative with a central protagonist.* This character who will occupy the most narrative space compared with other characters in the telling of their story.
- *This story will provide the dramatic focus for the narrative shifts* – between the three acts of engagement and also the climax of the narrative.
- *It will be told in a chronological order,* i.e. the story events will be revealed as if they were happening in real time, with all the boring bits edited out (note that this basic principle applies even when a framing device is being used, which essentially means the main story is in fact a flashback).

## What makes a good main story?

- *A great character*, whose story is strong enough to support the form and genre of narrative in which they are placed.
- *A great plot*, containing a series of dramatic surprises which are unpredictable with foresight but credible with hindsight.
- *A good second story*, one which reflects the theme and dramatic concerns of the main story. Only narratives which are completely theme based or are the shortest, i.e. under one minute, can operate effectively without a second story.

## How Do You Create a Screen Character?

All characters in any dramatic form have three essential aspects to them. These are:

- Outer presence
- Inner presence
- Context

These three aspects can be developed from scratch to form the basis of a character profile. The aim of the profile is to provide a handle on the character and to highlight any major areas for research or potential story development.

## *A Character Profile*

A character profile is a means of coming to terms with who your character is and what makes them who they are.[3] It is created by answering the questions based on the following attributes or relationships. These aspects of character are not in order of importance, nor will every character demonstrably need development in relationship to all these possibilities.

### Outer Presence

What physical characteristics does the character have and which ones are important?

*Sex* – male, female, androgynous, or neutral.

*Age* – not necessarily a specific number of years.

*Physical distinctions* – colour of eyes, hair, skin, build, disabilities.

*Movement* – speed of walking, facial expressions, mannerisms.

*Verbal expressions* – favourite expressions, slang, pitch and speed of voice.

*Hereditary characteristics* – physical features and family dis/similarities.

*Appearance* – clothes, accessories, cleanliness, style.

*Sexuality* – how it is expressed.

*Tension/pleasure* - how they are expressed.

Note that the character's attitude to all of the above can be as important as the existence of any particular attribute.

The aim is to create a *Dominant Impression*, a sentence or phrase summing up the physical impression of the character on screen. For example, Doug is a middle-aged man with middle-aged spread and a white spandex cycling suit. Maggie is wide-eyed and innocent with bags of enthusiasm, smiles from within her 'Bonnie the Bunny' outfit.

The dominant impression is essentially the 'first impression' but it also marks out the physical characteristics of the character. These may determine their ability to carry out certain tasks within the plot and with other characters.

### Inner Presence

The aim of this set of attributes is to arrive at some understanding of the intellectual and emotional parameters of the character.

* *Intelligence and knowledge* – not only how intelligent but what do they know and how well can they use this knowledge?
* *Ambivert, extrovert, introvert* – working out when a character will change from their dominant personality trait is often a key to dramatic development.
* *Temperament and quality of judgment* – how quickly do they respond emotionally and in what way?
* *What do they like/dislike about themselves?* – this could be a range of things or something very specific.
* *What or who do they care about most?* – what do they have to lose if something goes wrong?

- *Self image* – what is it and are they aware of it?
- *What do they want in the future?* – this can range from a specific goal to a general state of being.
- *What do they fear?* – the route to an obvious antagonist.

The aim is to produce a *Dominant Attitude*, a view of life which can be summarized in one or two sentences. However, the depth of a character is only found in the following developments of these basic attributes.

*Contradictions.* – something which contradicts the dominant attitude. The presence of contradictions within a character adds not only to the plot options but also to the character's credibility with an audience.

*Point of view* (POV). – establishing the character's POV on the subject of the narrative or a situation in which they find themselves in, is essential to developing a link between the character and their particular story.

*Interests.* – what the character does with their day – their work, hobbies, day-to-day concerns, routines. This adds not only action for scenes but topics of conversation which ground the character in a reality beyond the narrative.

These three aspects are extremely useful in character differentiation when dealing with a group of characters who are essentially in the same position, and have very similar backgrounds.

## Context

The aim of this aspect of the profile is to establish the world the character lives in. This forms not only the basis for supporting characters but also plot and specific motivational options.

*Relationships* – family, friends, lovers, co-workers, boss, employees, other people in the narrative. This includes not only which ones exist but which are significant and why.

*Culture* – birthplace/childhood locations, education, occupations, socio-economic group, nationality, ethnicity. This will provide a good basis for research and detailed references for the character's dialogue.

*General history* – the period in which the character lives. Big events have huge impacts on people's lives or their activities can be judged against them.

*Personal history* – significant events in a character's life: their backstory. The important thing here is to know how much backstory you need. If you are creating a new 'soap' you will probably need to know the life stories of all the main characters. If you are dealing with a small filler story, the chances are you only need to know what a character was doing just before their scene started.

## Limitations to the Profile

All these questions could clearly lead to an enormous amount of work. The degree to which you have to research a character and their world is limited.

- *You only need to know enough for you and the audience to understand them.*

- *The level of development depends on the amount of narrative time you intend to give them.* The more narrative time, the more you need to develop them. Note that this has nothing to do with being the protagonist of the narrative. A protagonist in a short narrative, or in an action-driven narrative, will have less time on screen and therefore needs less development than a secondary character in an on-going, episodic, television drama.
- *You must create a believable character who is well motivated in what they do.*
  They should be distinct from the other characters. This highlights the limitations of the individual character profile. Essentially, at this stage we have dealt with the character in isolation and we have not looked at what would make them an effective screen character.

## Characterisation
To build an effective screen character, you need to work through a set of six requirements.

### 1. Reveal their *emotional truth*
No amount of funny dialogue, fast action, clever plotting or special effects will make a character believable if the emotional truth of the character is not revealed and developed.

The emotional truth of the character is revealed in the number of emotional changes they pass through, in their changing motivations, from the beginning of the narrative to the end. This is often discussed in terms of the character's dramatic arc. However, the notion of an arc, with its smooth curve plus a clear beginning and end, hides the complexity of this development. The path of the dramatic arc in this sense is not a smooth line but more like a zig-zag towards the eventual destination.

A character's emotional state is first established and then challenged by some dramatic event. They respond to this challenge revealing another aspect of their character which is underpinned by a different emotion than the initial emotional state. Then as they face further challenges their responses reveal a widening range of emotions, until the final challenge produces a revelation and a change in their overall attitude to the situation or person which has been the source of conflict. Each step or reversal in this zig-zag path is a logical step from one point to the next. The art is always to keep the steps credible so the audience does not think the change is too quick, too slow or not credible at all.

The scale of these changes and reversals is determined by the genre and the style of the narrative.

*Creature Comforts (1989) by Nick Park, an Oscar-winning short where emotional truth was revealed in clay animation*

© Aardman Animation Ltd 1991

## 2. Let the character's attitude/s govern their overall response to events
(rather than just logic or instinct)

The dominant attitude being used in a number of different dramatic contexts is what reveals it to be the dominant attitude to the audience.

## 3. Define the basis of the character's *dramatic conflict*

There are five distinct bases for character conflict:
- *Inner* – the character is trying to control, defeat or find some inner aspect of the self.
- *Relationships* – the character is in conflict with other characters.
- *Societal* – the character is in conflict with an organisation, a belief system or a way of life.
- *Nature* – the character is in danger from some force/s of nature.
- *Supernatural* – the character is in conflict with a supernatural force. This can range from a god or ghosts to monsters or alien beings.

Each of these sources of conflict has been used successfully in all types of screenwork. However, some sources of conflict are easier to realise on screen than others.

Therefore, it is important to realise the implications for developing an inner conflict for plot and style. It is one of the most difficult forms of conflict to put on screen and screenwriters tend to adopt either a voiceover or an imaginary world as a solution to this. As both of these solutions have implications for the plot and look of the narrative, they cannot just be added to a standard naturalistic style with the hope that no one will notice the join.

Equally problematic is the question of the supernatural. Many horror narratives have failed because the nature of the antagonist was not defined clearly enough to make them credible. The result has either been a one-dimensional antagonist who is boring or something so powerful it is not credible that the protagonist/s would actually defeat or escape from it.

## 4. Develop credible character *problems and goals*

Having defined the basis of conflict and found the essential motivational framework through the character's story, various problems still remain.

These are essentially what will make both this narrative unique and this character's use of the story distinctive.

The answer lies in the setting of particular dramatic problems and goals and the structuring of the conflict between the protagonist and the antagonist in the plot. This latter point is dealt with in the next chapter.

There are two questions which always hang over the setting of problems and goals. These are 'Are the problems and goals appropriate to the genre, the form?' and 'Are they credible for the character to solve or achieve?'

The genre of the narrative will provide a solid basis for selecting a character's dramatic problems and goal, e.g. a character in a contemporary soap is not going to fight an inter-galactic war, nor are they going to spend a whole episode finding a

way to open a door. These problems would be highly appropriate for a Sci-Fi adventure or a slapstick sit-com.

The form also provides a good guide to the scale of the problem and goal. The shorter the narrative, the simpler the problem has to be and the goal self-evident in terms of the character's characterisation.

For example, in a ten-minute romance the obstacles to success must be encountered, developed and overcome in one basic action. In a seven-part serial the object of desire can change several times, the obstacles to success be numerous and the outcome be a complex web of consequences and action.

As these two aspects of the matrix provide such clear indicators, it becomes obvious that if you have a character with a problem and/or a goal, it is fairly easy to decide what genre and form the narrative might take.

### 5. Develop the character's responses to problems through *screen action*

Screen narratives are about revealing character through action. This can be as small as a look or as a big as the blowing up of a galaxy. Therefore, there is a need to realise character through action in a way that is not evident in the theatre, or on radio.

The range of options in terms of screen action in a particular narrative is largely determined by the genre. The problems which arise from this need for action are largely dependent on the nature of the conflict.

Inner conflict presents very real problems. These can be solved through the use of a confidante, e.g. the psychoanalyst in *sex, lies and videotape*; voiceover, e.g. *Trainspotting*; monologues, e.g. *Shirley Valentine*; point of view imagery, e.g. *Lost Weekend*; or an informed other character, e.g. almost every character talking about someone else in a soap.

Relationship conflict works well but the problem is to stop everything being reported and resolved through dialogue.

The degree to which this is a problem depends on the genre, e.g. in an observational documentary, the voiceover is separate from the action and complements it; in a soap, dialogue dominates owing to the scale of actions which are credible in everyday settings; in a video game, action dominates as the central protagonist is merely a representation of the player, and, therefore, dialogue is limited to encouraging the player.

Societal conflict requires the personification of the system or organisation into a solid character on screen, e.g. Darth Vader represents the Empire in *Star Wars*.

Nature is a great source of action, the only problem being keeping any human characters credible and emotionally engaging within a small amount of narrative space. For example, in action adventure based on volcanoes it is easy for the people to become lost to the spectacular visuals of the volcanic events. Similarly, when characters are pitted against a major force of nature, the force of nature has to be kept dormant for large parts of the narrative in order for the characters to become more than just a collection of types waiting to meet their fate.

Supernatural conflict presents plenty of action options. However, the

fundamental problem of defining what the supernatural can and cannot do in each narrative presents major problems of character credibility. Knowing what the limitations of the supernatural are is the quickest way to achieve the scale of drama and the plot potentials, when dealing with any supernatural characters in a narrative.

The degree to which this balance of action and dialogue becomes critical is dependent on the genre and the length of the narrative.

Generally, the shorter the narrative the greater the problem of revealing through action becomes. When the narrative time is short there is not sufficient time to have a series of developing dramatic events without a loss in character development. Therefore, characters become more dialogue dependent or stereotypical.

**6. Create *a significant set of characters* for the character to interact with**
This will entail creating a number of character profiles and working out how each character relates to each other and why.

The specific number of characters and their dramatic roles are defined by their relationship to the main character/s in the story.

One of the major weaknesses of many screenplays is the imbalance between the main characters and the rest of the characters in the narrative. It is worth remembering at this point that the value an audience gives to a protagonist is more often dependent on the quality of the antagonist than on the protagonist's own abilities.

## Types and Stereotypes
Screen characterisation can be efficient, effective and very short in terms of its narrative time. In fact, in some instances characters have to be registered, used and left within a minute of narrative space. It is this combination of visualisation, action and sound which makes characterisation on screen different from that of the theatre, radio and the novel. It is also the reason why types dominate so much of screen character history, why stereotypes are the major pitfall of many screenplays and why archetypes are re-used for each generation.

Character types by definition are individual people who share common traits/ attributes with a group or class of other people and therefore can be seen to represent them for an audience. Type is the characterisation framework for a character in the same way that story is the motivational framework. Stereotypes are types which are repeated time after time without variation. Most types have one or more stereotypes arising from them. For example, the academic is a type while the plain, other-worldly, academic is a stereotype, as is the eccentric, forgetful academic.

The addition of the adjectives points to the main area of original characterisation in a screenwork. The audience need the type to grasp the character quickly but you have the choice of what you then do with the character to make them distinctive, and worth watching.

The degree of freedom you have in this respect is dependent on the genre and narrative time. It is obvious that the level of characterisation available to a protagonist in a six-part serial is radically different from a minor character who appears for only two minutes in the same serial or from a spaceship in a stellar battle.

However, the ability to avoid the stereotype is one of the most singular arts involved in screenwriting and is not wholly dependent upon characterisation to achieve. Theme, story, plot, genre and style all play a part in making a character original.

### Why are stereotypes a problem, and yet often used and useful?

The reason a type has become a stereotype is that this particular type has been used several times and has become part of the audience's culture. Therefore, as soon as the audience recognises it, it knows what to expect. The problem with this level of expectation is predictability. If we know the character this well we can predict what they will do; if they just do it, the narrative becomes predictable and ultimately boring.

This provides you with the opportunity to work with the stereotype, and produce unexpected plot outcomes, e.g. Sam in *Cheers* is the successful womaniser who never gets the woman he really wants. Alternatively, you can work against the stereotype where the audience is led to believe one thing only for something else to be revealed. An example of this is the Postman in *Il Postino*. He is an inarticulate nonentity who will never make a mark on the world or capture the heart of a beautiful woman but he is ultimately revealed to be capable of poetry and of attracting the woman he loves.

There are clearly narratives where stereotypes appear to dominate the characterisation. A major form of this is in the comedic styles of parody or satire. However, the point here is that the characters are already stereotypes. In this style of comedy the comedic effect arises from the character's in-built typical attributes, which deny them what they set out to achieve.

Another major use of stereotypes is in supporting characters who have little narrative time and whose dramatic function is explained by their relationship to the main character, rather than the plot. Given these circumstances, especially in shorter narratives, e.g. a half hour sit-com episode, this stereotypical characterisation is often used to stop the audience worrying about how this character will develop or whether they have some other dramatic function.

In longer narratives, clearly-defined dramatic roles do allow for original characterisation, provided that once the characterisation is established it remains consistent throughout the narrative; for example, the villain's henchmen and women in the James-Bond films. This latter use of stereotypes points to the one use of type which is a major part of many screen narratives and which is nothing to do with character and all to do with story – the archetype.

## Archetypes

An archetype is a type of character who symbolises certain qualities across a number of narratives and cultures. In order to do this an archetype must remain unchanged and be involved in thematically simple stories and narratives, which can be re-used by different generations. There are very few archetypes.

- *Hero* – a character who overcomes all adversity and risks their life for the sake of others without seeking their own reward.
- *Villain* – a character who seeks power for themselves and will destroy others in order to achieve it.
- *Victim* – a character whose life is in danger and who is initially incapable of finding their own safety from the villain.
- *Investigator* – the character who no matter how difficult the pursuit, will seek out and reveal the truth.
- *Partner* – a supporting character to the HERO or the INVESTIGATOR, who provides the obvious solutions to the dramatic problems and often acts as a comic foil for the protagonist.

In working with archetypes the story defines everything about the character's motivations and the plot outcome. Therefore, the character can be characterised in a number of striking – and often supernatural – ways, e.g. Superman, Ripley in *Alien*. However, the archetypes' lack of development means the balance between the hero and the villain has to be equitable or the ending will feel too easy. Equally, the plot is dominated by action as there is no need for character depth beyond those of audience identification and relationship establishment.

The existence of archetypes has produced in a reflexive way the recognition by writers and audiences that this is too simple a view of the theme, often the morality of individuals. Therefore, a number of archetypal characters, whose relationship to the story is the same but who are thematically ambiguous, have developed. For example, the Guide in *Stalker*, the Samurai in *Yojimbo*, and Batman in *Batman Returns*.

## Characters within a Creative Matrix

Just as characters have no dramatic purpose without a story, so they have no life in a narrative without a clear set of relationships with the other elements of the matrix.

## Characters and Stories

Given that the defining quality of a dramatic character is that they have a story, it is important also to realise the role of other characters in realising this story.

Crucially, we need to understand the dynamic relationship between all other characters' stories and the main character's story. At this point it is worth pointing out the difference between the protagonist in a story and the protagonist in a narrative. Essentially, all characters are protagonists in their own stories but the writer chooses to make one, two or a group the protagonists for the narrative. This in turn defines the source of antagonism, depending on the genre. This choice is the

fundamental choice determining what the main story will be about, but it will not necessarily mean that this story will form the plot structure of the narrative. Two examples will illustrate this point.

*Rashomon* is the story of a hold-up of a man and his wife by a bandit. However, the narrative is constructed around a series of flashbacks of the trial of the bandit, in which the three characters involved in the hold-up tell their version of the events. These flashbacks are related between three other characters debating what to do with a small child they find abandoned. This second story occupies a small amount of narrative time compared to the hold-up, yet it is the means by which the hold-up is told and the narrative gains its wider meaning.

*The Usual Suspects* is the story of a criminal overlord who, having been betrayed, sets out to escape capture. However, the narrative does not reveal who the criminal overlord is or that this was the purpose of the events of the narrative until the last sequence of the narrative. Instead, the narrative concentrates on the other main story, which is the hiring of a group of Usual Suspects to carry out an audacious robbery.

Finding the story you want to tell is one thing. Finding the best way to tell it and then deciding on the secondary story and all the other characters' stories is where the art comes in and where theme plays a major role.

## Theme

In the matrix, theme is placed alongside story as a cornerstone of development. This arises not only from the power of engagement generated by theme in the selection of stories but, as has been illustrated above, from the possibility of some narratives working on a thematic basis rather than a story basis.

This is possibly best illustrated by the work of animators and what has been traditionally described as experimental film-making. However, there continue to be successful feature-length and long-form television series narratives which operate from a thematic basis, e.g. *Microcosmos, Small Objects of Desire* and *Wildlife on One.*

The advantage of a thematic basis for a narrative is that although the essentials of narrative structure apply and within episodes or sequences, plot and even story, can be used, it is really about juxtaposing apparently unconnected moments, images, events, and characters – a juxtaposition which reveals a connection or develops a new way of perceiving an aspect of reality.

Why use a thematic approach? There are a number of basic reasons for developing a thematic basis for narrative development.

1. *Stating the theme is the sole purpose of the project.*
This works where the purpose of the narrative is to represent a statement, e.g. naked flesh is sensual, war is frightening, blue has many meanings.
2. *The theme provides a coherence to disparate material.*
This is the basis of many experimental films and obviously underpins many

documentary series. The existence of the theme provides a means of engaging with a number of different events, circumstances, moments or images. For example, *The Old Man and The Sea, Koyaanisqatsi* and *Modern Times* – the TV series as well as Chaplin's film. Note that this can operate in an overt way and be stated as part of the narrative, or in a covert way where the theme is determining the selection of material but where this is not revealed in the narrative.

3. *Re-interpreting the theme in different contexts.*

This is where a theme is often used to underpin a common story or plot structure, e.g. the pursuit of love, but the writer wishes to raise questions about the value of this theme in our contemporary world. This approach often requires an episodic form, where the same story is repeated in different contexts to highlight the central theme. This is most evident in films such as *Flirt* and *A Night on Earth*. It is also the basis of many investigative documentary series and personal essays, e.g. *The Shock of the New* and *The Cook Report*.

4. *The theme is the direct experience of screenworks.*

This is not only where the medium is the message but also where the medium is tested and explored for its own qualities, e.g. colour, speed, sound. Examples of this are to be found in video installations or short screenworks, e.g. *24-Hour Psycho* and *Sunsets*.

## How many themes are there?

In terms of analysing themes it is clear that every narrative has its own particular thematic concern. However, these particular themes can be grouped under eight distinct thematic types which express major human experiences and reflect common emotional needs. These eight types are:

### 1. The Desire for Justice

An injustice is seen to be done and we desire to see it corrected. How it is corrected and whether or not the initial injustice is corrected is up to the writer. Almost any crime enquiry, or trial-based, narrative illustrates this theme.

Examples include *Murder One, Inspector Morse, The Bill* and *Twelve Angry Men*. However, it can be found in other narratives as well, e.g. *Seven Samurai, Bad Day at Black Rock, Shame* and *Bitter Rice*.

### 2. The Pursuit of Love

The sense of being alone is experienced by most human beings and we desire to see how other people deal with this situation, in particular how they meet the emotional need this often creates. How this need is met and whether or not it is ultimately fulfilled is up to the writer.

All romances illustrate this theme, e.g. *Casablanca, Romeo and Juliet, Four Weddings and a Funeral, The English Patient* and *Ju Duo*.

### 3. The Morality of Individuals

A choice has to be made between doing something which is defined as good and something which is defined as bad. The nature of good and bad is dependent on the writer, as is the outcome of the choice.

Examples of this include *The Searchers, The Fisher King, Rashomon, Murder on the Orient Express* and *Seven.*

### 4. A Desire for Order

Chaos exists, or threatens, and we desire to see some order imposed to make everyday life possible. The source of the chaos, its consequences and the means by which it is tackled are up to the writer.

In terms of individuals this can be seen in *Lost Weekend* and *Trainspotting.* With respect to society it can be seen in *Touch of Evil* and *Apocalypse Now.*

### 5. The Pursuit of Pleasure

Pleasure is possible and we desire to share in the experience of it. The nature of the pleasure, its cost, if any, and how this is portrayed is up to the writer. Comedies rely heavily on this theme and many of them are no more than individual/s in the pursuit of pleasure, e.g. *A Night at the Opera.*

The range of narratives which use this theme vary enormously, from the obvious – *Everything you always wanted to know about sex* – to *Naked Gun 2 1/2.*

### 6. A Fear of Death

Mortality is a fact of life and we desire to see how people cope with the threat of death. How the threat arises and the means of dealing with it are up to the writer.

This is the theme which underpins much horror e.g. *A Chinese Ghost Story*, but it is also the basis of personal dramas, e.g. *The Seventh Seal, Ghost,* and *Terms of Endearment.*

### 7. Fear of the Unknown/Unknowable

No one knows everything. Even collectively, humanity still struggles to grasp the magnitude of life experiences on this planet, leave alone the universe. In this context every human being at some level recognises their inability to understand much of what happens to them and the world around them. The result is a desire to see how the unknown can be confronted and dealt with.

This is the basis of most horror, e.g. *Quatermass, Alien, Nightmare on Elm Street, The X-Files,* but also some Sci-Fi, e.g. *ET, The Forbidden Planet,* and some personal dramas, e.g. *To Kill a Mockingbird.*

### 8. The Desire for Validation

Every human being is unique. The question is how much this uniqueness is a problem in relation to the other human being/s you live with and for you. The recognition of this situation leads to a desire to validate the individual choices human beings make in a communal context.

This is the basis of most personal dramas, e.g.*Bagdad Café, Thelma and Louise, Flirting, The Boys from the Blackstuff, Raging Bull* and *Lawrence of Arabia*.

## The Problem with Themes

These broad general themes have been highlighted to illustrate the relationship between story and theme as the fundamental underpinning of narrative developments. However, when a particular screenplay is being written or developed these boarder themes become transformed into the particular narrow themes represented in the screenplay.

In addition, the longer the narrative, the more likely it is – especially one which is story dominated – for there to be a number of themes competing for attention within the narrative. This brings to the fore the problem of sending out confusing messages as to what the narrative is really about, a confusion which may work as a narrative device for a short time but ultimately weakens the impact of the narrative as a whole.

The reason for this is that without a grasp of what the narrative is really about, the audience has nothing to judge the decisions taken by you in concluding stories or strands in a particular way. Part of the problem for any screenwriter in this context is the confusion which often arises between the active question which drives the plot forward and the question of theme.

For instance, if a narrative involves someone pursuing someone else to capture them, many people will say that pursuit is a theme of the narrative. However, this is probably a plot device. If pursuit were the theme this would be the focus of characters' decisions and narrative choices, not merely a means of moving from one sequence to the next.

The real confusion is when one or more stories are focused on themes different from that of the main story. As pointed out in the matrix, one of the most powerful uses of theme in narrative construction is for all the stories in the narrative to reflect the same basic theme.

This is the point though: they reflect the theme. They do not all follow the same story or concern the same particular problem/s as in the main story or strand. For example, in some soaps, episodes have unpublished titles, which are effectively the theme for the episode. No one watching the episode is told this but all the characters face similar or related problems, even though they will be pursuing radically different stories and goals within this episode. Therefore, the crucial point for a screenwriter is to realise what a narrative is really about and then choose stories and characterisations to reflect this.

## Theme and Dramatic Structure

How does dramatic structure operate within a thematic narrative? Given the lack of story to provide a clear dramatic framework within which to place characters, events and reveal motivations, thematic work is heavily reliant on form and plot. The use of repetitive active questions, combined with episodic structures, is one of the most effective ways to create the thematic framework of reference. This

provides the audience with a means of interpreting the narrative elements when there is no story to guide them. It is the failure to provide such a framework which undermines the intention of so many writers who seek to use a thematic approach and makes many screenworks unintelligible to their audiences.

The simpler the basis on which theme is being used the shorter the narrative needs to be, owing to the predictability problem stated earlier. Most thematic statements can be grasped within two to three minutes. If a theme is being questioned in terms of its relevance for story telling, or in a new context, then an episodic form will be required, as indicated above. This is also true for the bringing together of disparate stories or events. This is why a montage sequence, which is meant to establish time, place, atmosphere or to connect disparate story elements in a story-based narrative, also needs to be thought of in thematic terms.

Where there is a complete lack of story then the associational form is the only dramatic structure open to the development of the theme. With the lack of characters to follow throughout a whole narrative and, therefore, the dramatic engagement not arising from audience identification, the plot has to be simple and rest upon a strong active question, using curiosity and the pursuit of meaning as the means to engage an audience.

In this context, the single most important narrative point when working with thematically driven work is to establish a strong clear active question as soon as possible. This then provides a framework against which the elements of the work can be referenced. The point to remember here is that if there is no character to follow people will start to make assumptions about the connections between events and images. If they make the wrong assumptions in terms of your intentions, then the rest of the narrative will prove unintelligible or confusing.

### Theme And Style
The decision to use a thematic basis for the narrative means that style becomes ever more important in engaging the audience's attention and keeping it intrigued by the development of the narrative.

In some thematic works, e.g. those based upon the medium itself, style becomes not only the means of engagement but often the very thing which is revealing the theme of the work. It is the fluidity of animation styles which has allowed so much thematic-based work to emerge from this area of screenwriting. Animation's non-realist basis of representation forces the audience to engage at a strong level of sheer wonder and curiosity at what the screenwork can deliver. This allows for thematic, associational structures to flourish, as the style of representation itself is holding the audience to the narrative.

You should always ensure that the style reflects the thematic concerns and vice versa. If theme is being explored through a number of episodes, to ensure narrative variety and maintain interest, it is relevant to ask whether each episode could not take on a different tone and a different style. Equally, if a disparate set of events is being worked through an associational structure, then

style may be the overall narrative devise which provides some unity of representation.

However, a major impact of style on the development of a thematic project comes from the tone. Is it going to be dramatic, tragic or comedic? This choice will obviously affect the images chosen, the sequential development of the plot and the overall feel of the piece, regardless of any story elements which are introduced. In story-based narratives the overall tone of a project often emerges in development, and though this can happen with thematic projects, it is wiser to work this out very early on and select the narrative elements accordingly.

### How Do You Recognise Theme?

In some projects this is very easy. An experimental film which wants to explore the variations of the colour green has a clear theme expressed in its very conception. Similarly, a documentary series on how old established institutions are adapting to the modern world is clearly thematically driven.

In developing original dramatic narratives the broad theme can often be seen from the idea, type of story or genre the screenwork is developed around. However, it is only as the stories develop and the plot starts to take shape that any definite overall theme can be clearly identified. For this reason it is very hard to be specific about the theme of a project before the treatment stage. Recognising this point demonstrates the most important aspect of thematic development within a project: the theme is dependent on other narrative elements for it to be articulated through the narrative in the same way that a story is dependent on a character to be realised. Therefore, themes come and go as a project is developed and it is vital that the creator of the screenwork check at every stage what is happening at a thematic level.

It is common for a project to start off with a broad theme which is then narrowed down as the stories and plot take shape, and then become lost as the characters and dialogue take over the narrative development. In the final analysis, realising what the various elements of the screenplay are saying about the theme/s of the work is what the theme of the narrative is, regardless of what the original conception of the project was.

If the narrative draws no conclusions with respect to its theme then it loses its meaning, and becomes merely a narrative of moments, events or experiences for their own sake and as confusing as everyday events in their randomness. A failure to keep a focus on this aspect of a narrative's overall level of engagement will ultimately undermine the narrative's cohesion, emotional and intellectual power and its meanings. This does not mean that a narrator, character or another narrative device must spell out for the audience what this all means, although sometimes this is the wisest option. It does mean that the combination of narrative elements can clearly indicate what the narrative was concluding on this theme, and if they are not, why they are not.

Themes may come and go in the development of a screenwork but recognising and holding on to them at the end is vital.

## The Spectrum

Story and theme are two ends of a spectrum in terms of their relationship to the structure of narratives. However, even at both ends of the spectrum the influence of story and theme on each other are profound and extremely important in realising the full potential of any screenwork.

If you are working with a simple story, the power of the story will be enhanced significantly if you can create a narrative in which another story or stories are linked thematically with your main story. For example, a romance story is significantly enhanced by the addition of another romance story which explores a slightly different angle on the theme of desire or love than your main story. An illustration of this can be found in *The Bridges of Madison County*. In this narrative, a secondary story – about a woman who had an affair, was discovered and then ostricised – not only reflects on a possible outcome between the two main lovers, but also reflects on the theme of 'what is the value of love?'

If you are working with a theme, then using the emotional power of a story's means of engaging an audience will significantly enhance the impact of the theme. For example, the theme of the destructiveness of modern urban society would be enhanced by using the power of the need for freedom to engage the audience. An illustration of this is found in *Koyaanisqatsi*, where images of breaking free and the beauty of wide open spaces are established before the mechanical dehumanising aspect of city life is brought into the narrative. It should be noted at this point that the length of the narrative does matter, not only in terms of how much you have to write/create but also in terms of the complexity of relationships between story and theme.

In a very short narrative a simple story or a simple theme will be adequate to act as the basis of an audience's framework of engagement. However, the longer the narrative becomes not only does the dramatic structure become more complex, but also the need to develop a more complex interplay of stories and themes becomes essential.

These two elements of the creative matrix are the foundations on which all else rests and is interpreted by an audience. An idea may not start with either of them but before it will become a coherent narrative it will have to work with both of them.

## Notes

1. The original reply can be found in *The Guardian*.
2. The epic version is the one identified by Joseph Campbell in *The Hero with a Thousand Faces* and developed for screenplays by Chris Vogler in *The Writer's Journey*.
3. For other versions of character profiles, see Andrew Horton, *Writing the Character Centred Screenplay*. University of California Press, p83, and William Miller, *Screenwriting for Narrative Film and Television*. Columbus Books, p97.

# 6. Revealing Form and Plot

The means by which stories and themes are expressed in the narrative is dependent on its dramatic structure. You can have wonderful characters, beautiful settings and state of the art visuals, but it is a strong dramatic structure which ensures the audience is led through the mass of narrative information in an ultimately understandable and engaging way.

There are two radically different elements to dramatic structure – the form and the plot. Both have been defined in the creative matrix, so in this chapter the intention is to look at the implications of form and the use of plot in the creation of screen narratives.

## Dramatic Forms

The basis of dramatic form is the combination of length, the use of screen time and structure. These were discussed in some detail in Chapter 2, so I will only summarise them here. The five basic forms are:

*Linear* – a single character's story is revealed in a straight line time frame – the classical structure.

*Episodic* – a series of discrete incidents involving the same character/s but with time jumps and often re-arranged time sequences.

*Thematic* – a series of discrete incidents usually involving different characters linked by a similar problem, location or dramatic concern.

*Circular* – same as theme but containing one common element in all incidents and ending up back at the beginning when at the end of the narrative.

*Associational* – a collection of moments/incidents which are based upon strong universal concerns/experiences, e.g. birth, death.

Within these forms, stories operate as dramatic devices, while scenes and sequences provide the means for disparate narrative information to merge into a coherent dramatic narrative, and the plot is revealed through sets of active questions.

### Stories and Dramatic Form

One of the major mistakes made in the development of screenplays is to ask and answer the question 'Whose story is it?' with only one character's story. No narrative, no matter how short or long, will work on the basis of one story. It may, of course, work on the basis of one theme, as illustrated in the last chapter.

The problem arising from asking, 'Whose story is it?' can best be illustrated by the difference between a romance narrative and a narrative with a romance story in it. A narrative with a romance story in it can in fact be a quest narrative, an investigative narrative or in fact any type of narrative you care to choose. However, a romance narrative has to have a minimum of two characters, who are both

involved in romance stories which form the central plot of the narrative. This is what makes it a romance narrative and, therefore, if you concentrate only on one character's story, the whole narrative is weakened.

Even in the very short form where the time spent on the second story will be extremely short, it is nonetheless essential to the dramatic impact of the narrative. For example in *The Big Story*, a ninety-second animation narrative, a junior reporter argues with his newspaper boss about not being given the chance to cover a big story. The climax of the narrative is when an older journalist walks in having already covered the big story the junior reporter wanted to do. The first story is about the junior reporter not being given the chance to prove himself. The second story is the covering of the big story. In bringing them together in the climax the dramatic quality of the moment is increased.

The question to remember here is not whether a narrative can exist with only one story in it. Clearly the answer to this is 'Yes'. The question is whether it will fulfil its real dramatic potential if the second story is not there or is only implied. The point in developing a screenplay is, having established your first story, discovering what the second story is. The reasons for the type of second story have been discussed under theme. In this context, it is important to grasp the impact of form on developing a story or set of stories within a narrative.

The length of a narrative dramatically affects the time available to tell a story. However, it also affects the number of stories required to sustain interest in a narrative. As a rough guide, two stories will sustain any short narrative, i.e. up to thirty minutes; three to five stories will sustain an hour; five to ten stories are required for ninety minutes; and over twenty stories are required once you venture over two hours.

The extent to which each story is developed and the level of characterisation needed within each story is directly related to the dramatic form. In a simple linear narrative the level of characterisation has to be very high unless the narrative is going to be dominated by action arising from the genre. Therefore, in an action adventure, e.g. *Raiders of the Lost Ark*, or a disaster narrative, e.g. *Towering Inferno*, characters are very simple and often archetypes. On the other hand, in the Western *Dances with Wolves*, where characterisation was as important as the action, the narrative was extended to over two hours to compensate for this additional narrative information.

By contrast, the characterisation in a personal drama where there are few or no action sequences, e.g. *Terms of Endearment*, *Sunday in the Country* and *Burnt by the Sun*, is based upon complex life histories which are slowly revealed.

In episodic, thematic and circular forms the story lengths are shorter and characterisation is dependent on how many episodes a character appears in, but it is inevitably considerably less than in the linear personal dramas. Examples of how this can be dealt with are found in *Z*, *Underground*, *Reservoir Dogs*, *She's Gotta Have It* and *Trainspotting*.

In the associational form the degree of characterisation is minimal, unless the theme of the piece is the meaning of a character's life, e.g. *My Ain Folk*.

The choice of dramatic form arises either from the genre or from the point of view which will reveal the stories to the audience. In this sense, the real problem to resolve in any screenplay's development is whose point of view we see the stories from. If it is from one character's point of view, then the linear form will clearly work easily. If it is from several points of view, then the episodic form will work best. If it is the author's point of view, then the thematic, circular or associational forms will express this approach best, depending on the amount of story, as opposed to thematic, concerns underpinning the narrative.

In this context, do not confuse the author's point of view with the author's voice. The author's voice is the meaning of the narrative; the author's point of view is the way in which they wish narrative information to be viewed.

These choices highlight the first major problem you face after you have developed an idea through to a clear story or thematic concern. This is the way in which you are going to plot the various story and thematic elements to create a coherent narrative.

In order to solve this problem, and use all the elements of engagement available within the dramatic form, you need to decide how you are going to use stories to structure the narrative.

### Stories as Structural Devices

The following is a basic rundown of the different ways stories can be used as dramatic structural devices.

A story can operate as *the spine* of the narrative. Every other story springs from it. This is often found in linear dramatic structures, e.g. most contemporary feature films.

A story can operate as *a framing device*. This is where one main story provides the dramatic structure for the narrative but other stories dominate the narrative (without reference to this main story) inside this dramatic structure. This is commonly found in episodic television drama, e.g. *Casualty*, *NYPD Blue*.

A story can be *an establishing device*. This could be to establish an element of the narrative – e.g. a character or location – the theme, or even the world in which the main story will develop, e.g. the Longshoreman's-wife story in the opening of *Chinatown*, or the journey to the guerrilla camp in *Predator*.

A story can be *a thematic device*. This is where the same story is repeated several times within the narrative to express the thematic concerns of the narrative, e.g. the taxi journeys in *Night on Earth*.

A story can be *an episodic device*. This is crucial in writing sequences, as well as single episodes. Often a distinct story begins and ends within a sequence, even though the sequence is part of a bigger story, e.g. Luke training with Yoda in *The Empire Strikes Back*.

As all stories are dependent on characters to exist, as discussed in the previous chapter, it is evident that the use of stories as dramatic devices is realised through the use of characters.

### Characters and Form

The major problem you face in creating a credible and engaging character is the amount of narrative time available to them. The shorter the time, the less character development, and therefore, a heavier reliance on types. This is why in very short narratives or minor roles characters are often stereotypical or archetypes.

This problem can be circumvented by stylistic considerations, e.g. comedic style or surreal characterisation. These stylistic solutions bring their own problems of credibility, which will be discussed in Chapter 7. However, what is significant here is that the longer the narrative form is, the greater the freedom in terms of sustaining credibility. Therefore, one of the key areas for enhancing any narrative is to look at the minor characters and see how original and engaging you can make them.

Just as length of time affects characterisation, so it also impacts on the scale and development of the character's problem/s. Each story type presents you with not only the question of what is the specific nature of the problem/s in this version of the story, but also the scale of the problem/s. The larger the scale of the problem in relation to the character's abilities, the longer the narrative time necessary to provide the credible means for the character to overcome it.

Suspending disbelief is one of the key aspects of narrative engagement. The longer a character is on the screen, the greater the need to make their actions and mere existence credible. In this sense, there is a direct trade-off between action and character development. The more action, the less time for character development, and if the character is not capable of major development owing to their characterisation, then the more is the need for compelling action.

This relationship within a narrative, between action and character development, works within the parameters set by genre and style. However, it is the plot which actually makes the relationship work.

## Plot

The outline of plotting in the chapter on the creative matrix suggested some of the essentials of plotting. These were that active questions bind elements of a plot together, that three-act structures provide a means of understanding the development of characters, stories and ideas within a narrative, and that emotional engagement is essential for a plot to work.

This section on plot will take all of these points several steps further. In particular, the first part will examine the structural elements of plotting. This will include parallel editing, the shot, the scene and the sequence. The second part focuses on plot problems and how to assess a plot in terms of its relationship to genre and style.

### Structural Devices

Plotting is, along with character, one of the most open aspects of the creative matrix and is by definition original in each screenplay. For although the major active

question and genre conventions may determine the spine of a plot, it is the use of the active question from moment to moment which determines whether or not a particular screenplay is any better than the next one.

In order to develop this original use of active questions a screenwriter has to understand the significance of parallel editing, the building blocks of dramatic structure, and the use of active questions beyond the simple framing question which holds the whole narrative together.

## Parallel Editing

Plotting becomes much easier once two stories are seen to form the dramatic core of the narrative, primarily because the advantages of parallel editing become obvious.

One of the major ways in which time is ellipsed, enabling us easily to avoid unnecessary events, is by cutting from one location or time to another, or from one person to another. In this way we can see two different narrative developments happening in parallel. There are two basic types of parallel editing:

*Structural* – Two or more different situations are presented in parallel, e.g. various characters in different locations within an episode of a 'soap', or in sequential order, e.g. cutting from one story to another and then back again to allow development in both, often independently of one another.

*Character* – Two or more characters are shown in the same situation in parallel. This is cutting within a scene between different characters and, therefore, emphasising which character the audience should be more interested in moment by moment.

These two types also indicate the two levels at which active questions operate within a narrative.

The power of action and reaction in conveying meaning from moment to moment throughout a narrative forms the decision to use one shot as opposed to another.

The use of active questions at several different levels guides the choice of action within scenes, between scenes and the construction of sequences.

## Parallel Editing and Narrative Tension

The aim of any plot is to keep the audience engaged until the end of the narrative. In order to do this the audience has to be aware of certain narrative concerns and a range of possible outcomes. These concerns and outcomes are generated by the creation and resolution of active questions. It is the existence of these questions which forms the narrative tension, and which makes the narrative engaging.

The power of parallel editing comes from the possibilities it offers in terms of developing several active questions at the same time. To illustrate this here are the opening scenes from Troy Kennedy Martin's *Edge of Darkness*.[1] (Note that this layout has been adapted for publication from the original television script.)

1:1 A rail junction. Night

It is raining. A freight train carrying thermal oxides makes
its way slowly through the freight yard of a northern city,
its wheels clattering over the points as it slowly crosses
them. It carries the logo of the storage company ILF. It bends
round the side of a hill, and its brakes begin to hiss as the
driver brings the train almost to a halt. At walking speed it
snakes into a special siding, past a big warning sign for
radioactivity.

The freight train comes to a halt by a board which says
'International Irradiated Fuels'. Again we notice the logo. A
member of the UKEA Police Authority stands by the notice with
a machine gun, watching as the train comes to a halt. Almost
immediately a big low-loader switches on its lights, revs its
motor and begins to trundle across the freight yard towards
the siding. It, too, carries the logo.

1.2 Outside the British Legion Hall, Craigmills. Night

                    FIRST DRIVER(VO)
          Just look at him...

(Four cars are parked on the broken concrete apron, just off
a grade three road. It is raining hard. Water pours down a
farm track to meet the road just opposite the hall: then it
swims down towards the valley hidden below in the mist.
Despite the rain, a DRIVER stands swabbing the bonnet of the
biggest car, a Granada. He is being watched through the
fogged-up windows of a second car by two men. They look like
police drivers.)

                    FIRST DRIVER(VO)
          There has to be some reason for that kind of
          behaviour.

1.3 Inside the second car, British Legion Hall, Craigmills
Night

The two DRIVERS watch the man throw a bucket of water over the
car.

SECOND DRIVER
He's scared stiff of his boss. That's the
reason...

1.4 Inside the British Legion Hall, Craigmills. Night

GODBOLT stands on the platform, facing the almost deserted
hall. The wall behind him is draped with the union flag and
the colours of the local Territorial Regiment. Above him a
large trade union banner. It almost brushes Godbolt's head. He
is a large confident man of fifty, and he stares down at
RONALD CRAVEN, who sits alone in a stack of bentwood chairs in
the centre of the floor. The rain drums down on the corrugated
roof. They stare at each other in silence, stubbornly.

To one side is a trestle table on which is assembled piles of
twine-tied voting papers. Standing behind it and studying the
papers in an off-hand way is the assistant Chief Constable,
ROSS. He is more intent on the confrontation between GODBOLT
and CRAVEN than the ballot papers, but he does not want to
show this.

                    GODBOLT
        In God's name man, I'm not asking for much.
        All I'm asking you to do is delay the inquiry
        til we get back from Blackpool. (He comes down
        the stairs.) It's only two weeks. (He crosses
        to the island of chairs) I've been in your
        office, Ronnie, I've seen your workload,
        you've got cases piled on your desk. Frauds,
        rapes, robberies - (He pauses). I thought you
        would have welcomed an opportunity to get some
        of that cleared up.

                    CRAVEN
            (speaking quietly, but firmly)
        I want to get this cleared up.

                    GODBOLT
        So do I, Ronnie. It were me who said you
        should be called in! Remember?

(The rain drips down through a small hole in the roof and wets
some of the ballot papers on the long table)

                         GODBOLT

But to say you're coming to Blackpool with ten
men and start poking around, asking questions
in the middle of the Trade Union Conference -
about a voting irregularity in my union -

(ROSS pushes the papers out of the rain)

                         CRAVEN

It was fraud, Jim.

                         GODBOLT

We're talking three hundred bloody votes. And
what were my majority? Two thousand three
hundred!

(He looks at ROSS, who shrugs. It's not up to him. It's up to
CRAVEN. GODBOLT turns back to CRAVEN.)

                         GODBOLT

And we're on the brink of a national strike
and you want to divert the attention of the
conference to an alleged election fix.
'Miners' Union in Vote Fraud': the media would
have a field day.

(CRAVEN raises his head and looks at ROSS but the ACC looks
away. By now GODBOLT is at the other end of the long table,
pouring out a whisky for himself and ROSS.)

                         GODBOLT

What are you trying to do? Discredit the
union? Don't you think there's enough people
who want to do that?

(He stands there with an empty glass in one hand and the
bottle of Bells in the other. He looks at CRAVEN. Almost
imperceptibly CRAVEN shakes his head. Nevertheless GODBOLT
pours whisky into a glass and crosses to CRAVEN to give it to
him.)

                         GODBOLT

Come on Ronnie, stop playing by the rules.
They don't cover this contingency...

(He hands the glass to him. Fade in the sound of the low-loader.)

1.5 Outside the British Legion Hall, Craigmills Night

The low-loader breasts the rise and thunders past the hall, its cargo covered by a tarpaulin.

As it goes by we see a man up on the hill standing beside the wet trees. Camouflaged by his green anorak, his features are indistinguishable. All we can make out are his wet, worn trainers – he is standing half in and half out of the little stream which is running down the farm track.

1.6 Inside the second car, British Legion Hall, Craigmills Night

The older of the two DRIVERS, who has been sitting in the front passenger seat, slowly peers forward, and rubs a hole on the fogged-up windscreen. He peers through it.

                    SECOND DRIVER
          There's someone up there.

(The FIRST DRIVER looks at him.)

          Up on the track, in the bushes.

(The second driver leans forward and opens the glove compartment. Inside is a pistol. He pulls it out.)

The first major active questions established by the first scene concern the significance of the radioactive train, etc., and the company ILF, whose logo is seen three times in this one scene. These active questions are shown to be significant by the low-loader passing the scene of the main action in the opening Sc. 1.5. However, we have no idea what the connection is between these events at this stage.

The next active question is 'What are these men doing sitting in cars outside the hall?' This is kept interesting by the absurdity of the man swabbing a car in the rain, an action which is questioned in the dialogue and then immediately answered. The answer implies that we are about to see the boss.

The next long dialogue scene answers the question 'Why are the men waiting with the cars?' but instantly poses a number of other questions. The most significant is 'Why are the three men in the hall in the first place?' This is answered halfway through the scene with the revelation about the fraud.

It is worth noting at this point that most of the conversation is posed in the form of questions, both explicit and implicit. Dialogue is generally about posing active questions and answering them or avoiding them.

The dramatic tension of this scene comes not only from our need to understand what these men are doing and who they are, but once this has been established whether Craven will give in to Godbolt's request. This question is left open at the end of the scene, creating a space for another new active question to be posed.

This is started in Sc. 1.5 with the introduction of the man on the hill. Notice that it comes after the visual which has referred back to the question at the end of scene one about the low-loader. This active question is then given added tension by the introduction of the pistol in Sc. 1.7.

In the course of six short scenes and one long one, three different locations have been used and numerous active questions have been raised and answered with respect to establishing characters, but more importantly, several questions still remain unanswered:

Will Craven do as Godbolt requests? Who is the man on the hill? Does he pose a threat to the men in the hall? Will the policemen use their guns? What is the significance of the radioactive material?

This is one example of parallel editing and its ability to raise active questions within different aspects of the narrative. Structurally, parallel editing can be seen in terms of editing a sequence to reveal different stories and their impact on a character's situation. For example:

- The characters involved in both story lines are unaware of what the other group is doing, leaving the audience to anticipate the outcome, e.g. The bank-robbery scene from *Heat* and the majority of climaxes in most sit-coms.
- The information given in both story lines is incomplete, so the characters know what they are doing (though often they are caught by surprise at the end of the sequence), but the audience is purposefully kept in the dark, to stimulate interest. The opening of the above and most action thrillers.

In terms of scenes, parallel editing is used to emphasise the scale and nature of the character's problem. For example:

- Both storylines support each other, and the information which each contributes alternately builds up the expectation of the outcome, e.g. the final rooftop sequence from *Raise the Red Lantern*. In this sequence a woman is carried to a rooftop prison, watched by the protagonist. The protagonist follows the group and ultimately discovers what happens to the woman. The sequence is edited by switching between the group and the protagonist.
- In one storyline the movement or intention is kept the same, while in the other storyline the reactions to this steady repetition are varied, e.g. Sam in denial in a *Cheers* episode (the auction scene) or the final sequence from *Butch Cassidy and the Sundance Kid*. In the latter example, the two protagonists plan what they will do after they escape the trap they find themselves in. At the same time we are shown the numbers of soldiers ranged against them growing to overwhelming odds.

If these are the structural ways in which a plot engages an audience, how is this conveyed in a screenplay and, ultimately, in the finished narrative? In essence it is through the three key building blocks of dramatic action – the shot, the scene and the sequence.

## The Shot

A shot is literally a single camera event. A shot may range from a moment, e.g. the victims in the Odessa-Steps sequence of *Battleship Potemkin*, to a long travelling shot, e.g. arrival of the widow at the train station in *Once Upon a Time in the West*, or long take, e.g. the tea scene in *Tokyo Story*.

The content of shots is heavily influenced by questions of style but will be discussed here in terms of its role in creation, development and conclusion of active questions. The power of the shot arises from the notion of action followed by reaction. This is based upon two active questions which the audience brings to any narrative:

• What is going on?
• How are people involved/reacting to it?

This leads to the audience making connections between shots, even if this is not intended. This is known as the Kuleshov Effect, named after Lev Kuleshov, a Russian film-maker who eliminated establishing shots from various edited sequences. He then discovered that people automatically linked images spatially, and even re-interpreted identical shots of an actor's neutral expression differently depending on the shot which went before or after it.

This is one of the cornerstones of editing and one of the most useful devices within a screenwriter's tool kit. It also points to one of the major mistakes you might make in constructing scenes and editing sequences. If audiences are always trying to read meaning into and make connections between shots, they will attempt to make a meaning regardless of your intention.

Therefore, if you are not clear why one shot follows another or why you cut from the end of one scene to the image at the beginning of another, the chances are you will be generating confusion rather than clarity as the narrative progresses. If this happens a number of times, then the audience becomes aware of the narrative construction and distanced from the content.

Some screenwriters and screenworks have deliberately used this disruption to create a different type of engagement with the audience. It allows for a more critical appreciation while one watches the narrative. Examples of this include several works of Jean Luc Godard, Svenkmayer's *Dimensions of Dialogue* and many short experimental films about colour and sound.

However, if the questions posed by this technique are not relevant to one's everyday life, then there is no other aspect of narrative engagement to fall back on and the narrative loses its ability to engage. This is often compensated for in thematic screenworks by a distinctive style approach or by keeping the narrative short.

This search for connections is the driving force behind the active question but

here it is being applied at the smallest level of narrative engagement from moment to moment and allows active questions to come and go within the course of two images. For example, we *see* a troubled face looking at something. We *see* what they are looking at. The first shot raised a question. The second answered it. It almost certainly then asks – 'why are they troubled by what they are looking at?' This illustrates two further points that need to be noted.

1. The on-going nature of images in a narrative provides an on-going set of questions and answers, which the screenwriter has not only to be aware of but in control of – if they are to keep the audience focused on their intentions and not lose them in the welter of narrative options.

2. Emotion is the key to ensuring the active question is really active. 'A face' is neutral. 'A troubled face' implies something more. Even in abstract, image-based, narratives the shot must use its elements to inspire engagement through wonder or curiosity.

**How is a shot expressed within a screenplay?**
In general, one paragraph of action equals one shot. Therefore, if you wish to write a long dialogue scene without cuts, you should write the establishing shot showing who was speaking first. Alternatively, show what the audience was watching while the speech was made. Then, just write the dialogue.

If you want to have reaction shots while someone is speaking, or cut to a character as they speak, then you write the description of the person and how they speak as a distinct paragraph, in between the lines of dialogue. If you want to have an action covered by one shot, you write all the action as one paragraph. If the action moves through different spaces or is very fast, then many screenwriters simply do not put a full stop between scenes, or action, but make each distinctive visual within the shot a separate paragraph. If you wish to write a montage, then each image is written as a separate paragraph.

The key to writing good shots is to really think through what the camera will actually be showing on the screen at each moment, not just in the shot or scene as a whole. However, the key to using shots is to understand how they lead the audience through a scene or sequence and what active questions can be posed beyond what is happening, and how characters are reacting to it.

The aim of shots is to engage the audience with the narrative elements. However, for the shots to convey accurately your intentions you need to write a scene/sequence which provides a context for the shots and involves dramatic development.

*The Scene*
A scene is an event which takes place in a particular location at a particular time. Therefore, if we stay in the same place but it is a few hours later in the next shot, it is a new scene. Similarly, if it is the same time but a different room in the house, it is a different scene. The only time this principle of layout is not followed is in a montage sequence.

Scenes range in length from a moment – literally all it takes for the brain to realise something is on the screen – to an elaborate set piece involving several thousand characters.

There are four types of scene.

1. *An image.* A single shot in which no significant action takes place, e.g. the long desert road at the beginning of *Thelma and Louise,* the parked police car in *A Thin Blue Line,* the standard establishing shot of a building used in many television series.
2. *Dialogue without action.* Two or more characters talking in a static situation, e.g. most scenes in *My Dinner with Andre, Frasier* and *Steptoe and Son.*
3. *Dialogue with action.* Two or more characters talking amidst a moment or series of action/s, e.g. the escape in 'the mule' in *Romancing the Stone,* the assassination attempt in *Cyrano de Bergerac,* the opening montage and voice over of *Wings of Desire.*
4. *Action without dialogue.* For example, the whole of the final chase sequence from *The Terminator;* the dung beetle in *Microcosmos,* the silent cinema of Chaplin and Keaton.

As these examples illustrate, there is nothing about the type of scenes which inherently makes them work or belong to any one type of narrative. However, the relationship between types of scenes within a narrative is heavily influenced by the style and the notion of a rhythm within the editing of a narrative.

## The Purposes of Scenes

Scenes fulfil a number of different functions within a narrative. Sometimes this is accomplished in a simple way, which tends to be the case for short scenes, but generally it is through a combination of purposes that a scene works at a particular point within a narrative. These purposes can be listed as follows:

- To advance the story or theme (Story/Theme) – to raise or conclude an active question with respect to the development of a story or theme.
- To present exposition (Story/Theme) – simply to provide the audience with key information necessary for it to understand the significance of what has gone before or what is to follow.
- To establish a setting (Plot) – to provide a view of where we are physically.
- To develop character (Genre/Style) – creating an opportunity for a character to develop some aspect of their characterisation.
- To present the theme (Theme) – to articulate the theme of the narrative for the audience.
- To act as a transition (Plot) – an image which allows for a passage of time from one event to another.
- To create a pause in the action (Plot) – after a major scene or sequence, in which the audience has been highly emotionally engaged, there needs to be a pause in the narrative action. This allows the emotion to sink in before moving on to the next aspect of the narrative's development.

- To convey the passage of time (Plot) – similar to an establishing shot but in this instance purely concerned with showing that some time has passed.
- To establish the style of the narrative (Style) – this is vital to helping the audience at the start of narratives to decide on the range of emotions and the overall nature of engagement for this particular narrative.
- To give a sense of humour (Style) – the essential scenes of a visually comedic narrative and why a very thin plot line can work if the comedic action is funny enough.
- To establish genre (Genre) – similar to style but focusing on identifying the genre for the audience.

The references in brackets indicate which part of the matrix is determining the purpose for this type of scene. Clearly some scenes are not driven primarily by plot considerations, which points to the need to consider the wider implications of plotting other than just to reveal the stories – this is dealt with in the second part of this section. There are fundamental aims and objectives within each scene, and the writer must understand their relevance. The following is a list of the basic aims and objectives present in most scenes.

**1. Using its narrative purpose**

Every scene within a screenplay has to have a narrative purpose. It may be the most dramatic scene; it may only be a small transitional moment. The point is that every one of them contributes to the audience's engagement and understanding of the narrative and what you are setting out to achieve.

The only valid reason for pursuing a scene without a purpose is when you are at the point in the development of the screenplay where you want to explore possibilities with character, or are trying to solve a plot development, and cannot work it out in advance. The scene is then written as an experimental tool, not necessarily for use within the finished narrative.

**2. Knowing the writer's objective(s)**

The overall purpose of a scene is crucial but it is the particular means of expressing this purpose, or purposes, which is the essential question as to what to actually write. Therefore, you need to look at the number of purposes the scene is setting out to fulfil and the best dramatic order in which these can be achieved.

Generally, the resolution or setting up of an active question should come first, followed by any expositional moments. We then move to the active question at the heart of the scene which drives steadily to the emotional climax of the scene. The ending either provides a new active question or the answer to a significant one raised earlier.

This is clearly the structure of a scene with several dramatic beats in it. The shorter the scene, the fewer purposes it serves, the fewer beats it has. In a longer scene not only do the number of beats increase, but also the number of active questions increase, in order to keep the audience involved in the dramatic development.

### 3. Knowing the characters' objectives

Having this for each individual character, in each scene, is the only way to make the emotion underlying the scene work. However, how you reveal this to the audience is what the art of screenwriting is all about.

Crucial to this is the notion of sub-text. Sub-text arises when a character's actions or words are seen to be about something other than their content. It is achieved either by setting up the expectation of a certain outcome in a previous scene or by having the actions and/or expressions of a character run counter to their words or actions within the scene.

Crucial to *all* of this is the use of dialogue. This is discussed in detail in Chapter 7 but it is important to realise at this stage that it is often not the actual words which are important but the context in which they are said. Screenworks, uniquely amongst dramatic works, allow you to deal with small reactions, as well as big gestures, which more often than not provide the all important narrative meaning for the lines spoken.

You only have to think how gritted teeth, an arched eyebrow or crossed fingers change the meaning or impact of the line 'I love you' to realise the extent to which this link of visual to dialogue is one of the key tools of screenwriting. To illustrate this point, here is a scene from Alan Bleasdale's *Boys from the Blackstuff*. CHRISSIE and ANGIE are a Liverpudlian, married couple. He has been unemployed for some time, and though he has tried everything to bring home money, the couple are now desperate and on the point of breaking up. They have a young daughter. Note that this extract is printed in a condensed form of an actual television layout, as referred to previously.

```
INT. CHRISSIE'S LIVING ROOM

ANGIE IS IN A CHAIR, WITH HER BACK TURNED TO

THE DOOR. SHE IS SMOKING A CIGARETTE. CHRISSIE

ENTERS AND CLOSES THE DOOR

     CHRISSIE: She's asleep. And that's my

     last cigarette.

(ANGIE throws it at him, but he ignores it,

leaves it on the carpet. He sits down. They

both look at the cigarette, which is

smouldering)
```

CHRISSIE: It's alright I've stopped

smoking.

ANGIE: So have I.

CHRISSIE: That's what I call a sudden

decision.

(There is a pause)

CHRISSIE: I'm not picking it up.

ANGIE: Neither am I.

CHRISSIE: You threw it.

ANGIE: You never caught it.

CHRISSIE: My Dad's bigger than your Dad.

ANGIE: I've got a big brother.

CHRISSIE: But I can fight him. Anyway,

he's in Australia.

(CHRISSIE smiles.)

ANGIE: I'm not making friends.

(CHRISSIE puts his finger to his lips and

makes blubbering baby noises. She turns away

from him.)

ANGIE: You're not funny.

CHRISSIE: I'm not laughing.

(ANGIE bends down and picks up the cigarette)

CHRISSIE: I thought you'd stopped.

ANGIE: Yeah well. I've started again.

CHRISSIE: No will power, have you?

ANGIE: Oh! Sod off, Chrissie, I used to think you were funny but not any more.

CHRISSIE: Isn't it strange - I feel exactly the opposite about you. You're becoming more hysterical by the minute.

(There is a long pause as ANGIE finishes the cigarette. Then she stubs it out. )

CHRISSIE: Just like the home of our gracious queen.

ANGIE:  Shut up! I'm going to bed.

(She stands up, strides off upstairs.)

CHRISSIE: Is that an invitation?

(ANGIE ignores him and goes out. He stops being funny immediately)

CHRISSIE: Obviously not...

(CHRISSIE stands and goes over to where she was sitting. He inspects the cigarette end, and dismisses, reluctantly, the chances of smoking it. He walks back towards the couch

[*sofa*], reaches out with his foot, and boots the couch hard against the wall. As it hits the wall, the couch makes a jangling noise. He throws the cushions off. CHRISSIE looks at the couch in a new light. He tilts it on its back. He hears the jangle of money again, and he rips the fabric off the seam at the bottom end. He puts his hand into the insides of the couch, feels around and brings out a crumpled packet of cigarettes. When he opens it and sees it is nearly full, he chuckles fit to burst. He puts them on top of the sofa, then takes out half an ancient hamburger, some split chips, several crayons, a few coppers and two 50p pieces. He tries to put them on the sofa, fails and so puts them on the table. He rips the rest of the bottom of the sofa, finds a Liverpool FC programme, and then to his sublime joy, a five pound note. Almost infantile, certainly childish with pleasure, he holds it up to the light, inspects it, and kisses it.)[2]

The dialogue is about a cigarette but is infused with the underlying conflict, the sub-text. Equally, the action leading to the discovery of the money reveals the desperation and relief of the character at this moment, not just the finding of money. This is clearly only one example of how sub-text and action can be used within a scene to reveal different aspects of the stories and the characters.

There are innumerable options open to you as a writer to use this facility of screenwriting to reveal the key aspects of the narrative. The point is to do it and not to write scenes in which characters merely state their problem/s and action which merely conveys story information. The next major structural question with regard to a scene is its dramatic structure.

### 4. Working through the beginning, middle and end of the scene

Scenes have a dramatic structure in the same way as sequences, episodes and whole narratives. The key to the dramatic structure of a scene is knowing where to start it. The old adage 'arrive

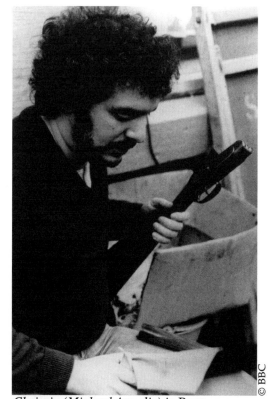

*Chrissie (Michael Angelis) in* Boys From The Blackstuff –
*w. Alan Bleasdale, d.  Philip Saville, p. Michael Wareing.*

late and leave early' applies to most scenes but there are times when this needs to be looked at very carefully. In particular, the main dramatic scenes, the introduction of major characters or the climaxes of stories or acts often require a slower start to emphasise their dramatic difference from the rest of the narrative.

The middle is always concerned with the key narrative information which led to the scene being necessary. The ending is about establishing and resolving active questions. It should come as soon after the main purpose of the scene has been achieved as possible. Note that even in narratives constructed from long shots and scenes, the rate at which information is relayed to an audience through a scene remains largely the same as when you cut rapidly from scene to scene.

How to start a scene is easy. It has to be a visual, as we need to know what is on the screen. The key questions are 'What visual?' and 'How does it relate to the final visual of the previous scene?' In this sense, the end of every scene is setting up the beginning of the next and making this transition is part of the art of screenwriting.

How to end a scene is more difficult. The crucial thing to remember is that the last shot of the scene is the one the audience will remember. Therefore, it should contain an element of an active question, which can be carried over into the next scene or sequence.

The same basic principle applies to the last line of dialogue. It reveals the intention of the character who is speaking and will be remembered by the audience. Refer back to the *Edge of Darkness* extract if you need to see how this is achieved.

### 5. Playing the scene visually

Far too often writers and development personnel forget this is screenwriting and use dialogue in every scene. In television, in particular, there appears to be an almost pathological fear of letting the images convey the meaning. This not only undermines the power of the medium but also to an increasingly screen literate audience it is ultimately insulting and boring.

Therefore, it is always relevant to ask how much of a scene can be conveyed visually and how to break up dialogue sequences with visuals. Remember that this is a visual medium and images are extremely efficient at conveying information.

### 6. Making the dialogue work

The issue here is that often characters are given a dominant attitude and then they merely demonstrate this attitude in every scene throughout the screenplay. In certain genre, in particular action adventures and action thrillers, this arises from the small amount of screen time given over to character development. Even within this limitation the best dialogue works on the basis that the audience cannot predict precisely how the character will react in every situation.

The main way of varying the attitude is to understand precisely what the attitude of the character is in this moment and what they want at this moment? This will allow you to create a range of emotions which relate specifically to individual characters and situations while reflecting the dominant attitude and goals of the character.

### 7. Establishing the point of view that governs the action

A scene is constructed from a series of actions and reactions which are expressed in gestures, words, camera angles or cuts. In terms of writing the scene, deciding whose point of view dominates the pattern of action and reaction is crucial. This informs the audience as to who is the really important character within the scene. For example, take the following scene:

> A crowded café. Person A rises and goes to the toilet. He is watched by Person B, who signals for the bill to be brought. Person A re-enters the coffee bar from the toilet and walks past Person B, giving her short but significant eye contact. Person B rises, and follows Person A out of the coffee bar, having left money with her bill on the table.

This can be written in two radically different versions. One option would be for it

to be written/shot as two wide shots divided by the time jump of the signal for the bill and the re-entrance of Person A.

```
INT. CAFÉ - DAY

A crowded, chrome and mirror café.

PERSON A rises from his table and walks to a doorway indicated
by a sign 'Toilets'. PERSON B watches him disappear through
the doorway, turns, and indicates for her bill to be brought.

LATER

PERSON A emerges from the toilets and walks past PERSON B.
They make eye contact but show no obvious reactions. PERSON A
leaves, closely followed by PERSON B. Money lies on top of the
bill on PERSON B's table.
```

Alternatively, it could be shot all from Person B's POV.

```
INT. COFFEE BAR - DAY

PERSON B's POV: A crowded, chrome and mirror café. PERSON A
rises from his table and walks steadily towards the toilet. He
disappears into the toilets. A WAITER at a nearby table, turns
and nods in recognition of being called.

LATER

The toilet door opens. PERSON A re-enters from the toilet and
walks past. He stares momentarily directly at US. His face
remains fixed, unmoved, before he walks quickly on.

A QUICK PAN to reveal money lying with the bill on the table,
as WE RISE and MOVE TOWARDS the exit, following PERSON A.
```

These are not the only ways in which this small scene could have been visualised but they demonstrate the importance of deciding the point of view in writing a scene. The choice of how the scene is visualised is the judgement call of the screenwriter and director. The presence of action and reaction is not.

### 8. Knowing whose scene it is
The judgement call on the visualisation of a scene will be dependent on whose scene it is. All character-based scenes within a screenplay work on the basis that

someone wants something to happen and someone or something is obstructing them. This is the basis of the drama within the scene.

Knowing who is the driving force within a scene will determine how it is visualised. Even when the protagonist is in a scene it does not mean they are driving it. Another character may well at this point in the narrative be the one whose desire is greater and thus driving the action of the scene.

Whoever is driving the scene becomes the focus for the camera, the dialogue and action and reactions. The ability to shift focus within long scenes is what makes a longer scene sustainable, e.g. the shift in focus to Michael Corleone in the scene where he outlines his plan to shoot the corrupt policeman in *The Godfather*.

### 9. Choosing a setting

The right setting for a scene may not only enhance its visual qualities but when dealing with climactic scenes it may be crucial to them achieving their necessary dramatic effect.

The overall approach to setting is largely determined by style and genre but the specific setting for an individual scene needs to reflect the drama of the scene. For example, a powerful emotional scene between two characters is underscored if it happens in public, as this is not where people normally allow their emotions to surface. Similarly, a fight scene works better if the location enhances the danger inherent in the action, e.g. on a clifftop or in a room with a bomb.

### 10. Creating the potential for action

Deciding on the action of a scene is vital to achieving a sense of the role of dialogue and the tempo of the scene. It also points to what will be the most dramatic moment within a scene. Is the climax action or dialogue based, and therefore how will the scene be written to arrive at this point?

Remember, all scenes which last more than a few seconds have the potential to serve more than one narrative purpose. The hallmark of many new screenwriters is that each scene only has one function. Therefore, the narrative progression is painfully slow and the subject of the narrative underdeveloped.

No scene works alone. The essence of building a screenplay is to realise the power of sequences of scenes and the overall shape sequences give to a screenwork.

## *The Sequence*

A sequence is a series of scenes which are connected by dramatic function, active questions, plus theme, action, place, characters or time. This is where the strengths of parallel editing and the use of active questions really come into their own as tools of screenwriting.

The power of screen language to hold together different and often disparate stories is best illustrated by the multi-stranded story-telling involved in soap opera, e.g. *EastEnders, Melrose Place*; television series, e.g. *Casualty, ER*; or serials, e.g. *Cracker, Prime Suspect*.

This power arises from the use of sequences to focus the audience on one story

at a time, while still keeping other stories alive through the use of active questions. This point is illustrated below.

**Sequences in a Television Soap**
Here are two examples of sequences in action. The first is a step outline breakdown of a soap episode – a sequence from a step outline for an *EastEnders* episode written by Tony McHale. The second is a schematic breakdown of a ninety-minute feature film.

    *EastEnders* is a contemporary soap opera centred on the families and friends who live in and around a square in the old East End of London. The action is centred in the houses around the square, the Queen Vic pub (VIC) and a café, THE MEAL MACHINE.

```
SCENE:714/1 INT. THE FOWLERS'. DAY (08.15)

Boxing Day. Aftermath of Christmas. Pete, in

hangover mode, again, asleep in an armchair.

In his hand he still holds Martin's Christmas

present – Game Boy. Martin comes down the

stairs and carefully takes it out of his hand.

SCENE:714/2 INT. RACHEL'S DOWNSTAIRS. DAY (08.20)

Vicki by herself playing with the doll Pauline

bought her from Grant. It is talking Japanese.

SCENE:714/3 EXT. THE SQUARE. DAY (08.30)

Nobody but nobody about. Curtains closed... a

square in repose... and then... suddenly the

voice of Sharon can be heard resounding from

the Vic. 'You've done what?'

SCENE:714/4  EXT. THE SQUARE. DAY (08.30)

Upstairs in the Vic an almighty row has broken
```

out. Gradually we learn that Grant has booked this day to marry Sharon at eleven o'clock that morning, but this is the first she has heard of it. Sharon is not best pleased. She's refusing to go for a start. Phil (*Grant's brother)* keeping out of the way... goes and answers the door.

SCENE:714/5 INT. VIC UPSTAIRS. DAY (08.31)

Phil lets in the hairdresser Grant has booked for Sharon.

SCENE:714/6 INT. VIC UPSTAIRS. DAY (08.31)

The crockery is now flying about. Sharon seems impossible to pacify. Phil, poking his head round the door saying her hairdresser is here, doesn't help either. The whole thing has very quickly reached an impasse. Phil tells Grant there's another problem. Ian was meant to be here first thing with the food and he hasn't shown. Phil, despite Sharon saying she's not getting married, is despatched to try and find Ian.

SCENE:714/7 EXT. THE SQUARE. DAY (08.35)

Phil tries to get a response from Ian's flat,
but only succeeds in getting a response from
Kathy. Phil tells her about Grant and Sharon's
impending marriage. Kathy in turn tells Phil
she spent most of Christmas Day looking for
Ian. He eventually rang and told her not to
worry.

SCENE:714/8 INT. VIC UPSTAIRS. DAY (08.40)

Grant tries talking to Sharon, and even though
the heat of the temper's gone, she still feels
cheated and insulted. This isn't how she
envisaged her big day. What about her family,
what about her friends? No – she won't go
through with it.

SCENE:714/9 EXT. MEAL MACHINE. DAY (08.45)

Phil is knocking on the door of the Meal
Machine, but is getting no reply.

SCENE:714/10 INT. IAN'S OFFICE. DAY (08.45)

Ian is sat by himself, his arms bandaged, the
remnants of the fire still very evident.

SCENE:714/11 INT. VIC UPSTAIRS. DAY (08.50)

The hairdresser waits patiently. Grant has
virtually given up, and in his effort to make
a dignified retreat, a vulnerable quality
appears. It seems it was his insecurity, and
his belief that Sharon would not really want
to marry him in the first place, that made him
go about it in a covert manner. Sharon can't
but warm to this, and when Phil returns to say
Ian has done a disappearing act, somehow the
situation has become so ludicrous that she
relents. There is one stipulation to her going
through with this though, and that is she
wants Michelle there. No Michelle - no
marriage. Phil, the messenger, sets off again
as the hairdresser starts on Sharon's hair.

SCENE:714/12 INT. RACHEL'S DOWNSTAIRS. DAY (0855)

Vicki, still playing with her Japanese
speaking doll. Michelle answers the door to
Phil, who tells her about the forthcoming
wedding and the fact that she is now a
witness/bridesmaid.

```
SCENE:714/13 INT. THE FOWLERS. DAY (10.00)
```

Still no telly, much to Arthur's chagrin, and

we hear how they didn't manage without it on

Christmas Day. Pete is determined to get

another for the rest of the holiday period.

Martin finds the present Arthur bought Pete:-

i.e. *The Joys of Sex*, and unwraps it. Thanks

to Mark (*Pauline/Arthur's son*), neither

Pauline nor Pete are aware of this. Arthur is

now very pleased he never gave the present to

Pete, because Pete bought him a pocket watch

for Christmas and Pauline a wristwatch. Pete

and Arthur vie to play with Martin's Christmas

present, and out of this melee Pete takes

Martin and goes looking for a replacement

television. Suddenly, Mark knows this is the

opportunity to tell his parents he has HIV. He

asks them to sit down.

This marks the end of the establishing act for this episode, an act which contains the establishment of three separate stories.

*Story One*: 'Will Sharon agree to marry Grant on Boxing Day?' is the main story of this act. It ends with her agreement. This story acts as the framing story for act one and is the main story for the episode.

*Story Two*: Mark's decision to tell his parents about his condition. The basis of this story has been established in earlier episodes and so the establishing

scenes for this story are all about the on-going relationships between people. However, we realise this is a solid story for this episode when Mark sits his parents down.

*Story Three*: Ian's problems are the basis of the third story. Scene 714/7 establishes that there is a problem with Ian. Scene 714/10 illustrates what the nature of this problem is. These two scenes set up the third story, which provides the cliff-hanger for the end of the episode where Ian sacks all his staff in a fit of anger.

In addition to these three stories, we have three scenes which set the time and place and provide some characterisation for minor characters in this episode. These are the first three scenes, with Pete asleep in the armchair, Vicki playing with her doll and an empty quiet square. It ends with an overt active question: 'You've done what?' These three scenes fulfil the establishing function for the whole episode.

By cutting away from the main story of Sharon and Grant, not only does the emotional change in Sharon become more credible, as time is allowed to pass, but the other stories are established without getting in the way of the main story's development. In terms of building a dramatic order, it is worth noting that the first main active question is settled before the second story's main active question – 'How will Pauline and Arthur react to Mark's news?' – is posed directly on screen.

This establishing sequence from one episode of *EastEnders* illustrates the role of sequences in terms of functioning as an underlining structure for the dramatic development of a narrative as a whole. With respect to this episode, we first have the three-scene sequence establishing time and place. This is followed by the establishment of the main active question and sequence, which shapes the whole of the first act of the episode. The other stories are then established around this main active question. This is only possible because the ability to parallel edit allows us to swap from one story to another by using active questions at each stage to keep the audience focused on the relevant story at the relevant time within the narrative.

**Sequences in a Feature Film**
In terms of feature films, however, where characters have to be introduced to audiences for the first time and stories cannot be concluded in another episode – leaving aside the question of sequels – the nature of sequences follows a slightly different pattern.

This example is based on a simple, linear narrative of approximately ninety minutes to two hours in length. The sequences described in the following model are the major sequences of the film. It is a schematic model to illustrate the fact that this pattern of sequences can be found in innumerable feature films, and I will leave you to analyse one of your own favourite films to see how it fits.

a. *Opening sequence*
   Establish the setting, the genre and the initial protagonist and their world.
b. *Introduce main character/s*
   Establish main story – protagonist and their problem.

c. *Introducing secondary story*
Establish existence of second story and main second character, often antagonist, and their problem.

d. *Development of initial problems*
The main story dominates and takes on a new dimension as the initial problem works towards a resolution. This sequence builds the main characters into engaging characters.

e. *The first crisis*
The initial solution to the main story problem and the actions of the secondary story bring about a crisis for the protagonist. This either brings a solution to the first problem, but creates a new problem, or the initial problem is not resolved and is compounded by an additional new problem.

f. *A pause*
Time for audience and characters to reflect on the impact of the crisis.

g. *New solutions*
The characters involved in the main story decide on a new course of action to solve their problems and proceed accordingly. This establishes a secondary goal for the main story.

h. *New developments*
The secondary story develops a new angle. The secondary character reveals a new problem, which has consequences for the main story.

i. *New complications*
Tertiary and minor stories are developed to add new problems and options to the outcome of the main story.

j. *New revelations*
The main story takes on the possibility of a different outcome. This is then pursued by the main character/s.

k. *Further developments*
The secondary story reveals further complications for the main story's resolution.

l. *The second crisis*
The characters in the main story succeed or fail in their attempt to solve their secondary goal but the resolution of the major problem remains and new problems arising from the tertiary stories are compounding the situation.

m. *A pause*
Time to reflect on the outcome of the crisis.

n. *The final solution*
The characters in the main story decide on a course of action which will resolve the outstanding major problem.

o. *First resolutions*
Minor stories are resolved, leaving only the main and secondary stories to be concluded.

p. *Secondary resolution*
The secondary story is resolved, though the possibility of a final complication is not ruled out.

q. *The final crisis*
The final resolution of the main story's problem, and the final resolution of the secondary story.
r. *The closure sequence*
Moments in which the audience is informed it is all over and this is an appropriate time to stop the narrative.

This is obviously only a major sequence breakdown; all sorts of minor sequences will exist within these blocks and in some cases between them. It is also true that in some narratives an image / scene will be inserted and developed throughout it which will not be fully explained until the climax or end of the narrative. This analysis is clearly based on understanding the function of each sequence and seeing how it works within the narrative as a whole, in the same way that functions were identified for scenes in the preceding section.

There are two things worth noting about this breakdown which may not be obvious on a first read. First, sequences 9 to 11 are where the screenwriter has the greatest freedom within the narrative and within the three-act structure as a whole. Second, though this example is a linear narrative, the need to develop secondary story sequences applies just as much in an episodic narrative as in a linear one.

The reason freedom is possible in the middle of the narrative is that the dramatic structural needs are less at this point than at any other. At the beginning, the establishing sequences have to provide all the essential information and active questions to make the narrative engaging. The closing sequences have to tie up all the loose ends and deliver the climax for the narrative to work. Therefore, it is the middle where there is space left to develop character, theme, place, secondary issues and, crucially, the minor stories. It is where you have space to address what the narrative is really about, yet all too often it is used merely to complicate the plot.

A good example of how this freedom can be used is the barn-raising sequence in *Witness*. John Book, a city detective, has been forced to hide out and recover from a gunshot wound in the middle of the Amish community in Pennsylvania. In the course of his recovery he starts to fall in love with Rachel, an Amish woman. Then one day he is invited to help build a barn in a day.

The barn-raising sequence not only provides some wonderful moments of rivalry between Book and an Amish suitor over Rachel, but demonstrates the collective power of the Amish way of life. This stands in direct contrast to the individualism of Book. Though the romance does progress within this sequence, it is the sense of community achievement and lyricism of this way of life which dominate the narrative at this point. It is in the middle of the narrative, just before the climactic sequence which leads to the end of act two.

**Sequence Functions**
These two examples – the soap step outline and the linear film structure – illustrate the essential blocking out of the sequential development of the narrative; in

essence, the step outline stage of development. Small sequences complement the major sequences but each has a distinct function.

The function of any sequence is dependent on different active questions. In order to clarify the range of functions possible within a narrative, here is a breakdown of sequence functions in relation to other parts of the matrix. These are listed in two groups: *major functions*, which relate to essential sequences within any narrative, and *minor functions*, which can be used in different places or not at all within a narrative.

## The Major Functions

• *To unite a number of story events*
The key active question at the start of any story driven sequence is 'Where are we in the story and where are we going?' Having established which story each character is involved in, sequences are built in order for the audience to follow the development of the character's story. It is the protagonist's story sequences which are the biggest sequences within the narrative.

• *To reflect the underlying dramatic structure*
This is most evident in the opening, the crises and the closure of the narrative.

The *opening* addresses 'Where are we?', 'What is the genre of film, its style?' and 'Who, or what, are we meant to be interested in?' The crises reflect the dramatic power of the three-act structure. These sequences address the major active questions which are holding the whole narrative together. These convey the spine of the plot. They provide resolutions to the active questions and raise new problems.

The *secondary story sequences* establish who the other major characters are and how their stories will affect the possible outcome of the main story. These also allow for major transitions of time and emotion within the main story through the judicious use of parallel editing.

The *closure* provides all the necessary narrative information for the audience to realise this is the end of the narrative and feel satisfied with it finishing, even if some points remain unresolved, ambiguous or act as a cliff-hanger.

• *To illustrate the main characters' transition from one crisis to the next*
This type of sequence follows a major crisis within the narrative and answers the questions about the characters' motivations and their potential for resolving the new situation and its problems.

• *To establish character*
Each major character needs not only a scene, which they can dominate, but a sequence to ensure that the audience understands they are important, why they are important and who they are.

## The Minor Functions

• *To reflect the style of the film*
The opening sequence of any narrative establishes its style. However, the style

needs to be reinforced throughout the narrative. Therefore, within an epic adventure there is the need to have epic scale sequences at regular intervals to sustain the emotional scale of the drama. Equally, a lyrical narrative needs sequences which reflect the lyrical qualities of its content.

• *To convey the passage of time*
Extremely useful when a pause is required in the action but also essential if the narrative has made a time jump which is not referred to in the dialogue.

• *To establish locations*
Any major change of location usually requires a short sequence of shots or scenes which establish for the audience where it is.

• *To develop and use minor characters*
The distinction between minor and major here is based upon the amount of narrative time each one occupies. Clearly some minor characters relate the key piece of narrative information, or discuss the theme, or act as the catalyst for all the action – all of which have a major dramatic function, but this does not make them major narrative characters.

Whole sequences may be developed around a minor character, especially in the character development sequences of the main and secondary stories. These can be used to allow another side of the main character/s to be discussed and/or developed.

These sequences are extremely useful as they allow character development to take place while the main stories are held in suspense. They are also used to illustrate or discuss the main themes of the narrative. Yet we do not miss these minor characters when they are gone, as they are not essential to the main stories.

## The Foundations of the Plot

These three blocks of dramatic action – the shot, scene and sequence – form the basis of any plot construction. However, their mere existence does not mean a narrative will work or explain why some sequences are weaker than others.

Plot, like all the other elements of screenplay, is dependent for its effectiveness upon story, theme, form, style and especially genre to fulfil its function within any given narrative. Even so, there are particular problems which are related to plot alone which appear in many screenplays and screenworks. The following provides an overview of these.

1. *No coherent dramatic development*
This arises from one or more of the following situations.
   • The essential active question has not been posed clearly enough.
   • The various stories are not developed throughout the narrative to deliver a coherent and emotionally satisfying climax and closure.
   • The various stories are developed unevenly, resulting in the lack of any obvious dramatic form.

   All of these result in an incoherent screenplay which appears to lack direction and is difficult to focus on in terms of theme and/or stories.

2. *Lack of variety in the pacing of sequences across the whole narrative*
Variety in the length of sequences, with a general rule of building shorter, faster, sequences towards the end of the narrative, ensures the emotional engagement is varied throughout it.

3. *Lack of significant active questions*
Every moment in a narrative contains, or is contained by, an active question. The problem is ensuring that with all this activity the significant active questions are given enough weight and stand out from the small questions which last only a few seconds or the length of a scene.

The way to achieve this is to establish the sequence question in the opening of the sequence and answer it at the end of the sequence. Also ensure that all minor, i.e. non-major, stories' questions are resolved within the scene or sequence in which they are posed. End scenes on active questions which will be answered within the next scene or are to be carried over several other scenes.

4. *Scenes are all the same length*
Variety in and of itself is a major means of ensuring a narrative remains watchable. Ensuring that long scenes are not written next to each other and that a series of short scenes does not go on too long before a pause are two basic rules which will help you achieve this.

5. *Little effective use of parallel editing*
Cutting from one story to another within the narrative and from one character to another within a scene will ensure the audience is asked to keep a number of active questions in its head, and therefore, stay with the narrative to look for answers.

These technical problems will undermine a plot but even if they are solved could still leave the four major plot problems unanswered.

## 1. It is too predictable
This essentially arises from not developing enough credibly different outcomes to the solutions pursued by the main characters and ensuring the resolutions are not seen, in advance, as the most likely outcome.

We all know at the start of most stories what the likely outcome is and in some genres it goes without saying that the protagonist triumphs at the end. The point is to keep the audience from seeing how, and under what circumstances, even this most predictable of outcomes is achieved.

This is the most important plot issue to be tackled at a step outline or treatment stage.

## 2. The dramatic cycle of action is not rising
The final climax of the narrative must be the most dramatic moment within the whole narrative. It is where the characters face their biggest crises and where there is most at stake for all concerned.

Therefore, all the other crises and story developments must work back from this moment, forcing the dramatic action to start off at a lower level.

In disaster movies many thousands of people may be in danger at the beginning of the narrative, but the audience has not emotionally invested in them yet. At the end of the narrative there may only be a handful of people in danger but we care about each of them.

This sense of raising the dramatic stakes within the narrative does not follow a straight line.

After each major crisis there is a pause, a moment when the bigger questions are allowed to drop away before being taken up again, as indicated in the sequence breakdown above. Also the middle of the narrative focuses on the second story more, which forces the audience to take on more problems, and relate to the character/s at a different level.

This is initially tackled at the outline stage and reviewed throughout the project's development.

### 3. The characters' actions are not credible

Motivation and believability are the two assets a character derives from the plot.

'Why does a character keep tackling the problems when they keep piling up?' is the essential information the audience needs to have and it needs to be reinforced as the stakes rise.

The rational part of our mind requires that for a character to remain credible their motivations have to work every time they make a decision. We have to see them making this decision and ultimately understand why.

These are vital moments which are often missed out of the plot and render the character merely a puppet of the plot, rather than driving it.

In broad terms, these points can be identified in a treatment but the detail will have to wait until a first draft. Equally, if a character has to do certain things within the narrative, it must be clear to the audience how easy or difficult it will be for them to do it, and if they succeed, it must be believable.

This is achieved by planting key pieces of character backstory and skills into the plot prior to the action required, or immediately afterwards. This latter approach is very useful if humour is needed to offset the dramatic situation.

These aspects of plotting can be identified as necessary at the treatment stage but can only be realised in a full screenplay.

### 4. It is not emotionally engaging enough

Much of a plots emotional power arises from the genre and style of the narrative. However, it is the plot which has to deliver the potential which comes with genre expectations and stylistic tone.

Therefore, recognising the key emotions which dominate an audience's engagement with a particular genre, and thetone which has been selected, is essential to making a plot work. These are reflected in the following three aspects of the narrative.

a. *Character identification*

In terms of characters, their overall motivation and importance for an audience derive from story and theme, which provide a good solid emotional base. However, it is the characterisation which makes them distinctive and engaging.

The key to making an audience identify with a character is establishing their relationship with their world and within this reflecting some aspect of the audience's own experience.

A common method of establishing sympathy for a character is to give them an undeserved misfortune. This reflects a common sense of injustice and because the character suffers the undeserved misfortune they deserve an audience's support.

Equally, a character may be shown demonstrating power. The fear of power and its use engages the notion of what they might do with it.

Or the character might have a problem, which most of the audience has encountered or might encounter in everyday life, and seeing them deal with it engages the notion of 'they are like me'.

All of these incidents may have nothing, or little, to do with the story but establish the character as someone worth watching.

b. *The scale of emotion*

The range of emotions possible in a narrative covers everything from calm contemplation of a blue dot merging with a green space to the total shock of someone, or something, being completely destroyed. The point is clearly to identify what the scale of emotion is which will keep the audience concerned about the outcome of any particular narrative.

Knowing how far you can push a character within a narrative will tell you what the scale of the emotion is. This will then determine the range of credible actions and reactions you can use for all the characters involved in the narrative.

The scale of emotion has to match the type of narrative to be credible and dramatically effective. It is no good throwing in a big all-action climax at the end of a quiet personal drama, or starting with an inter-galactic war and then climaxing on a debate about the price of oranges.

c. *Surprise and suspense*

Surprise, obviously, arises from the use of active questions and not providing the predictable answers. Suspense arises from sub-text and is therefore dependent upon planting an expectation that something will happen, and then watching and waiting for the expected to happen.

The way in which surprise and suspense are used is dependent on the genre and the style.

However, surprise and suspense are essential for an effective plot and every scene needs to make some use of these two complementary elements of emotional engagement.

## Assessing a Plot

The various levels at which emotions are developed and responded to within the plot means that some aspects of engagement can only be tackled in the screenplay.

The major active questions are obviously essential early parts of a screenplay's development. These are the framing questions such as 'who will survive?' in a disaster movie or 'when will they finally recognise their love?' in a romantic comedy.

Problems of predictability need to be addressed from the very start of the project and continuously re-assessed as each stage is completed. Surprise and suspense work at the same pace of development and need continuous re-assessment. The emotional range will be set by the development of the idea and its agreed form. Character identification at a story, or theme, level will be set early on, but in terms of characterisation this will not really be assessable until the full screenplay is complete.

It is worth remembering the point made about outlines and treatments in 'Tools of the Trade'. These two versions of the narrative tend to be plot heavy. Therefore, anyone seeking to assess character motivation, the level of suspense/ surprise, or the overall emotional impact of a narrative at this stage will be asking too much of the material.

## Rhythm and Tempo

There are two final elements of dramatic structure which inform the creation of a plot: rhythm and tempo.

*Rhythm* is the overall pacing of a narrative. This is created by repetition of shots, the variations in the types of scenes within sequences, and variations between sequences through a whole narrative.

*Tempo* is the level of activity within scenes.

## Rhythm

The aim of rhythm is to provide a unity of experience. This is achieved through the creation of patterns within the narrative. These patterns unite all the disparate scenes of the narrative and a variety of experiences as different types of scenes are placed side by side in the narrative. It can also be used to provide a growing sense of expectation and engagement with the plot.

Rhythm works at a number of levels within a narrative. At its most basic it is about establishing a pattern of different types of scenes, for instance, short and long. These patterns can be created by dialogue versus non-dialogue scenes. In some cases this can be as simple as always breaking up two dialogue scenes with a visual scene, e.g. the opening of *Thelma and Louise*. They can also work on the basis of interior scenes versus exterior scenes.

It can work through the repetition of a scene or shot to signify a break in the stories, or a return to a similar position within the narrative, e.g. the crow flying between episodes in *Kaos*, the repetition of the monster's POV in horror films to signify their presence, the exterior establishing shots with location details in *The X-Files* and the Emperor always finding closed doors in *The Last Emperor*.

The most significant use of rhythm is the pattern of scene and sequence lengh throughout the narrative. At its most basic, for example within a video game, it

means at each level the sequence of events is longer and contains more obstacles. At its most complex, it is a series of montages broken up by longer scenes and sequences, e.g. *Ivan the Terrible, JFK,* or the first half of *Chungking Express.*

However, the most crucial thing is to provide variety throughout the narrative. This allows the narrative to achieve different levels of pacing at different moments as it unfolds.

Each narrative establishes its own rhythm but there are some basic principles which apply to the creation of a satisfactory rhythm.

- The initial pattern established withinthe opening of a narrative becomes the benchmark by which the rhythm of the whole narrative will be judged. Therefore, if you know the narrative will be dominated by long slow scenes, then ensure a sequence of long slow scenes dominates the opening of the narrative, even if the very opening is a quick cut montage to establish another aspect of the narrative's dramatic parameters.
- In building to a dramatic climax there is a need to vary the rhythm, and possibly the tempo, of scenes to provide a sense of an impending event – the resolution of a major active question.
- The openings of narratives, generally, have a slower rhythm than the endings. This arises from the combination of the biggest climax being at the end and the fact that the audience knows most of the narrative information by act three while in act one it is still getting used to who or what is important and why.
- A similar dramatic build as the whole narrative happens within sequences for the same reasons.
- Varying the length of scenes and breaking up long dialogue scenes with visual moments are the two simple ways to ensure the variety that rhythm requires to work.

Rhythm is what provides the pacing across the narrative; tempo is what provides the pacing within a scene.

## Tempo

Tempo is one of the most difficult things to work on and assess prior to the completion of a first draft, as it is about the sense of balance between the action and dialogue in one scene compared with another.

The importance of tempo arises from the problem of either overloading a scene or moment – and thus making it difficult for the audience to take in all of what is being given to it – or achieving too little, in which case the attention of the audience wanders. The critical nature of these choices is probably best illustrated by a big all-action fight or chase sequence.

The aim of a good action sequence is to present as much of the action in as dynamic a way as possible. This is why you will often repeat an event from different angles, slow it down and cut from one person's perspective to another person's and back again within two fast shots, etc. In this plethora of information the aim is not that the audience will grasp and remember every shot or moment, but that the overall effect will be overwhelming and yet not confusing.

However, the moment this sequence of shots ends, the audience needs to be given time to relax and take in all that has happened because it has been overwhelmed. The problem is, you cannot stop the narrative. There still has to be something on the screen and it is a judgement call as to how long you take before the next significant piece of narrative information is provided.

If it is provided too quickly, the audience may miss it, which undermines the next piece of dramatic development. If you take too long, the audience starts to think of other things and wonders about the plausibility of what it has just witnessed.

Then there is the vital question of how long to wait before the next action scene? The answer to this can only be given by reference to the rest of the narrative and the style and genre it reflects.

Another area where the judgement of tempo is vital to the success of a narrative is in comedic material. The pacing of comedic moments within a narrative is vital to the effectiveness of the humour and comedic tone. The variation here is between the type of comedic moments, the pace at which they are delivered and style of the humour.

In a comedy drama, e.g. *The Full Monty* or *Kelly's Heroes,* the humour arises from the characters' comments in relation to the action and is placed to highlight the dramatic developments in the scene. In a sit-com, e.g. *Frasier* or *Keeping Up Appearances,* the humour arises from every action and reaction between the characters, while the pacing within scenes is about allowing for laughs and ensuring the person who is driving the scene delivers the climactic moment.

In fast-paced parodies, e.g. *The Blues Brothers* or *Peking Opera Blues,* the pacing of scenes is deliberately frenetic with the aim of overwhelming the audience with the absurdity of action based upon a genre and strong character types.

Each of these uses of tempo varies the pace depending on the genre in which they are operating and the comedic style they have adopted.

The major limitation on the pacing of scenes and sequences is the capacity of the human brain to absorb certain levels of narrative information. The two extremes of this produce either a sensation of confusion or boredom.

In a short narrative, under five minutes, these parameters have little impact as the brain adjusts to the level of the narrative and the experience is over before too much has been demanded at a level of engagement. Even so, as many short-film festival-goers will report, it is still very easy to confuse or bore in under five minutes.

The problem of confusion, or burn out, arises when the narrative's tempo is too frenetic and the rhythm does not allow any breathing spaces within which the brain can catch up with the experience. This can be illustrated in two radically different narratives, *1941* and *Prospero's Books.*

*1941* is a fast-paced comedy about the possible invasion of Southern California during World War Two. In it, almost every shot contains new visual narrative information, almost every new sequence introduces a whole new set of characters and the relentless pace of the action continues without a break for the whole

narrative. The audience preview cards suggested it was 'Too Loud'. They were not referring to the soundtrack, although that was also packed with sounds to add to the sense of overload. They were expressing the fact that there was too much going on and therefore it was impossible to enjoy the experience.

Although the humour of *1941* was intentionally fast and furious, the level of information people were being asked to retain was too much and therefore they could not engage with the narrative all the way through. Their brains had to take a rest and in those moments the sense of what was happening in the narrative and who was important was lost.

In *Prospero's Books*, a reworking of William Shakespeare's *The Tempest*, the drama was heightened by an elaborate use of sets, voiceover and a multi-layered visual style in which one screen image could contain several different moving images imposed upon each other. The result was a kaleidoscope of information and visual splendour which, if taken in small parts, just like the scenes or sequences from *1941*, worked well, but placed end to end in a continuous narrative without a break was overwhelming.

Not only did several members of the audience leave, but it was common to see people dozing in the middle of the film as their brains demanded they switch off for a moment from the strain of concentrating on this plethora of images and sound.

At the other end of the scale, boredom arises from the lack of new narrative information and the failure of the narrative to extend the intellectual engagement beyond the screen experience.

Almost every person can cite dramas, documentaries, video games, etc. which are boring because of their content, or the conclusions drawn, or weaknesses in the plot which result in a lack of engagement. The impact of rhythm and tempo, though, is most noticeable when it is taken to an extreme and becomes the essence of the screen narrative's engagement as in *Wavelength* and *24-Hour Psycho*.

*Wavelength* is a single shot forty-five-minute narrative which zooms in from a wide shot of a large loft apartment to an image of an ocean on the far wall of the loft. The effect is to make the audience very aware of the steady but very slow camera movement and the passing of time. However, after a while, most people's minds having registered that this is all the narrative has to offer and they not only start thinking about other things but wonder why the narrative had to be this long to make the point.

*24-Hour Psycho* is a gallery installation in which Stefano/Hitchcock's *Psycho* is shown on a screen at roughly two frames per second rather than at the standard twenty-four frames per second. The effect is to pixillate the action at such a slow pace that the very grain of the image, the texture of clothes, plus other *mise en scène* details and the minutiae of camera movement form the basis of narrative engagement rather than story or other narrative elements.

As with *Wavelength*, once this has been registered, the majority of people stop watching and the purpose of the narrative as a whole is lost to them. Even though this is clearly deliberate, in that most galleries are not open for the twenty-four

hours it would take to watch the film in this way, the effect would be the same even if they were. The narrative is capable of delivering a great deal – it is *Psycho* – but in this form it is reduced to a simple moving image which soon loses its appeal.

Ultimately, the decisions about rhythm and tempo are taken in the editing suite. However, if the screenwriter does not take the rhythm of scenes into account, then the director and/or the editor will end up with too little variation to work with and the rhythm of the screenwork will not work. Equally, if the tempo of all the scenes is the same, then unless the director has deliberately compensated with camera work and editing options, the narrative will fail to hold its audience.

## Bringing it all together

Ultimately the aim of a plot is to bring the audience to the climax and in so doing answer all the active questions which need answering, deliver the final crisis for all the main stories, and emotionally and rationally bring the narrative to a close. In order to illustrate the degree of complexity which can be achieved in a screenplay, I have chosen the final scenes from one of the most complex narratives of recent cinema history, *Twelve Monkeys*, written by David and Janet Peoples.

This futurist conspiracy thriller centres on the character of COLE, a criminal who has been sent back in time by a group of astrophysicists. His task is to discover who the Twelve Monkeys were and how they are connected to the emergence of a deadly virus which has killed most human beings on the planet. Cole himself is haunted by a dream in which he is a young boy who sees a man shot and a young woman stares at him intently. This dream is revealed in flashes throughout the narrative, and is set in an airport.

In his quest for the Twelve Monkeys, Cole forms a relationship with RAILLY, a young female psychiatrist who is the only person to believe his story of being sent back from the future. Unfortunately, she and Cole are not able to convince the authorities, represented by DETECTIVE DALVA, and are forced to flee, in disguise, to the airport.

JOSÉ is another criminal from the future who appears while Cole is in the airport and tells him the scientists have worked out his message and granted him a pardon. Cole is confused by all this and temporarily separates from Railly. Also at the airport is someone who is directly connected with the deadly virus.

I know it is complex, but this is the end of a one hundred and twenty-nine minute feature film, so bear with me and enjoy the following scenes (Note that this is the final draft version of the screenplay, dated 2/6/95).[3]

```
170 INT. GIFT SHOP/TERMINAL - DAY

RAILLY takes a travel book on Key West from a rack, considers
it, includes it with several magazines she's holding. She
doesn't notice MR. PONYTAIL enter the Gift shop behind her!

The P.A. System DRONES info as RAILLY nervously checks her
watch. Where's Cole?
```

She heads for the cash register to make her purchases.

MR. PONYTAIL, seen from behind, is at the cash register
already.

He sets a newspaper on the counter and searches for change.

The paper's headline screams... 'ANIMALS SET FREE' and a sub-
head... 'PROMINENT SCIENTIST FOUND LOCKED IN GORILLA CAGE'
over a photo of DR. GOINES being released from the cage and
another photo of JEFFREY, grinning triumphantly, cuffed hands
raised, making a Victory 'V' with one hand, giving the 'bird'
with the other.

Stepping in line behind MR. PONYTAIL, RAILLY checks her watch
again. MR. PONYTAIL, having paid, turns to go and RAILLY looks
up and sees his face, though it is not visible to us.

Startled, RAILLY frowns. Does she know this man?

As MR. PONYTAIL exits WE SEE HIS FACE! AND RECOGNIZE HIM
IMMEDIATELY! He's DR. GOINES'S ASSISTANT, DR. PETERS... the
man who attended RAILLY'S lecture!

RAILLY turns back to the counter as PETERS hurries off and the
CLERK rings up her purchases.

Still bothered, she glances back toward PETERS ... and
remembers!

171 INT. RECEPTION ROOM/BREITROSE HALL - NIGHT (FLASHBACK!)

                    DR. PETERS
          Isn't it obvious that 'Chicken Little'
          represents the sane vision and that Homo
          Sapiens' motto, 'Let's go shopping!' is the
          cry of the true lunatic?'

172 INT. GIFT SHOP - DAY

RAILLY, stunned by the memory, is startled as a DELIVERY MAN
SLAMS a bundle of newspapes on the counter beside her.

RAILLY'S POV: underneath the banner headline, 'TERRORISTS

CREATE CHAOS', beside a photo of RHINO in freeway gridlock, are two more photos ... DR. GOINES in the gorilla cage and a file photo of DR. GOINES in his lab.

CLOSE ON THE SHOT OF DR. GOINES in his lab. There's someone else in the picture. It's a man wearing a lab coat and a PONYTAIL!

ANGLE ON RAILLY, reacting, turning , looking for PETERS.

> RAILLY
> Oh, my God!

But PETERS is gone!

> P.A. SYSTEM
> — flight 784 for San Francisco is now ready
> for boarding at Gate 38.

173 INT. ESCALATOR/TERMINAL - DAY

COLE, face forward, rides down the escalator, trying to ignore JOSÉ, one step behind him.

> JOSÉ
> Come on, Cole, don't be an asshole.
>     (then, blurting it out)
> Look, I got orders, man! You know what I'm
> s'posed to do if you don't go along? I'm
> s'posed to shoot the lady! You got that? They
> said, 'If Cole don't obey this time, Garcia,
> you gotta shoot his girlfriend!'

COLE spins around, too stunned to speak.

> JOSÉ
> I got no choice, man. These are my orders.
> Just take it, okay?

Riding on the up escalator next to COLE, passing him... SCARFACE. In a business suit. Looking at COLE with narrowed eyes.

Resigned, COLE accepts the gun now. They've got him.

                              COLE
          This part isn't about the virus, is it?

                              JOSÉ
          Hey, man...

                              COLE
          It's about obeying, about doing what you're
          told.

The escalator has reached the bottom COLE stumbles as he gets
off.

                              JOSÉ
          They gave you a pardon, man. Whatdaya want?

Just then RAILLY calls out and COLE sees her fifteen yards
away, rushing across the lobby toward him.

                              RAILLY
          James! James!

COLE turns back to JOSÉ

                              COLE
          Who am I supposed to shoot?

Backing away, JOSÉ doesn't answer as RAILLY rushes up
breathlessly, doesn't notice him.

                              RAILLY
          James! Dr. Goines's assistant! He's
          an...apocalypse nut! I saw him a minute ago. I
          think he's involved. The next flight to San
          Francisco leaves from Gate 38. If he's there,
          I'm sure he's part of it!

Looking behind RAILLY, COLE sees from JOSÉ'S satisfied
expression as he melts into the crowd that he heard what
RAILLY said.

Abruptly, COLE is yanked away as RAILLY pulls him toward the
Security Check Points.

                         RAILLY
          Maybe we can stop him. Maybe we can actually
          do something.

                         COLE
          I love you, Kathryn. Remember that.

She doesn't hear him or see the look of doom in his eyes.

174 INT. SECURITY CHECK POINT/TERMINAL - DAY

A six year old boy passes through the magnetic arch grinning.
YOUNG COLE! Exactly as he appears in the dream!

He joins his PARENTS, who are only visible from their chests
down, and they continue along the concourse.

WE LINGER and DISCOVER DETECTIVE DALVA and AIRPORT DETECTIVE
watching TRAVELERS pass through the magnetic arch and retrieve
their bags from the x-ray machine, comparing their faces to
photos of COLE and RAILLY.

ANGLE ON AN AIRLINE SECURITY OFFICER, watching the x-ray
monitor.

ANGLE ON THE MONITOR, showing the X-RAY IMAGE of a sports bag
moving along the conveyor belt. The bag contains some strange
objects.

ANGLE ON THE AIRLINE SECURITY OFFICER, reacting.

                    AIRLINE SECURITY OFFICER
          Excuse me, sir. Would you mind letting me have
          a look at the contents of your bag?

ANGLE ON DR. PETERS, coming through the magnetic arch,
reacting.

                         DR. PETERS
          Me? Oh, yes, of course. My samples. I have the
          appropriate papers.

174A INT. END OF LINE/SECURITY CHECKPOINT - DAY

RAILLY and COLE arrive at the very long suddenly stalled line
of TRAVELERS waiting to pass through security.

                    RAILLY
        Oh, God, we don't have time for this.

ANGLE ON THE SECURITY CHECKPOINT, where DR. PETERS unpacks his
Bulls Bag, pulls out six metal cylinders along with a change
of clothes and a Walkman.

                    DR. PETERS
        Biological samples. I have the paperwork right
        here.

DR. PETERS produces a sheaf of official papers while the
AIRLINE SECURITY OFFICER examines one of the tubes, turning it
over in his hands.

                    AIRLINE SECURITY OFFICER
        I'm going to have to ask you to open this,
        sir.

                    DR. PETERS
        Open it?
            (blinks stupidly, then)
        Of course.

DR. PETERS takes the metal cylinder and starts opening it.

There's a SOUND OF VOICES RAISED behind them. DR. PETERS pays
no attention, but the AIRLINE SECURITY OFFICER turns toward
the NOISE.

AIRLINE SECURITY OFFICER'S POV: RAILLY, trying to explain
something to a SECOND AIRLINE SECURITY OFFICER.

ANGLE ON DETECTIVE DALVA and AIRPORT DETECTIVE, nearby,
interested in the commotion.

ANGLE ON DR. PETERS, oblivious to the fuss, pulling a closed
glass tube out of the metal cylinder.

                        DR. PETERS
Here! You see? Biological! Check the papers - it's all proper.
I have a permit.

                   AIRLINE SECURITY OFFICER
      It's empty!

Indeed, it looks like a sealed clear glass tube with nothing
in it.

                        DR. PETERS
      Well, yes, to be sure, it looks empty! But I
      assure you, it's not.

ANGLE ON RAILLY, at the end of the line, arguing with the
SECOND AIRLINE SECURITY OFFICER.

                         RAILLY
      Please listen to me - this is very urgent!

                SECOND AIRLINE SECURITY OFFICER
      You'll have to get in line, ma'am.

                    IMPATIENT TRAVELER
      We're all in a hurry, lady. What's so special
      about you?

ANGLE ON DR. PETERS, producing the glass tubes from the other
metal cylinders as the AIRLINE SECURITY OFFICER examines the
papers.

                        DR. PETERS
      You see! Also invisible to the naked eye.

A beat. DR. PETERS grins suddenly, opens one of the glass
tubes, and waves it under the AIRLINE SECURITY OFFICER'S
nose.

                        DR. PETERS
      It doesn't even have an odor.

The AIRLINE SECURITY OFFICER glances up, sees what DR. PETERS
is doing, and smiles as he hands the paper back to the
scientist.

                    AIRLINE SECURITY OFFICER
        That's not necessary, sir. Here you go. Thanks
        for your cooperation. Have a good flight.

Hastily, DR. PETERS snatches up all the tubes and cylinders
and shoves them back into his gym bag.

ANGLE ON RAILLY, raging as the SECOND AIRLINE SECURITY OFFICER
jabs her with her finger.

                 SECOND AIRLINE SECURITY OFFICER
        Who are you calling a 'moron'?

                            COLE
        Get your hands off her!

The SECOND AIRLINE SECURITY OFFICER stiffens for trouble.

ANGLE ON THE TWO DETECTIVES, watching the fuss, ready to get
involved. Suddenly, DETECTIVE DALVA frowns.

DETECTIVE DALVA'S POV: COLE'S mustache is slipping. COLE
senses it, reaches up to touch it, catches DALVA's look. For
half a second their eyes meet, then COLE looks away.

ANGLE ON DR. PETERS, hurrying away.

                    AIRLINE SECURITY OFFICER (o.s.)
        HOLD IT! JUST A MOMENT.

DR. PETERS freezes, turns, ashen.

The AIRLINE SECURITY OFFICER is retrieving a pair of jockey
shorts from the floor beside the search table. He waves them
at DR. PETERS.

DR. PETERS hurries back for his underpants.

ANGLE ON COLE, trying to keep his head turned away as he
confronts the SECOND AIRLINE SECURITY OFFICER.

                            COLE
        I said, get your hands off her. She's not a
        criminal. She's a doctor...a psychiatrist.

RAILLY looks alarmed at that.

ANGLE ON THE DETECTIVES, coming this way. DETECTIVE DALVA has the photos in his hand.

ANGLE ON DR. PETERS, bagging his jockey shorts, then starting hastily down the windowed concourse toward the gates.

ANGLE ON RAILLY, suddenly spotting DR. PETERS!

>                    RAILLY
>        THERE HE IS! THAT MAN! HE'S CARRYING A DEADLY
>        VIRUS! STOP HIM!

ANGLE ON COLE, following RAILLY'S look, seeing MR. PONYTAIL, THE MAN FROM HIS DREAM!

ANGLE ON DR. PETERS, frightened, glancing back, walking faster.

>                    RAILLY (o.s.)
>        PLEASE, SOMEBODY - STOP HIM!

ANGLE ON THE DETECTIVES, reaching RAILLY and COLE.

>                    DETECTIVE DALVA
>             (raising his badge)
>        Police Officer. Would you step over here,
>        please.

ANGLE ON COLE, lunging at DETECTIVE DALVA, knocking him off balance, then sprinting toward the magnetic arch and through it.

The ALARM goes off!!!

The FIRST AIRLINE SECURITY OFFICER tries to stop COLE, but COLE knocks him aside like a rag doll.

ANGLE ON DR. PETERS, fifty yards up the concourse, glancing back.

ANGLE ON COLE, pulling his pistol.

ANGLE ON THE FIRST AIRLINE SECURITY OFFICER.

                    FIRST AIRLINE SECURITY OFFICER
          HE'S GOT A GUN!

ANGLE ON AIRPORT DETECTIVE, raising his pistol at COLE.

                         AIRPORT DETECTIVE
          STOP OR I'LL SHOOT!

ANGLE ON COLE, gun in hand, sprinting along the concourse
toward DR. PETERS as frightened TRAVELERS SCREAM and dive for
cover.

ANGLE ON YOUNG COLE, standing at a concourse window, watching
a plane land, flanked by his parents whose faces we don't see.
IT'S SUDDENLY AS IF THE DREAM IS HAPPENING IN REAL LIFE!!!

THE SAME MOMENTS INTERSPERSED WITH 'NEW' MOMENTS FROM THE POV
OF YOUNG COLE who, hearing the commotion, turns just as DR.
PETERS hurries by.

DR. PETERS bumps into YOUNG COLE and reacts by pulling his
Bulls bag close to his body and calling...

                         DR. PETERS
          WATCH IT!

ANGLE ON YOUNG COLE, wide-eyed, watching...

YOUNG COLE'S POV: a BLONDE MAN, dashing up the concourse, his
mustache slipping over his lip, a pistol in his hand.

YOUNG COLE'S POV: AIRPORT DETECTIVE, aiming, looking for a
clear shot in the crowded passageway.

YOUNG COLE'S POV: a BLONDE WOMAN in flashy clothes, gaudy
earrings, high heels, and sun glasses SCREAMS...

                    BLONDE WOMAN (RAILLY)
          NOOOOOOOOO!!!

YOUNG COLE'S POV: AIRPORT DETECTIVE, firing! CRACK!

YOUNG COLE'S POV: the BLONDE MAN, shuddering, staggering, falling...

ANGLE ON YOUNG COLE, stunned, as his PARENTS try to shield him.

> MOTHER'S VOICE (o.s.)
> My God! They shot that man!

Mesmerized, YOUNG COLE watches the BLONDE WOMAN rush to the BLONDE MAN, kneel beside him, minister to his bloody wound.

YOUNG COLE'S POV: the BLONDE MAN, fatalistically reaching up and tenderly touching the WOMAN'S cheek, touching her tears. (WE'VE SEEN THIS EXACT IMAGE IN COLE'S DREAM, A POWERFUL MOMENT, UNFOLDING UNNATURALLY SLOWLY, OPENING LIKE A FLOWER.)

ANGLE ON YOUNG COLE, not able to hear the BLONDE COUPLE'S words, but staring at them as AIRPORT MEDICS arrive and push the WOMAN aside and try to save the MAN.

> FATHER'S VOICE (o.s.)
> Come on, Son – this is no place for us.

ANGLE ON YOUNG COLE, as his FATHER'S ARM drapes over his shoulder, steering him. YOUNG COLE turns to look back as he's led away.

YOUNG COLE'S POV: the AIRPORT MEDICS, exchanging glances, shrugging helplessly. It's too late. The BLONDE MAN is dead.

YOUNG COLE sees the WOMAN, her face streaked with tears, suddenly turn and look around, scanning the crowd, searching for something. The two DETECTIVES approach her, say something to her. Even as she responds, her eyes continue to scan the concourse.

ANGLE ON YOUNG COLE, being hurried toward the lobby by his PARENTS. He can't help sneaking another look back.

YOUNG COLE'S POV: POLICE, handcuffing a distracted, unresisting RAILLY. Even now, she continues to look around almost frantically. Suddenly, her gaze falls on YOUNG COLE and she reacts...

she's found what she's looking for!

ANGLE ON YOUNG COLE, reacting to the intensity of her look.

ANGLE ON RAILLY, her eyes speaking to the boy across the crowded concourse.

ANGLE ON YOUNG COLE, overwhelmed by the look.

> FATHER'S VOICE (o.s.)
> Hurry up, son.

With a last lingering look toward the mysterious BLONDE WOMAN, YOUNG COLE turns away, tears welling in his eyes. WE MOVE IN... CLOSE...CLOSE...CLOSER...on his eyes.

> MOTHER'S VOICE (o.s.)
> Pretend it was just a bad dream, Jimmy.

175 INT. 747 CABIN - DAY

DR. PETERS closes the door to the overhead luggage rack containing his Chicago Bulls bag and takes his seat. Next to him, a FELLOW TRAVELER, unseen, says...

> FELLOW TRAVELER'S VOICE (o.s.)
> It's obscene, all the violence, all the
> lunacy. Shootings even at airports now. You
> might say...we're the next endangered
> species...human beings!

CLOSE ON DR. PETERS, smiling affably, turning to his neighbor.

> DR. PETERS
> I think you're right, sir. I think you've hit
> the nail on the head.

DR. PETERS' POV: the FELLOW TRAVELER, a silver-haired gentleman in a business suit, offering his hand congenially. DR. PETERS doesn't know who this man is, but we do. It's the ASTROPHYSICIST!

> ASTROPHYSICIST
> Jones is my name. I'm in insurance.

```
176 EXT. PARKING LOT/AIRPORT - DAY

As YOUNG COLE'S PARENTS (their faces unseen) usher him into
their car, the boy looks back, sees...

176A EXT. AIRPORT/RUNWAY - DAY

A 747 ... CLIMBING INTO THE SKY.

FADE OUT:
```

I will not attempt to unravel all the stories and plot twists which lead to this ending. Instead I wish to concentrate on the elements of plotting which inform it and the power of certain moments. In order to do this I will discuss first the technical aspects of these scenes, and then the emotional and rational impact of the active questions.

**Technical Aspects**
1. Major revisions have been added even in this a late-stage revised draft. These are signified by the addition of an 'A' to the scene numbers as in 174A. This is an indication of how late in the process some revisions and changes in plot will occur.
2. The use of capitals at several points within the screenplay emphasises certain visual aspects of shots. This is unusual but I think necessary in these circumstances as so much detail is being deliberately held back or revealed by these shots, which are all taking place within the one central location, the airport.
3. The use of ANGLE ON to identify a specific shot on someone or something within a larger scene. This could have been achieved by just describing what we see. However, the ANGLE ON lends the power of visual emphasis which the screenwriter desires in the shot and the edit of this moment.
4. The use of a short flashback as an act of memory in Sc. 171. This fits with the style of the narrative which has been flicking back and forth in Cole's mind but here it is Railly's and we do not find it jarring.
5. The screenwriters' style is evident throughout the writing in terms of the editing and characterisation. However, it is also present in the use of short think moments, e.g. Does she know this man? Sc. 170, and the adjectives used to capture Young Cole's vision of the shooting.
6. Parallel editing is used to its full extent, not only to split up the action within one location and within scenes, but also across time.
   The final scene in which the young Cole is watching his older self being shot and Railly spots the younger version of the man she has fallen in love with, just as he has been killed, demonstrates just how far a screenplay can take the manipulation of time, space and characterisation in the right plot.

*Cole (Bruce Willis) in* Twelve Monkeys.
*w. David and Janet Peoples,*
*d. Terry Gilliam, p. Charles Rowan.*

**The Active Questions**

This is a conspiracy thriller and the framing question established early in the narrative is 'Who was responsible for the plague which wiped out most of the human race?' The Twelve Monkeys were established as the probable culprits.

This climax shows it was in fact someone else, and the protagonists, suddenly realising this, attempt to stop him, with tragic consequences. However, the framing story is finally resolved by the scene on the aircraft when we realise that one of the scientists who originally sent Cole back in time is on the plane and has clearly identified Peters as the culprit.

The other major active question was Cole's dream and what its significance was. This is resolved in the scene mentioned above and produces one of the most telling emotional moments within the film. The stare of Railly as she looks at the young Cole knowing what she knows and he does not, is what led him to remember this moment for the whole of his life.

The airport sequence as a whole is initially driven by the active question of 'Will Cole and Railly get away?' This is then superseded by 'Will they find Peters?' which is followed by 'Will they stop him?'

The focus is then shifted to the Young Cole and the active question which has hung over the narrative with respect to Cole's dream suddenly takes over. We then switch back to the answer of the overall framing question by seeing the scientist on the plane.

We then have the end with the closure moments of the plane leaving – CLIMBING INTO THE SKY – and a different future from the one which opened the narrative.

*Telve Monkeys* is an extremely complex narrative. I hope you found this analysis of its final moments useful in bringing together all the elements which make plotting one of the essential original elements of a screenplay.

## A final note on dramatic structures

It is fairly clear from this chapter that the shorter the form, the simpler the plot. The problem is then to deliver the emotion with such limited narrative space and

characterisation. It is this trade-off relationship which has to be carefully assessed when deciding on any dramatic structure and the complexity of plot which will be used within it.

You can tell an extremely complex tale within a very short narrative space if you use all the devices available, especially stereotypical characters and a simple single story. However, very quickly the the characters' actions become absurd and the plot pushes the characters into a comedic style.

It is this dynamic relationship between the elements of the matrix which makes any discussion of dramatic structures without a clear understanding of story, theme, style and the characterisation involved largely redundant. It is also true that the nature of characterisation and the pacing and tone of the drama are to a large extent dependent on the genre and style of the project.

## Notes

1. Troy Kennedy Martin, *Edge of Darkness*. Faber and Faber, 1990. This six episode serial won six Bafta awards in 1986.
2. The complete screenplays of *Boys from the Blackstuff* by Alan Bleasdale are published by Hutchison in their Studio Scripts series.
3. This unpublished extract is reproduced by kind permission of David and Janet Peoples, Atlas Entertainment and Universal Studios

# 7. Explorations of Genre and Style

These two elements of the narrative are the ones which an audience becomes aware of first. In many cases a genre will be the starting point for many screenworks, especially within television. However, as the previous chapters have illustrated, the engagement of any screenwork rests upon its underpinning elements and for its effectiveness upon its dramatic structures.

So what does a genre, or style, bring to the narrative, and why does a screenwriter have to make decisions about genre and style early on in a project's development? The simple answer is unity.

Any screenwork is a set of disparate images, multiple stories, thematic concerns and various dramatic strategies. The combination of genre and style provide the unifying framework for all these narrative elements. This means that as the narrative is experienced by the audience, it does not have to work out all narrative relationships from scratch; once certain known elements are established, then a series of narrative expectations and parameters are assumed to apply.

In this unifying process, genre provides the bigger narrative framework, while style works at the moment-by-moment level. Style as a working process is discussed later in this chapter. For the moment, let us concentrate on genre.

## Genre

As illustrated in Chapter 2, genres have developed and work around ways of grouping various narrative elements together. Unfortunately, this book is not able to consider all the various genres operating across the whole of the screenwork spectrum. Therefore, in order to illustrate how genre impacts on the other elements of the creative matrix, I have selected two genres – the thriller and the personal drama – to demonstrate the various relationships which do exist.

However, before we look in detail at these two genres, I wish to explore how genre can be used differently and to put in context the old problem of seeing genre as merely 'hack' writing, or a block to original screenwriting.

### Using Genre in Creating a Screenplay

When conceiving an idea most writers have a sense of the genre they wish to work in, or are at least aware of the genres they do not wish their work to be part of. However, the failure clearly to articulate a set of genre references throughout all media remains one of the major stumbling blocks in the way of you successfully using your characters and dramatic situations to reach your audience.

The heart of this problem is a misconception about originality versus familiarity in a screenwork context. Genres have in some minds been identified with the same problems that stereotypes have with characterisation – namely, that if you write a genre piece you are merely reproducing what has gone before.

Therefore, there is nothing original which can be said or done by working this way. In part, this problem is based on the lack of a clear understanding of certain genres, in particular the personal drama. However, the issue of originality in a genre context is something no one involved in the creation of a screenwork can ignore.

In order to understand how genres can be used, it is worth looking at two distinct approaches. These are the 'B-movie' and the developmental approaches to genre. Two highly successful commercial films in recent American film history illustrate these two approaches to genre – *Independence Day* and *Seven*.

*Independence Day* is a traditional alien invasion Sci-Fi genre narrative. The plot is as follows:

a. The aliens are coming – are they good or bad? Note that the answer to this is in the hands of the screenwriter. In B-movies they are always bad, as this is the simpler version to work with.
b. The protagonists are attacked and only some survive. How will the survivors now defeat the aliens? Brute force is tried and fails.
c. Find the alien's weakness. Having found it, discover a way to exploit it.
d. The central protagonists set out to exploit the weakness.
e. They succeed and the aliens are defeated.

Owing to the simplicity of the plot, other elements have to be used to make the narrative effective. Hence, the use of style in the form of massive set pieces and regular action/fight sequences. In addition, the use of multiple protagonists provides for quickly recognisable types, even stereotypes, which allows for a broad spread of empathy and sympathy in terms of character identification.

In this context, most characters have only one goal – surviving the aliens. This basic goal is supplemented with minor character relationship points, e.g. proving yourself to a child, a loved one or yourself. These are minor in the sense that, once established, it is predictable that these goals will be realised, with the minimum of effort and screen time. In terms of the antagonists, they are simply characterised as evil villains out to destroy humanity. They are about as far from *ET* or the planet in *Solaris* as they could be.

Given the limited narrative time available for story and character development, dialogue is reduced to exposition and humorous characterisation. This latter usage offsets the limited types and emotionally diffuses the danger the characters are in.

The power of the narrative derives from the fear of the unknown – its thematic underpinning – which it answers with the idea that we can destroy the unknown, no matter how powerful it is. This is reinforced with a second thematic assertion – human beings united can defeat anything.

The essential aspect of this version that makes it a B-movie approach to genre is that it does not fundamentally attempt to alter any of the genre expectations. In fact, this narrative has been made throughout the history of screenworks and the only differences are the technical effects, the visual appearance and powers of the alien and the particular list of usual suspect protagonists.

Now contrast this with the developmental approach evident in *Seven*, a traditional investigative thriller. The plot is as follows:

a. A murder is committed. The active question is 'Who did it?' The second question is 'Why?' The answer to the second question is not one of the standard motivations, i.e. greed, revenge, envy or jealousy.

b. The protagonists set out in pursuit of the killer. They are a partnership rather than a solitary individual.

c. A string of murders follows. These are overtly thematically linked, i.e. the seven deadly sins.

d. The partners are seen to operate differently in the face of the mounting mayhem. One of them is seen to be losing control of the situation. The other seeks answers in books and breaking rules of confidentiality.

e. They discover who the antagonist is and nearly capture him.

f. The antagonist gives himself up but offers an answer to the final murder he has committed.

g. The antagonist now works on the mind of the protagonist who is losing control and sets up the final confrontation.

h. The protagonist, who has been targeted by the antagonist, is goaded into exacting revenge and kills the antagonist.

The variations on the genre are fairly obvious. The use of two protagonists is common within television series and serials but the lone protagonist is the norm in the one-off investigative thriller. The characterisation of the two policemen is standard – older reliable type, young innocent type. However, to this is added the bookworm quality of the older character, while the young one is a country policeman on his first job in the city. The latter is something which has been done before, though played slightly differently here in that he is not seen as a smart 'hick' in this narrative.

Dialogue is used not only for exposition but for developing the theme and the underlying motivations of the characters. The motivation for the murders is not the norm but an intellectual puzzle set to challenge the very nature of the society the antagonist finds himself in. This is, in turn, a reflection of the society the audience is in. The antagonist is not finally cornered but gives himself up – a major plot variation from the norm. The final confrontation is a battle of wills not of firepower or physical prowess – again a major departure from the norm.

This level of variation from the genre works because of the power of the essential plot framework and the balance struck between the other narrative elements and the expectations of the genre.

The essential changes in the genre are as follows:

1. A tragic tone is adopted instead of the standard dramatic tone. This leads to the failure of the protagonist in the climax and why no one is saved, as is the case in the dramatic approach.

2. The young naive policeman is given a personal drama characterisation. His dramatic arc is enormous compared with most detective protagonists, and even compared with his partner. He starts off an innocent believing he can solve crime

and protect people. He ends up killing someone who is defenseless, having failed to protect anyone, including his own wife.

3. An expressionist style is used instead of the naturalist style. This reflects the scale of the personal drama arc described above and the theme of the piece.

4. Thematically it is about a desire for justice but it overtly questions the value system within which justice is being sought. Do we value consumption, sexual satisfaction, physical beauty, etc. over life itself?

*Seven* is an investigative thriller but it has not been made before. It is a contemporary piece which relates directly to its culture and time and uses genre expectations to challenge the thematic and emotional basis of the audience's choices.

The degree to which the audience is aware of this is debatable, given the thriller aspect of the engagement with the narrative. However, I am in little doubt that most people were asking themselves questions about the nature of American society after seeing this narrative and not just thinking this was a simple 'detectives getting the bad guy' routine.

These two highly contrasting approaches to the use of genre illustrate that there is no one way in which to use genre within screenworks. However, it is worth noting that the developmental approach can be used any time any place – all you need is a strong sense of the contemporary culture in which you are creating. Compare this with the 'B-movie' approach, which requires a new generation who have not seen this genre before and a new level of technological effects to provide visual surprises and wonder.

Having established the variety of uses to which genre conventions can be put, let us now turn our attention to the two specific types of genre which I will use to illustrate how genres work and their relationship with other narrative elements.

### The Thriller

Before looking in detail at the ways in which genres work it is necessary to establish the basis of the thriller genre.

1. The central active question focuses on a mystery which must be solved.

2. The central protagonist/s face death – their own or someone else's.

3. The force/s of antagonism must initially be more clever and/or stronger, than the protagonist.

4. A notion of innocence must be at risk (Note that this is usually represented by a character but it may be an institution or way of life).

5. All action and characters must be credibly realist/natural in their representation on screen (Note that this is the essential boundary line between thriller and horror. In horror, the boundary of realism can be and usually is crossed).

6. Thematically, thrillers centre around injustice and the morality of individuals.

7. Narrative construction is dominated by the protagonist's point of view. Note that this varies slightly depending on type.

8. The main story is either a quest or the character who cannot be put down.

Secondary elements lead to the following types of thriller:

### 1. Relationship thriller
a. The main story is concerned with the personal lives of two or more characters.
b. The main characters are ordinary people, i.e. in the general course of their lives they do not encounter the threat of death and danger – as encountered in this narrative.
c. Betrayal is crucial to the plot.
d. Action centres on a threat to the central protagonist/s.
e. The plot is constructed from the protagonist's point of view.
f. There are a small number of victims, who die on an individual basis.

Examples: *Double Indemnity, Body Heat, Play Misty for Me, Dial M for Murder, Dead Again, Jagged Edge, Le Boucher.*

### 2. Conspiracy thriller
a. The antagonist derives his power from an institution.
b. The protagonist is an innocent in terms of the nature of the conspiracy and the world in which it takes place, and it is they who discover the conspiracy.
c. The protagonist has the skills to uncover the conspiracy.
d. The plot's central active question is, 'Who is behind certain actions?'
e. The ultimate antagonist is not revealed as being the ultimate antagonist until the third act of the narrative. This means various other characters have to act as antagonists in the early part of the narrative.
f. Victims are numerous and become victims as a direct result of the conspiracy being exposed.

Examples: *The Parallax View, Edge of Darkness, Illustrious Corpses, Tinker Tailor Soldier Spy, Three Days of the Condor, The Usual Suspects.*

### 3. Investigative
a. The protagonist is a 'professional' investigator. They may not be paid but they undertake investigations on a regular and successful basis.
b. The narrative point of view is widened to encompass the antagonist's point of view, on occasions.
c. The protagonist is forced to make moral choices and is pushed beyond their normal involvement in investigations to solve the mystery.
d. The antagonist is as intelligent and complex as the protagonist.
e. Victims are small in number but integral to the plot in terms of the stages of the conflict between the protagonist and antagonist.
f. The ultimate nature of the antagonist is not revealed until the climax of the narrative. Therefore, the earlier parts require a substantial secondary antagonist, plus at least one other significant antagonist to sustain unpredictability within the plot.

Examples: *The Maltese Falcon, Prime Suspect, Chinatown, Cracker, The Silence of the Lambs.*

## 4. Murder mystery

This is essentially a variation on the investigative thriller. c varies from this while a, b, d, e and f remain the same.

c. The protagonist remains detached from the other characters, acting mainly as an observer who even when threatened is not overtly concerned. They do not face any significant moral dilemma or change significantly in the course of the narrative.

Examples: *Murder on the Orient Express, Miss Marple Investigates, Murder She Wrote, Colombo., The Hound of the Baskervilles.*

## 5. Action thriller

a. The protagonist is a victim of the antagonist's actions.
b. The narrative point of view is widened to become an omnipotent point of view.
c. The plot is dominated by action sequences.
d. Characterisation is reduced in direct relation to the length of the narrative, owing to the demands of the action sequences.
e. The protagonist has the specific skills to undertake the tasks set him.
f. Victims may be numerous and incidental to the central dramatic conflict.

Examples: *The Fugitive, Die Hard, Speed, The Italian Job, The Hunt for Red October, Tomorrow Never Dies.*

At this point, it is worth considering the thriller genre's impact on other aspects of the matrix.

### The Thriller and Form

As you will have realised, most of the examples given above relate to one-off narratives. The one group of exceptions is the murder mystery. This points to the major impact of form on the genre. In television, where the characters have to be returned to in the numerous episodes of a series, as opposed to a serial, the characterisation changes.

Most television thrillers are investigative in nature, e.g. *The Bill, Homicide.* This presents a problem in terms of the protagonist facing large moral dilemmas and changes as a result of the dramatic conflict. If this happened every episode, then the credibility of the protagonist would soon be in doubt.

Therefore, to characterise a long-running series investigator, it is more credible to go with the detached-observer type of the murder mystery, e.g. *Colombo, Taggart,* or a large multiple cast, e.g. *Between the Lines, NYPD Blue,* which allows the changes to be paced over time and across different characters.

Given these limitations, how do you develop an original thriller character? Well, the simplest way is to move as far from the dominant norm as possible. Colombo was specifically created as the antithesis of the all-action, hard-hitting, fast-talking, gun-toting, sharp-looking policeman which dominated the screen before him. He never used a gun, there were no chase sequences, he drove a

battered car, dressed in an old raincoat and his conversations were long, but deadly, in reaching their point.

This points to the most salient aspect of characterisation within genre. The genre framework remains largely the same over time and across cultures, but the characters are very much of their time and their culture.

### The Thriller and Plot

The essence of thriller is that the main active question is kept active until the end of the narrative. Crucially, this is 'Who did it or is doing it?' In action thrillers this is often supplemented with 'How will the protagonist survive?'

In order for this to work this active question has to be posed early within the plot, while the secondary active questions pose possible antagonists, who are ultimately revealed to be only part of the problem.

Thrillers, being dependent on action-based suspense and surprise for most of their emotional impact, require very careful choices over point of view. The narrower the point of view, the easier it is to construct surprises. The wider the point of view, the more locations and opportunities for suspense occur.

In this sense, the various types range along a spectrum. This ranges from the relationship thrillers with very narrow points of view and often extremely restricted locations, through the conspiracy and investigative which have a slightly wider point of view and encompass numerous locations but usually within one area – e.g. a specific city – to action thrillers which have the widest point of view and often range over numerous locations in different places, even different continents.

This aspect of a genre's impact on plotting works at the macro level of the narrative's conception and construction. However, genre has an equally important part to play in the specific plotting of key scenes and moments within a narrative.

For example, in the investigative thriller it is crucial we stay with the investigator for most of the plot. This allows for the surprises experienced by them to be experienced by the audience at the same time. This in turn maintains a strong bond of identification with the character, even if they are not so sympathetic in their characterisation.

### The Thriller and Theme

As was discussed earlier, secondary stories – in order to maximise the dramatic impact of the stories – reflect the same theme as the main story. However, in genre terms they also become the source of the thematic issue for the protagonist.

Therefore, in thrillers it is the secondary story which raises the question of the protagonist's morality and asks them to transgress their own code of practice. This is illustrated in the secondary romance story of most relationship thrillers, the relationship with senior officers in most police investigative thrillers, a friendship with a potential suspect in most murder mysteries, and the 'buddy' or partner relationship in most action thrillers. In terms of plot, this conflict of interest reaches its climax in the final climactic sequence of the whole narrative.

## The Thriller and Style

All of the above relationships are essential for any screenwriter to understand and work with, if the thriller genres are to used to their full effect. However, it is the impact of style which is the most obvious on a first read, or experience, of a narrative and which enables the audience really to notice the difference between one thriller and another.

Relationship thrillers are dominated by an expressionist style in which everyday settings are shot to reflect the state of mind of the protagonist. Therefore, point of view shots, visions of what might have happened or flashbacks of what did, dreams sequences, nightmares are all common. The colour is saturated, providing a heightened sense of where we are and the emotional state the characters are in. This state of mind also influences the editing style. Interior locations dominate, with small rooms, and a few people acting as the backdrop for the main characters.

The conspiracy thriller is essentially a naturalist style, with the use of expressionist sequences or moments, and multiple exteriors giving it a substantially different feel from a relationship thriller. Editing is used to provide point of view sequences and expressionist moments within the narrative. Colour and locations are treated as neutral and serve only as background to the action for the majority of the narrative. However, locations are used to isolate the protagonist and few people, if any, feature in the background of most scenes.

Investigative thrillers are dominated by either a realist or naturalist style in which the everyday settings are shot to reinforce the sense that 'this could be happening now'. The camera work is not intrusive. Flashbacks are rare and generally confined to revealing backstory information of a motivational nature. The editing style is simple and paced to reflect the state of the drama, not the state of the character. The colour and *mise en scène* are used to represent the worlds of the characters. The differences in location represent the differences between characters and the needs of the plot, rather than the state of mind of the protagonist.

Note that recent investigative thrillers have started to use aspects of the expressionist style to enhance their own impact – e.g. the expressionist camerawork in *Homicide*, and the desaturated colour, dark shadows with dismal rainy *mise en scène* in *Seven*.

The murder mystery is essentially naturalist in style with no deliberately enhanced colour or camera work. The essence of the style is to not detract from the plotting, which is complex, or the performances of the key characters. The locations are often historical, lending a detached distance to the events, and supporting the intellectual curiosity which is key to the genre.

Action thrillers are essentially naturalist in style but rely heavily on editing and the scale of the action to achieve their effect. The pacing of the editing is designed to enhance the action sequences and reflect the increasing emotional stakes for the main characters. The use of locations is completely dependent on achieving a certain scale of action. The action sequences dominate the narrative.

Therefore, the style itself becomes a major contributor to the narrative and its effective engagement with an audience.

## Comparing genres

The above notes illustrate how the thriller genre works within the matrix and is influenced by, or influences, the other narrative elements. However, in order to grasp more fully how genres as a whole work, it is necessary to look at another genre and compare how these relationships change between genre.

Personal dramas is one of the most difficult genres to work in and the least understood in terms of its use as a framework for narrative development. This is in part because various types are not seen to stem from a common core, it is highly character oriented and it works on an apparently smaller scale. This latter point is the key to why it has been so seldom discussed.

In general, genre as a term of reference has been seen to be a largely cinematic concern, while personal dramas dominate television. However, in order to see the genre it is easier to look at its manifestation in a one-off linear form first, rather than in the television series form. Therefore, the following definition of the genre is based on personal dramas within feature film narratives.

## The Personal Drama

The primary defining qualities of the personal drama are:
a. A single isolated protagonist, who undergoes or attempts a major transformation. Note that the nature of this isolation is dependent on the type of genre.
b. A distinct world with which the protagonist is at odds.
c. The dominant story types are a quest or the character who cannot be put down.
d. The dramatic structure is a linear framework but often has an episodic form.
e. Thematically it is either a desire for order or the desire for validation.
f. The central character's dramatic arc is enormous compared with the changes within the characters of other genres.
g. The dominant style is expressionist but naturalism is also commonly used.

There are five types of personal dramas derived from these basic elements, which are defined by the nature of the central conflict:

## 1. The Inner Drama

Seen by most screenwriters as one of the most difficult conflicts to realise on screen, it focuses on an inner conflict of the central character.
a. The central character dominates the narrative space and is in every scene, in some way.
b. The central problem of the character drives the plot and provides the motivation for all the action.
c. The main character provides a narrow point of view on all events. The use of voiceover is common.
d. The second story is often also the main character's story. This is the mechanism by which the main character dominates the narrative.

e. Secondary characters are merely used to express the options the central character has with respect to their problem.

Examples include *Lost Weekend, My Dinner with Andre, Trainspotting, Atlantic City, Talking Heads, Raging Bull.*

### 2. The Domestic Drama

a. The main story is about the central relationship/s which is/are either familial or situational, i.e. it is not a romance.
b. The central problem for the main protagonist is that the other character/s present a threat to their world.
c. The second story has equal weight with the first, similar to a romance plot.
d. Secondary characters merely present additional problems for the main characters.
e. Locations are restricted, with much action set in interiors.
f. Thematically it centres on a desire for validation.

Examples include *Only Fools and Horses, Clerks, Terms of Endearment, My Life as a Dog, Short Cuts, On Golden Pond,* and most soaps.

### 3. Rites of Passage

These are essentially a variation on the domestic drama with c,d,e and f remaining the same but the focus in a and b being slightly different.

a. The main story centres on a teenager or a group of teenagers who wish to be seen as more adult.
b. The central problem is seen as a challenge to the protagonist's current way of dealing with their life/situation.

Examples include *Stand By Me, The Year My Voice Broke, Muriel's Wedding, Gregory's Girl.*

### 4. The Communal Drama

a. The main story places the protagonist at odds with the community.
b. The second story reflects the same conflict.
c. The plot is driven by the main character's desire to avoid or resolve the conflict.
d. Secondary characters reflect the acceptance of the wider community position.
e. The setting is restricted to a particular community setting but several individual locations are common.
f. Thematically, it centres on the desire for validation.

Examples include *Raise the Red Lantern, A Short Film about Killing, Thelma and Louise, The Crucible, The Sexual Life of the Belgians 1950-1978.*

### 5. The Epic Drama

a. The main story centres on the protagonist's desire to change or experience a wider world.

b. The second story is a major conflict between differing cultures or value systems.
c. The plot is driven by the changing circumstances of the second story's major conflict.
d. The locations are various and are determined by the development of the major conflict.
e. Point of view is omnipresent, with many scenes not involving the main character.
f. Thematically, it centres on a desire for validation.
g. The style is dominated by naturalism with very few expressionist elements. However, as with the action thriller, the scale of events means that scale becomes a major part of the style. This impacts on locations, crowd scenes and *mise en scène* details.

Examples include *The Battle of Algiers, Gandhi, Lawrence of Arabia, The Last Emperor, Dances with Wolves, The Killing Fields, La Reine Margot*.

These types provide a solid basis for seeing how the personal drama has been used in a variety of ways to create a range of vastly different narratives. Now let us look at how as a genre personal drama works with the other elements of a screenplay.

### Personal Dramas and Form
Personal dramas dominate the series form on television, everything from *Byker Grove* and *Casualty* to *Baywatch* and *Northern Exposure*. The only major difference between them and one-off dramas is that the character arcs, instead of being completed within one narrative, are developed over several. Sometimes, in the case of soaps, they are completed over many years.

In terms of types, then, clearly the epic has become the basis of several serials, e.g. *Heimat 2, The Water Margin, Shogun* and *The Jewel in the Crown*. However, both of these points indicate that the major change from the single one-off narrative of film to the series or serial television form is that the notion of the single protagonist is invariably replaced with multiple protagonists, all pursing their own story of personal drama.

### Personal Dramas and Plot
The episodic nature of personal dramas inevitably means that the plot is more concerned with using secondary stories to frame the main story developments than in linear narratives, such as most thrillers. It also means the plot is less concerned with sustaining suspense and shock events and more with revealing backstory and changing character motivation.

The episodic nature of the plot also means that major secondary characters are often introduced late in the narrative. These characters tend to dominate whole sequences and then disappear, while other secondary characters may never dominate a sequence but will have scenes evenly spaced throughout the narrative to ensure a sense of continuity beyond the main protagonists. This use of secondary characters illustrates one of the problems with personal dramas: sustaining interest in one person's problem for any lengthy narrative.

This is overcome on occasion by placing several characters in the same situation, e.g. *The Secaucus Seven, Company of Women*. Another technique is to adopt a thematic approach and have each episode concentrate on different characters, e.g. *Rashomon, Kaos, Murder One*. In the epic type it is the use of scale which offsets this limitation.

However, if these are not realistic options then the answer has to be the combination of the backstory of the main character, the high number of incidents in which they become involved, and the world in which they live. This is evident in *Burnt by the Sun, Saturday Night and Sunday Morning* and *Thelma and Louise*.

The key to making the personal drama work is the nature of the problem faced by the main character. It has to be capable of destroying them and they must start off in a very weak position to overcome it. These two parameters combine to ensure a large dramatic arc of character development and a reason for identification at the beginning of the narrative. In addition to these two narrative elements, the character's problem must have a contemporary relevance. Therefore, it either has to have a universal human quality or address a recognised problem within the culture of its audience.

These are not issues which automatically apply to any thrillers or other genre and demonstrate why personal dramas need very careful character development and a strong sense of their time and place.

### Personal Dramas and Style
As indicated in the above notes, the expressionist style dominates the genre as a whole, with only the epic drama using naturalism as the dominant style. Historically, realism was a major style of this genre but this has declined in the recent past. Examples of this type of style are *The Bicycle Thieves, The Rise of Louise XIV* and *Kes*.

The style changes when personal dramas are moved into the everyday situation, as in 'soaps' and some serials, where a naturalist style dominates the narrative.

## Writing with Genre
This variation from genre to genre demonstrates the complex nature of the interrelationships between the various elements of the matrix and any one genre type. The key, therefore, for any screenwriter is to recognise the genre with which they are working and to understand fully its parameters in developing a screenplay. The challenge then becomes how to use genre in constructing a narrative.

### Genre Openings
At the beginning of any narrative the audience has no idea of what particular type of narrative this is going to be. Even assuming they have seen previews or reviews or publicity, most people will only have a general idea of the narrative's content and what type of thriller, romance, personal drama, it really is.

This makes the opening moments of a narrative crucial in telling the audience what specific type of narrative this one is. In particular, the audience needs to know what the genre and style parameters are. Therefore, the first images and events of any narrative inform the audience of what to expect from the rest of the narrative.

If you look back at the opening of *Edge of Darkness*, you can see how the elements of a conspiracy thriller are being set up. The opening takes place at night. Darkness establishes a sense of danger and uncertainty. It is also raining, which means that all the activity has to be taken under some pressure – few people volunteer to work in the rain. A sense of danger is explicit in the first scene with the shot of the machine gun. This is reinforced by the unidentified man on the hill and the pistol in the glove compartment.

Power is explicitly mentioned with reference to the driver swabbing the car – 'He's scared stiff of his boss'. It is then reinforced by the main scene being played out by a leader of a major trade union and two senior police officers. The content of the main dialogue scene concerns a fraud and a question of delaying or covering something up. A conspiracy is about to be uncovered or continued.

If *Edge of Darkness* were not going to be a conspiracy thriller, then some major shifts in the audience's expectations would have to be achieved given these solid foundations laid in this opening.

This example illustrates that if you do not choose the right images and events in terms of laying down the specific genre parameters of what is to follow, the audience will start with the wrong impression of the narrative. This, in turn, means that as other events unfold that run counter to the first impression, the audience will spend some time trying to work out what the real parameters are – a period of the narrative time when you may be signalling the significance of a particular character or revealing a key piece of story information. This may result in the audience missing this information and cause the whole narrative to lose its coherence.

You can, of course, use this to your advantage, especially when working with a comedic style. However, the need to lay down the parameters clearly is so paramount that if you deliberately set out to subvert the initial expectation, then screen time has to be set aside to achieve this.

## Genre Emotions

Signalling the dramatic parameters of the genre early on is just as important. For instance, in thrillers the introduction of danger and the intimation of death are crucial to the plot. This is why a murder takes place so early in most thrillers. However, in relationship thrillers where only one person's life may be at risk, this becomes problematic. This is why main characters often witness the death of someone else or attend funerals, or we see an apparently unconnected death, which is later revealed to be connected to the protagonist's situation.

Each genre has a range within which the level of surprise and suspense works for each particular narrative. Therefore, you not only need to work out what is the biggest surprise or shock you wish to use within the narrative, but how often and how many will occur. These are then used within the three-act structure to provide

a solid relationship between dramatic structure, the genre and the emotional engagement of the audience.

In some genres surprise is little more than the revelation that someone likes a particular person, while in others it is the transformation of a monster. You need to know the expectations of the genre you are working with and what its contemporary manifestation is. This is why whole genres become exhausted within a generation, as the parameters are pushed by each new version until the expectations break through the bounds of credibility and audiences reject the genre.

This phenomenon is perhaps best illustrated by the disaster films of the Seventies. These could only be returned to in the Nineties when a new generation of audience had matured and effects technology had moved on enough to present a new set of disasters.

### Genre and Style

In many discussions of genre, style has been seen as integral to genre; in the matrix it clearly operates as a distinct element of narrative construction in its own right. However, many particular genres do have dominant styles, or aspects of style, associated with them. Examples of this range from the dominance of night-time locations and fast editing in horror narratives to long-dialogue scenes in sit-coms.

In that these relationships do exist then clearly you have a choice whether to work with the dominant style associated with the genre, to add to it or to subvert it.

The most common form of subversion is to apply a comedic tone to a genre dominated by a dramatic tone, e.g. the sitcom *The Thin Blue Line* about a police station, or *Police Squad*, a parody of the police detective series. Adding the style of one genre to another has often produced some ground-breaking work, e.g. the setting and look of the sci-fi genre being applied to a horror genre to produce *Alien,* or the surrealism of horror being applied to an investigative thriller to create *Twin Peaks*.

This does not have to be done in a wholesale way either, but can be used just to add narrative variety to a strand of the narrative. Examples of this include the direct-to-camera address of documentaries in the sofa scenes of *When Harry Met Sally*, the surreal dream/nightmare in *Trainspotting*, the ghost of the husband in *Ghost*.

However, recognising the dominant style is extremely important as it is part of the expectation which comes with the genre, and you need to know in what way you are using the genre's dominant style in any particular screenplay. To use the power of genre you have to be able not only to understand the one/s you are working with, but also the original aspects you are bringing to the screenplay which will make it different.

### The Common Problems of Working with Genre

• *The basic parameters of the genre are not established early enough in the narrative.* This leaves the audience still wondering about these essential narrative questions

while the rest of the narrative information is being presented. The result is confusion and a distracted sense of not knowing what to concentrate on within the narrative.

- *The main characters are too close to type and therefore quickly become stereotypes and lose their ability to engage an audience.*

The audience will start to predict how a character will act. If the character then proceeds to do just this, the audience will be bored. Even in comedy, where so much of the fun arises from expecting a character to make a mistake, you still have to make the outcome, i.e. the final moment of the scene/sequence, an unexpected one for the audience really to stay with the narrative.

- *The genre expectations are seen to be enough to make an audience watch.*

In fact, it is the originality of the characters and plot within the genre which makes the narrative compelling.

- *Genre brings with it a huge amount of predictability.*

This is what makes it effective. Therefore, it is essential to ensure that the story outcomes are not predictable. However, all the unpredictable aspects must be credible and not just a string of unbelievable surprises.

- *A mismatch of genre and style which does not reflect the overall characterisation or story development.*

This is the most difficult to avoid, as it relates to the narrative as a whole and the balance struck between original elements, genre parameters and the style of the narrative. This balance can only really be assessed at the re-write stage and only fully assessed in the polishing of a screenplay.

Genre references are the sign posts at the start of a narrative which allow the audience to know what type of journey it is about to start. From the flashing names and figures at the start of a video game to the discordant sounds over the titles of a feature film, these signs inform the audience of what to expect.

These sign posts create expectations whether you want them to or not, and it is your ability to use them and your original development of the expectations to mark out your screenwork as distinctive and comprehensible.

## Style

Style as part of the creative matrix was outlined in some detail in Chapter 2. The aims of this section are to expand each of the points made in the creative matrix and to look at how the elements of style are captured in a screenplay.

This section is broken down into three parts.

- a list of the major types of style.
- a detailed look at what goes on the page in terms of a writer's own style, scene and shot descriptions and, last but not least, dialogue.
- a look at the impact of style on the narrative as a whole, in particular on the relationship between rhythm and tempo and the unifying qualities of tone.

## *Types of Style*

The following is an attempt to provide a comprehensive view of the various types of style currently in use within various screen narratives. The point about style is that individuals are constantly playing with it and combining certain aspects of one established style with another.

Therefore, this list, as with the primary elements of genre, is concerned with the central elements of any one style. These may be used for part or all of any one narrative, but they are distinctive in their own right and have been used to provide the style for numerous screenworks.

### Naturalism

This is the dominant style in contemporary screen narratives. The aim of the style is to use the credibility of everyday reality without adhering to everyday events or actions within the parameters of genre and plot.

a. Genre rules apply to the look and realisation of reality in the narrative. For example, sit-com homes are bigger, cleaner and less cluttered than real flats, houses or apartments. Similarly, 'mean streets' are full of rubbish, dark and moody and everyone looks threatening.
b. Dialogue reflects the tone of the narrative.
c. Events adhere to the needs of the form and the plot.
d. The editing style reflects the dramatic needs of the plot.
e. Characters and characterisation reflect the needs of the genre, the dramatic form and the theme.
f. Sound and music are used to enhance dramatic moments.

Examples of this style reflect a diverse range of narratives, e.g. *Only Fools and Horses, Friends, Tilia, Sunday in the Country, Pride and Prejudice, Grosse Pointe Blank.*

### Realist

The driving purpose of the style is to achieve the sensation of the camera having merely recorded what happened, as it happens, with all the rough edges of life showing.

a. The settings are not clean and smart, unless they are in reality.
b. The dialogue reflects the uncertainties, repetitions and unfinished qualities of everyday speech.
c. Relationships and events are deliberately left unfinished, as they are in life.
d. The editing is simple and allows the passing of time to be directly experienced in the narrative, not just inferred.
e. The pacing of sequences reflects the experience of the protagonists, not any genre or plot imperatives, although the personal drama is the most common genre in which it is used.
f. Sound is ambient, and music is minimal, if used at all.

Examples of this style are *The Bicycle Thieves, The Battle of Algiers.*

## Expressionist

The purpose of this style is to use imagery to express the emotional state of the protagonists directly on the screen. This can range from the simple representation of raw emotion to metaphorical expressions of states of mind.

a. Requires genre focused on personal states of mind, e.g. dramatic romance, psychological thrillers, personal dramas, horror.
b. Dialogue is emotionally charged and often replaced by expressionist imagery.
c. Relationships and events reflect the emotional journeys of the protagonists.
d. Editing reflects the genre.
e. Characters reflect the genre but characterisation reflects the style.
f. Sound and music play a significant part in shaping scenes and often dominate sequences within the narrative.

Note that expressionism is often achieved in certain shots or sequences within a naturalist style, rather then being the dominant style for the whole narrative. For example, Valmont's rejection of Tourvel in *Dangerous Liaisons*, and almost any point-of-view shot within horror narratives.

Examples are *Heimat, Like Water for Chocolate, Vertigo, Apocalypse Now, The Life and Death of Colonel Blimp, Yeleen, Shanghai Express, Malcolm X.*

## Surrealist

The purpose of this style is to represent reality as a distorted, unreal place where our sense of the everyday has been undermined or exaggerated in some way.

a. Surrealism dominates the look of the narrative to such an extent that it appears to break free of genre parameters, but it does adhere closely to personal dramas.
b. The dialogue is naturalist to contrast with the surreal setting.
c. The relationships and events reflect the dramatic form and the plot.
d. The editing style reflects the dramatic form and the plot.
e. Characters reflect the genre but have an absurdist quality in the characterisation.
f. Sound and music support the plot.

*Surrealism in* Delicatessen (w./d. Jean-Pierre Jeunet and Marc Caro) – with flying pigs!

Courtesy of Alliance Releasing

Note that, as with expressionism, surrealism can be used in shots or sequences within naturalist or expressionist narratives, e.g. the hell sequences in *Beetlejuice*, the castle of the beast in *La Belle et Le Bête*.

Examples include *Delicatessen, Edward Scissorhands, Roadrunner, The Nightmare before Christmas.*

### Theatrical

Arising from the desire to transfer the power of theatrical performances onto the screen, this style focuses on the actors and the nature of performance, where the screen operates as a form of proscenium arch.

a. The style dominates over the genre in terms of representation as the range of sets and camera angles are severely restricted. The main genre is personal dramas.
b. The narrative is dialogue driven, with most action being reported. The style of dialogue becomes a focal point for narrative engagement.
c. Relationships rather than events dominate the narrative, though it is usually an event which provides the climax to the narrative.
d. The editing style is restricted with the intention of capturing the performance rather than creating drama through editing.
e. Characterisation is less naturalist and closer to caricature on occasion, but the complexity of character motivation is greater owing to amount of narrative space given over to this aspect of the narrative.
f. Sound and music are minimal, unless they are integral to the performance, e.g. a musical, or the setting for the action, e.g. a party.

Examples of this style are *Secrets and Lies, Edward II, Death of a Salesman*.

### Fantastical

The purpose of this style is to make the unbelievable believable in terms of the setting or characters within the narrative.

a. This style is a necessity for certain genre, e.g. sci-fi, horror, martial arts and, of course, fantasy itself. It dominates the setting of the action and much of the action itself.
b. Dialogue is naturalist to contrast with the setting but is used sparingly and does not dominate the narrative space.
c. Relationships and events are defined by the genre but the credibility of both is reliant upon the style working with the plot and the characterisation.
d. Editing style reflects the form, the genre and the plot.
e. Characterisation is dependent on the level of fantasy. The less real the characters and the setting, the more characterisation has to reflect the style, and in the case of ghosts, etc., style becomes a defining quality of the narrative.
f. Sound and music enhance the plot.

Examples of this style are *Alien, Casper, Gulliver's Travels, Babe*.

### Observational

The aim of this style is to capture real events in real time with the minimum amount of editing or interpretation.

a. Confined largely to the documentary genres where it dominates the form of representation and the means of engagement in the narrative.
b. Dialogue is dependent on the subject/s.
c. Relationships and events dominate over plot and form requirements.

d. The editing is minimal with an emphasis on allowing events to play out to the full before leaving them.
e. Characters and characterisation are totally dependent on the subject under observation.
f. Sound and music are minimal, and though used in some instances to enhance the atmosphere, are generally not used to enhance the plot.

Examples of this style are *Titicut Follies, The Space Between Words, The Wedding*.

**Impressionist**
The purpose of this style is to present moments, impressions, of reality.
a. This style dominates the very short form of narrative and certain documentary genre, e.g. observational science programmes and promotional narratives.
b. Dialogue is minimal and used stylistically rather than naturalistically.
c. All events and relationships are determined by the form and the genre.
d. Editing style reflects a fast graphic quality.
e. Characterisation is minimal, with strong types in common usage.
f. Sound and music play a significant part in shaping the narrative.

Examples include almost any television advert, episodes of *Survival*, pop promos, e.g. *Sledgehammer*, and feature length works, e.g. *Koyaanisqatsi, Sunless*. This style is also used to create sequences within many narratives dominated by other styles. These options include montages of action, e.g. the shoot-out in *Heat*, the climax of *Battleship Potemkin*; and establishing setting, e.g. the opening of *NYPD Blue*.

## Style and What Goes on the Page
The various examples of documentation in 'Tools of the Trade' illustrate some of the limitations a screenwriter faces in terms of the use of language and layout. However, what I wish to concentrate on here is the actual screenplay itself and the different ways in which a screenwriter can approach working within these formats.

When writing a promotional screenplay with the brief that no more than five words must be used, and these must act as the slogan for the campaign, a writer has little, if any, room for manoeuvre. However, it is the choice of the five words and the focus chosen for them which makes their contribution unique and telling.

While the twenty thousand words plus of a feature length screenplay or the unlimited number of words of an on-going series may appear at first a radically different situation, in essence it is not.

The reason is that *economy* is the most vital aspect of a screenwriter's approach to the use of words, and as a result every single phrase, sentence or utterance within a screenplay is operating much as the five-word brief was. However, there are clearly some other aspects which do apply in the longer forms.

### A Screenwriter's Own Style
Most people who experience the outcome of a screenwriter's work will never actually see the screenwriter's written words, although the publication of some

feature film screenplays is beginning to change this slightly. This does not mean the choice of words is less carefully selected or worked on less than a novelist's. The reason is that the screenplay has to be read before it can be made. The people who need to read screenplays have a direct impact on what goes on the page. Thus, the old film studio convention of camera directions has disappeared as directors see them as intruding on their territory and screenplay readers find them distancing in terms of emotional engagement with the work. Equally, television schedulers' tendency to believe that people listen to television rather than watch it means that dialogue is favoured over visual reaction shots and montage sequences in television screenwork.

Where does this leave the screenwriter's style, and what things do you need to avoid when writing a screenplay? A screenwriter's style is ultimately dependent on the genre and their relationship with directors and producers. An established screenwriter with past successes to their credit will be given considerable leeway in terms of what is acceptable on the page. This goes double if they are intending to direct the work.

Assuming you are not in this position, what means are available to you to express your own voice and distinctive writing style? In terms of the former, all of the various elements in the matrix, and your distinctive way of using them. With respect to the latter, there are, in essence, a very limited number of options which relate directly to the style of the narrative you are writing.

In terms of series writing, clearly you are guided by the style of the existing screenplays. In terms of format documents or outlines, as long as the essence of the narrative is well represented, you have enormous freedom to write the document as you see fit. However, the style of the format or outline must reflect the intended style of the eventual series or feature, in order for it to be seen to lead directly to the next stage of the process. In terms of one-off narratives, the writing style must reflect the genre expectations.

In this context, it is worth noting that the opening page of many good screenplays break many of the rules of economy and put on the page something which cannot be shown on the screen. The reason is that style has to be established in the reader's mind, just as much as it does in the finished screenwork's audience's mind, and so using more suggestive language, interior thoughts and references is acceptable to launch a screenplay. This approach is then abandoned for the rest of the screenplay.

Having accepted the specific limitations of the screenplay, what other factors affect the words on the page and express the writer's style? The first one is the notion of *the shot*. All screen narratives are made up of a succession of screen images, essentially shots. Therefore, the screenwriter has to know how to imply a shot on the page. This is achieved by a number of simple devices.

a. *Each descriptive paragraph equals a separate shot.*

b. *The length of the paragraph implies the length of the shot.*
Therefore, the line 'The room is a mess' implies a brief establishing shot, while

'Numerous take-away cartons cover the floor, newspapers and magazines litter the furniture, and clothes lie in crumpled piles where they fell' implies a longer, travelling, establishing shot.

c. *Cuts are implied by the arrangement of paragraphs.* For example:

```
A car drives steadily down the rough road, passing a series
of small houses. There are no signs of life. The car passes
a TALL THIN MAN walking in the opposite direction. The Thin
Man walks on, without noticing the car. He passes several of
the houses, and then turns towards the front door of one of
them. He walks up to the door, opens it and disappears
inside.
```

Written in this form, a single shot is implied and probably from a static position, whereas the following format implies three separate shots:

```
A car drives steadily down the rough road, passing a series of
small houses. There are no signs of life.
```

```
The car passes a TALL THIN MAN walking in the opposite
direction. The Thin Man walks on, without noticing the car. He
passes several of the houses, and then turns towards the front
door of one of them.
```

```
He walks up to the door, opens it and disappears inside.
```

The first paragraph establishes the street and the car. The second paragraph implies we move with the man back down the street, while the third paragraph suggests a cut to him approaching the front door. The latter takes place immediately in front of us, not at a distance as in the first description.

The reasons for implying particular shots will be dependent on the overall style of the narrative and the tempo required within the scene. However, the reason for having the shots in the first place is because they help you reveal essential narrative information. This may be a location or character or it may be the set-up for further action in the next scene.

d. *The closeness of the shot is implied in the detail of the description.* For example:

```
The fields stretch to the distant horizon.
```

is a wide shot.

```
A smile creases her weathered face.
```

is a close-up.

They stand together, smiling at the photographer.

is a medium shot.

Variations on the framing of action can imply everything from very close-up to panoramic. The shots which require specific notation are points of view (POV) and some travelling shots, meaning that WE FOLLOW. However, these are very specific shots, and may not appear in the narrative at all.

e. *Camera movement is implied by the description of action.* For example:

EXT. PARADE - DAY

JOANNE moves through the crowd. Her face scrunches up as she squeezes between the packed bodies.

She passes a succession of people,

An OLD MAN, who smiles,

A YOUNG COUPLE in fancy hats,

A WOMAN with a screaming baby,

and a SMALL GIRL, who she nearly trips over, as she emerges from the throng into a quiet back street, with a smile of relief.

This implies a series of cuts and a moving camera following Joanne. An alternative could be:

EXT. COUNTRYSIDE - DAY

The ground is hard and stony. Its burnt red colour broken only by grey dry sticks and wisps of dead grass. Suddenly, the ground falls away revealing a wide open plain, lush in green vegetation. Birds circle overhead and a blazing sun fills the sky.

This implies one continuous travelling shot of the ground, the valley and eventually the sky.

f. *Speed of action, or editing, is implied through the choice of words and length of description.* For example:

```
EXT. CITY - NIGHT
```

A cityscape at night.

Towers of lit windows, surrounded by streams of car lights. One tower stands out, taller than the rest.

The tower is a confusing array of lit office windows.

Several rows of lit windows.

A row of lit windows.

A lit window.

Another.

And another.

And another.

Finally, through one window the fleeting vision of someone leaving an office.

The light in the office goes out.

**An alternative could be:**

```
INT. GRAINMILL - DAY
```

A gloved finger presses a green button.

A large oily cog engages another.

The sound of an old engine spluttering into life.

A pulley tenses and starts to turn.

A trap door bangs open.

Grain swirls down a giant funnel.

```
A shutter is thrown open. Sunlight pours in.

AN OLD WOMAN turns, and smiles a satisfied smile.
```

The first example has an increasing urgency and speed, which is brought to a halt on one window. Significance is implied by the halt in the fast editing and a final action. In the second example, all the shots have equal weight as this montage builds a sense of place but the final shot of the old woman smiling informs us it is her place.

Clearly the next shots in each of these screenplays may reinforce these conclusions or take us in a completely different direction. This is up to the screenwriter. The point is that all of these devices ensure you are able to communicate the visual sense and rhythm of shots to a reader on the page.

Note that the television format's extended layout of action leads to a reluctance to use montages and action sequences, as these end up sprawling over several pages and hence lose the very speed and quick juxtapositions which they are intended to generate.

In the documentary/corporate format, the two column approach makes it difficult to synchronise dialogue with a specific visual, except at the start and end of speeches. In addition, the length of a shot is almost impossible to judge from the words on the page. This leads to the editor and the writer of any commentary being the final judge on shots and lengths of scenes, etc.

The second area in which a screenwriter heavily influences the style of a narrative is in the *scene descriptions*. The layout of paragraphs and the framing of action imply the shots, but it is the overall scene description which expresses your visual concerns in terms of the subject of the screenplay.

Scene descriptions include the description of action, the scale of scenes, locations, visual characterisation, sound, colour and special effects. It is the scene descriptions which also play the most vital part in the opening of a screenplay to establish its style, as illustrated by the opening of *Shooting Fish* at the end of this section.

### What goes into a scene's descriptions?

1. *A description of the location.*
Keep it simple, economic and evocative of the style.
2. *Who is in the scene and when are they revealed to the audience?*
Only describe characters in a scene as they appear on screen. If it is the intention to reveal someone's presence only at the end of the scene, then do not describe them before this moment.
3. *How the character/s look – dominant impression/s?*
If the characters have not altered since the last scene we saw them in, this can be largely ignored. However, their attitude as expressed in terms of body language or manner of speaking should be carefully identified. This again should be economic, more 'agitated' than 'playing with papers, paper clips, running their fingers up and

down the spines of books, flicking through magazines'. The degree of detail will obviously depend on the length of time that this action is observed within the shot or scene.

4. *The action of the scene.*

Probably the most important part of the scene and, therefore, requiring the greatest amount of thought. There are no simple rules as to how to write action but there are some basic parameters.

    a. *Action relates to the narrative function/s of the scene.*

    b. *It reflects the style of the narrative.*

    c. *It conveys something which is not contained in the dialogue.*

    d. *It reflects the rhythm of the scene/sequence.*

    e. *It conveys the atmosphere of the setting.*

    f. *It expresses characters' expressions and intentions in looks and gestures.*

    Each of these parameters will impact on the scene in some way, even if only by a writer ignoring it!

5. *The basic visual framing.*

The selection of shot frames. This can vary from focussing on minute detail to emphasising a character's relationship to a landscape.

6. *Special effects (SFX)*

The essence here is to recognise what is a special effect and what is simply an aspect of set, costume or model-making. Almost any aspect of a visual image can now be generated through special effects, especially digital enhancement. However, this does not mean every image which contains something which is not part of our everyday reality is written as a special effect.

    An explosion is a special effect but in the screenplay you write, 'the explosion ignites a tongue of flame' without designating it as a special effect. Similarly, in fantasy films all sorts of creatures will appear on screen but they are not marked as special effects.

    The only time SFX is used is when the visual image contains a distortion of reality within the shot, e.g. the transformation of a human being into a creature, a hand passing through a solid wall. Note that you only describe the visual image, not how the effect is created or how it might be achieved.

## Common scene description mistakes

• *Describing what cannot be seen on the screen.*

The most obvious example of this is what someone is thinking. This can be revealed by a look or a visual juxtaposition, but just writing 'someone is thinking about X' is not screenwriting. Another example is describing what is hidden within a scene, e.g. a letter in a drawer or a person in a cupboard, when we have not had a shot of the inside of the drawer or the cupboard.

• *Overwriting.*

Scene descriptions must reflect the amount of screen time used to absorb the information. Therefore, if we are concentrating on a character in a scene rather than the visual look of the setting the scene description needs to be minimal with respect

to the setting. However, even if the action of a scene is elaborate and extensive the actual descriptions of it should be economic and simple.
• *Failing to provide any indication of shots.*
The most obvious example of this is a scene description at the start of the scene, which describes the whole of the location and who is present, but adds nothing more within several minutes of dialogue.
• *Providing a jumble of implied shots with no sense of the editing or visualisation on the screen.*
• *Failing to reflect the style of the narrative.*
If it is an action thriller, then the description of action and images should be sharp, active and surprising. If it is a reflective observational narrative, the descriptions should be evocative, full of sustained and detailed images. If it is comic, then the descriptions should be comic. In describing the visual moments in a screenplay you express your own style and your own unique way of revealing the style of a particular narrative through imagery.

## Dialogue

This is the third area in which a screenwriter has an impact on style. The degree to which this is in the hands of the screenwriter obviously varies from screenwork to screenwork. Spoken words may play little part in a promotional video compared with a television soap opera, while in the latter the speech patterns of the characters are normally established before a new screenwriter starts on the show.

For all these variations the role of dialogue is extremely important in most screenworks and many people see dialogue as being the major contribution a screenwriter makes to the narrative. Unfortunately, this is a misconception both of the role of dialogue and of the balance being struck between the various elements of the narrative.

Dialogue for a screenwriter is the icing on the cake. It is the last thing to be worked on, and yet it is the first thing most people reading a screenplay will see, and in some cases the only thing which will interest them. The key thing to remember about all dialogue in a screenwork is that the visual context gives it its meaning.

This is a visual medium in which dialogue cannot be judged or experienced on its own. If it is, then the medium is not being developed to its full potential and the screenwork may be better suited to the stage or radio.

### The Uses and Functions of Dialogue

The following is a very brief introduction to the ways in which dialogue can be used within a screenplay and the reasons for using it at all. There are four uses of dialogue in relation to scenes and images within a screenplay.

1. *Dialogue is integral to the image.*
This is the dominant usage, where the person we hear on the soundtrack is the person seen speaking on the screen.

2. *Dialogue arises from a source not on the screen.*
This includes the classic voice over (VO) but equally significantly the off-camera

(OC) option within a scene. The most common use of the voice over is as a narrator within documentaries or as the voice of the author in adaptations of novels to the screen. The idea of a narrator is often used in personal dramas, as the protagonist looks back on previous events in their life. It is also used to demonstrate thoughts of a character, e.g. a detective in a thriller, or a person remembering certain phrases.

The off-camera device is a specific dramatic tool to focus the audience on something other than the speaker while a speech is being made; for example, watching the face of an individual, or a crowd, for a reaction to a speech rather than the person who is making the speech.

### 3. *Fragments of Speech.*

These are moments of dialogue, which when juxtaposed with other snatches of dialogue form the basis of sequences. If such moments were taken on their own they would make little sense, but juxtaposed they provide a sense of time, place or people.

Examples of this include the chat-up lines from would-be boyfriends in *She's Gotta Have It*, the doorstep auditions in *The Commitments* and almost every party or crowd scene where establishing the nature of the event is important.

### 4. *Reproduced Speech.*

The use of recorded speech, in the widest sense of this term, has been a constant aspect of narrative development throughout screen history, starting with the title and speech cards of the silent era through to whole narratives hinging on what was recorded where and by whom, e.g. *The Conversation*. This use of dialogue allows for many different ways of dealing with key expositional details.

Apart from the obvious examples of radio, television, tape recordings, answer machine messages and PA systems, screenwriters also use letters, computer screens, newspaper headlines and notice boards to reveal information.

These uses provide you with numerous options when writing a scene, but the screenwriter must use them with the knowledge as to why there is dialogue at all. The functions of dialogue, as with its uses, fall into four distinct groups.

### 1. *Providing information.*

This is not as some people assume providing information from one character to the other but providing essential information to the audience, which would be difficult or time-consuming to do in any other way.

This is generally done at the beginning of scenes and/or sequences in order to provide a context for the dramatic action which is to follow.

### 2. *Defining character.*

Dialogue is one of the most effective and efficient ways of defining a character's attitude, their relationships with a number of people and their inner motivation.

This is the *black hole* of dialogue writing. It is very easy to fall into the trap of writing wonderful 'characterful' speeches without advancing the character, the stories or the audience's understandingof them.

3. *Establishing active questions.*
A character's next steps in the development of their story are often conveyed in dialogue, especially at the ends of scenes and sequences.

The reason for this is that it is efficient. One line often establishes a question which underpins the action of several scenes, and the last line of a scene, if shot and delivered correctly, will remain in an audience's mind for some time.

4. *Establishing ambience.*
Dialogue can express the essence of a location or a certain group of characters very effectively and is thus used to establish the setting, or ambiance, of the action.

The danger here is to write too much of it. A couple of lines is usually more than enogh to convey the ambience of any location.

These functions show the ways in which dialogue is used within screenworks but they do not, in and of themselves, point to what makes good dialogue.

## Creating Good Dialogue

1. *It has a clear dramatic function.*
Why write a line of dialogue, if there is no reason for it to exist within the narrative?

2. *It relates to the visual aspect of the moment.*
All dialogue in a screenwork exists in conjunction with a visual or several visual images. This juxtaposition is what makes dialogue for radio and the stage so fundamentally different from dialogue for the screen.

The decision of what shot to use is just as important as what action to show in defining the impact of dialogue. This is ultimately up to the director to achieve, but you have to make the intention of the image and dialogue juxtaposition clear in the first instance.

3. *It is character specific.*
The impact of characterisation on dialogue is enormous and should be reflected in every line written. Even in a voice over commentary, where we never see the narrator, the tone, speed, style of language and the use of phrases will work better if a sense of the narrator's character is present in the commentary writing.

In a dramatic situation the dialogue has to come from the character in that moment. This is achieved by understanding the character's intention/s, the events which preceded the line, and who they are talking to. In addition, the actual words used should reflect the character's background, skills and overall worldview.

4. *It is economical.*
Speeches are short and to the point. Even in long scenes the individual exchanges are generally one or two lines each. However, there are exceptions to this rule and it is worth noting the two most important.
  • Introductory monologues – speeches which introduce us to a whole world with which we are not familiar, either because it is not contemporary or it is outside our everyday experience.

- Motivational monologues – an instance which reveals why a character is about to embark on what seems to be a major problem, which under other circumstances they would probably avoid.

The trick with motivational monologues is either to give them to a secondary character, who we therefore know little about and who provides the context for the protagonist's action; or to put the protagonist in a situation where they cannot progress without explaining their action to someone else.

A commentary, which is essentially a monologue, is written as if the visuals were the response in a dialogue, and the same basic rules of dramatic structure, short sentences, etc. still apply.

5. *It reflects the style of the narrative.*
If the characterisation is right in terms of style, then thi logically follows. However, many minor characters come and go within screenplays, and if their dialogue is not in tune with the overall style it can undermine the unity which the narrative needs to achieve its full impact.

6. *It delivers only what the action and visuals cannot.*
Writing shots, scenes and sequences which convey all the essential narrative information without dialogue is the primary reason for screenwriting, as opposed to radio, novel or stage writing. Therefore, one of the real tests of good dialogue is that it is used sparingly, no matter how well written.

One image can convey a thousand words, and there are moments within a screen narrative when no ords would be adequate and it has to be left to the visuals to convey the intention.

7. *It is speech, not prose.*
Human beings do not speak as they write, and dialogue has to reflect the broken phrases, lack of subjects and all the other amendments we make to language from the written page to the spoken word.

## Dialogue Scene Questions
All of the above relate to the overall assessment of dialogue within a screenplay. The following points relate to the specifics of a scene and how dialogue works within it: it assumes that you have decided there will be dialogue in the scene and that the style of the narrative is already worked out.

- *What are the essential story points which have to be covered?*
Does the audience need to know something prior to the action of the scene? Is this essentially an expositional or character scene, and how can all the information be revealed in a few words?

- *What is each of the characters' objectives within the scene?*
It is not enough to know what a character's overall goal or intention is; this is about what they want to happen in this scene.

• *What is each character's attitude within the scene?*
Again, it is not enough to know what a caracter's general attitude is but also what their emotional state is in this scene, and why?

• *How will the scene begin?*
What image is on the screen prior to the dialogue, or in conjunction with it, and why?

• *How will the scene end?*
Having reached the dramatic climax of the scene, how will it end, will this be a visual or a dialogue moment, and why?

Once the scene is written there needs to be a review process. This is probably best done at the next writing session, rather than immediately after the scene is written. However, here are a few questions to frame the review.

• *What is the dialogue's dramatic structure?*
   a. Is there a hook or active question posed at the beginning of the scene to ensure interest while other information is being relayed?
   b. Is there a dramatic build within the scene and is the strongest dialogue moment at the climax of the scene?

• *Does the dialogue flow, and stop, to emphasise the most dramatic moments of the scene?*
Flow is enhanced by the use of patterns, e.g. question and answer, repetition of a word or phrase from one speech to the next, agreement/disagreement, and parallel development, where one person speaks about one subject independently of the other character's response. Stops are created by non-responses, action or emphatic responses.

• *Is the dialogue aimed at influencing action?*
People talk because they want something to happen, even if it is in essence a negative action. Characters must do the same in order to keep the audience interested in their problem/s.

### Things to Avoid when Writing Dialogue
Inevitably, when writing dialogue, as with all aspects of screenwriting, there are classic problems which need to be identfied and removed from the screenplay.

1. *Characters who volunteer information for no obvious reason.* This undermines their credibility and the overall credibility of the plot.
2. *Stating the obvious in a dramatic situation.* When stating the obvious in a comic situation, delivering the expected reply when the unexpected is what is required.
3. *Unnecessary repetition of information.* It can be necessary to tell the audience something three times in the course of a narrative to ensure the majority have understood a key relationship. These repeats should be spread out and are only necessary if the relationship has not been revealed through action elsewhere in the narrative.

4. *Reverse building*. Starting the scene with a big dialogue moment and then reaching a climax which is smaller.
5. *Using the names of characters in every sentence.*
6. *Underscoring words or sentences to emphasise them.* The intention of the words should be clear from the context. It is also an insult to actors, whose ability to interpret lines is a major asset in the translation to the sreen.
7. *Parenthetical directions.* Instructing readers/actors how to read a line is rarely necessary as it should be clear from the context how the line should be spoken.

Note that the last two points may well not apply when you are writing for people who do not normally read screenplays or where the actors will have no time to rehearse or discuss their lines with the director.

### *The Most Common Mistakes of Dialogue Writing*
The following are often found in first-draft screenplays.
1. Speeches contain too much essential narrative information for the audience to register it all at once.
2. The order of information is confusing with minor set-up points coming after, or in the middle of, the big emotional development of the scene.
3. No reaction time is left to allow the emotion of the moment to register with the characters and with the audience.
4. No reaction shots are made instead of dialogue to vary the way in which narrative information is being revealed.
5. There is no action to complement, reinforce or contradict the dialogue.
6. There is no variation in the use of dialogue between scenes or within the screenplay as a whole.
7. There is no variation in tone – even in the bleakest of tragedies comic moments are necessary, as are dramatic moments in the best comedies.
8. It is not character specific – in many first attempts at screenplays, all the characters speak in the writer's own everyday voice.

All the above points are about technical problems but it is the emotional characterisation of dialogue which makes it believable and engaging.

Dialogue is also one of the few aspects of a screenplay which people remember with ease. From 'You do know how to whistle, don't ya Steve?' in *To Have and Have Not* and Harry Callahan's 'Make my day' to Bugs Bunny's 'What's up, Doc?' and Bond's 'Shaken not stirred', the art of the memorable line is one element the screenwriter is always seeking to use.

Good dialogue will always attract a reader and engage an audience's attention. The definition of 'good' is that it belongs in the screenplay and if any of it were removed, the work would be damaged. However, lines which stand out from the rest of the screenplay, even extremely characterful or linguistically extravagant dialogue, do not in and of themselves make a good screenplay. In this respect, screen dialogue is about reflecting the style of the narrative.

All the above points illustrate the importance of good dialogue and its

significance in conveying the overall style of the narrative. It is at the re-write stage where dialogue can really be assessed, as it is only at this stage that the dialogue has its real context.

## Style and Pacing

The fourth and fifth ways in which a screenwriter influences style are with *rhythm and tempo*. The need for variety in the pacing and form of scenes and sequences and the way in which basic rhythm and tempo are established have been set out in Chapter 6. The point to note here is the way in which the combination of genre and tone place distinct parameters on the rhythm and tempo of a narrative.

One of the easiest ways to see this is within the action adventure. The genre requires a series of major action sequences, with escalating danger, and yet a complex enough plot and characters to stop it appearing predictable. The action sequences clearly have to be fast-paced and aim for a sense of overload and surprise, without actually confusing the audience. Therefore, after each action sequence the audience has to be given enough time to draw breath before the ext action sequence strikes.

This means that the intervening sequences must be more character oriented and expositional but, crucially, their tempo has to be less than the action sequences. Equally, the tempo of the action scenes needs to vary within the overall rhythm of the narrative to ensure that the sense of danger varies and escalates as the narrative unfolds. In writing the sequences and pacing the scenes, the screenwriter develops the rhythm and tempo of the action thriller narrative and uses dialogue and images to slow down or off-set dramatic moments so the style is reflected from moment to moment.

Another example is the relationship between the commentary's contribution to the narrative, and the visual elements in a narrated narrative. Where the commentary contains key information, the tempo of the visual imagery needs to be slow in order not to detract from the information on the soundtrack. Where the observed material is extremely active, the commentary is excluded to avoid overload. As the commentary is providing the context for the action, this necessitates an early establishing sequence of slow tempo action. Equally, the dramatic structure means that the most active moments have to be saved for the climactic sequence by which time all the basic narrated information needs to have been given to the audience to allow the images to speak for themselves.

These two reference points within the narrative provide the framework for establishing a rhythm. owever, it is the need to break up long passages of commentary, which produce overload, that creates the need for fast tempo scenes at regular intervals. In writing the narration the screenwriter develops a rhythm by using blocks of dialogue focused on key points. As these are placed throughout the narrative, they determine the tempo of the scenes which accompany them. The other scenes/sequences, which visually provide the counterpoint, are the breathing spaces for visual engagement.

These are just two examples of how the dynamic between genre and rhythm and tempo operates within narratives. Each narrative, with its own particular genre

parameters, will reflect a particular approach to style, and in some narratives style will dominate. When the latter is the case, rhythm and tempo become an important aspect of defining the narrative's means of engagement. However, the most significant aspect of style which the screenwriter contributes to a narrative is the tone.

## Tone

Tone is the strongest element of style in influencing the other elements of the narrative.

To illustrate its impact I have selected three narratives, each with a different tone. The three narratives are *Raise the Red Lantern* (*Dahong Denglong Gaogao Gua*), *Bagdad Café* and *Babette's Feast*. Each narrative is based on a (female) stranger entering a distinct and isolated community that is unknown at first to her and the audience. In this community she tries to survive and fulfil her own desires. The narratives all address the theme of the value of individuals and fulfil the genre requirements of the personal drama. However, the characterisation, plot and style are all influenced significantly by the tone adopted by the screenwriters.

The first film, *Raise the Red Lantern*, has a tragic tone.

The tone is reflected in the very first moments of the narrative when the protagonist, Songlian, a young, impoverished, eighteenth-century Chinese woman, cries as she is told to whom she has been pledged in marriage. The full tragedy of her situation after entering her husband's fortress-like mansion does not become clear until the climax, but the sense of tragedy pervades the setting, the plot and characterisation.

A tower in the mansion houses the remains of previous generations' wives, who had affairs. The three other wives at the mansion vie for the attentions of the husband and attempt to undermine Songlian's status within the household, as does Songlian's maid, who wishes to be a wife herself. Songlian's desperate need to retain the attention of her husband and the privileges which go with it leads her ultimately to confront the maid and reveal that one of the other wives is having an affair. Both these actions lead to deaths. The latter leads Songlian into a state of madness, which is the only state of mind in which she can cope with the oppressive nature of the household.

Each character's story reflects the frustration and failure to find happiness within this community. Even the husband is seen to have failed to find it as yet another wife arrives at the end of the narrative.

To offset the depressing nature of this journey of an innocent being betrayed, corrupted and trapped by a rigid social system and her own desires and fears, the film is expressionist in its use of colour, location and sound. The opening scenes take place in warm bright spring light, the climax in stark cold winter snow. The costumes and interiors reflect the personalities of the different wives. The red lanterns, hung outside the rooms of the most favoured wife, provide a constant source of spectacle and colour. The ceremony of foot massages is accompanied by

*Songlian (Gong Li) in* Raise the Red Lantern,
*a narrative with a tragic tone.*

rhythmic tapping, which provides an aural delight and an ominous accompaniment to later action. The music of a flute unites two of the characters and Songlian with the memory of her dead father. The past recording of the third wife's opera singing also adds to the overall sound quality of this closed off world.

However, it is the use of natural silence, i.e. only ambient sound, at key dramatic moments, and at those crucial pauses within the rhythm of the narrative, which are the most telling – in particular the moment after Songlian follows the bound and gagged wife she has betrayed across the rooftop towards the dreaded tower, when she is left alone to discover the wife's fate. At this precise moment all the sound of the rhythmic tapping and choral voices stop, and silence dominates the scene, just before Songlian screams.

The tragedy of Songlian's life is that she was an innocent and strong-willed individual entering a world which was already tragically flawed. The power of the narrative is its use of all the narrative elements to reflect this tragic tone in a compelling and beautiful way.

The second film, *Bagdad Café*, has a comedic tone.

The opening scenes of *Bagdad Café* establish several of the secondary characters in an absurdist set of relationships. Then, Jasmin, a large German tourist is abandoned by her husband in the middle of nowhere in America. Their conversation is absurd and the manner of his leaving unexpected. It is a funny opening, in what is a tragic situation.

Jasmin seeks help in Bagdad, a road stop, comprising of no more than a café, petrol station and nearly empty trailer park. At first she is not welcomed by Brenda, a sharp-tongued black woman, the café owner and head of the motley band of people who live in Bagdad. However, when Jasmin discovers she cannot leave easily, she decides to clean the place up and starts to have a radical effect on this small community. This effect is played for comic moments, crucially for comic reaction shots to an action. However, the characters' stories are all revealed with pathos, all of them being slightly tragic. The visuals are used consistently to off-set the potentially tragic tone by comic juxtapositions.

Eventually, Brenda and Jasmin perform magic tricks – one of the things left by Jasmin's husband – and turn the café into a major success. In the meantime, Jasmin has a romance with a retired Hollywood set painter, wo produces ever-more revealing portraits of Jasmin. In addition, Brenda's son, and a young woman tattoo-artist, start to see life in a new light thanks to Jasmin's interventions. The narrative comes to an end when the local, pig-tailed, Native-American sheriff discovers Jasmin's permit has expired and she must leave. However, it is clear she will be coming back.

All of the characters involved are comic. They are a collection of recognisable human beings with eccentric touches, from Jasmin, in her husband's *lederhosen*, and Brenda's son, who silently plays a painted keyboard, to the absent father who watches all the proceedings from an abandoned car in the desert.

The situation is absurd – even the set painter's portraits have an absurd quality to them, but the emotions are real. They are the emotions of people who feel they have nowhere to go and have nothing more to say to those around them. Into this environment comes an outsider, who is overtly optimistic and, through a series of comic encounters, re-ignites their will to enjoy life. What is a tragic opening is overwhelmed by the comedic tone, which allows for the major character changes within the narrative.

This comic tone is reflected in the dialogue exchanges, the inclusion of numerous comic visuals and the characterisation. The overall feel of the narrative is also enhanced by the use of a haunting song and careful use of shots in framing scenes for comedic effect.

This is a very simple set of stories, in which small things matter. It is saved from being boring, too incredible or merely predictable by its comedic tone. It is also the reason the film is able to approach such a bleak situation with the warmth and openness that are ultimately the film's strengths.

The third film, *Babette's Feast*, is dramatic in tone.

Babette is a middle-aged refugee who ends up in a small, impoverished, Danish community, which adheres to an austere way of life reflecting their belief in God and their environment. She is an outsider who is welcomed first as an act of charity and then because she turns vegetable broth into something wonderful to eat.

Babette is a dramatic character. Her past is hidden at first. She is set up to be seen as a tragic figure but does not act in a tragic way and ultimately her personal values and beliefs are revealed in the climax of the narrative. The other characters are dramatic characters, with humour only arising from their actions and reactions to each other and Babette, not from their character types.

The actions are small, ranging from collecting herbs to community meetings and the final feast of the film's title. However, they all take place against a larger background which includes the beliefs of this small religious community, the turmoil of Europe in the 1880s, and the value of love, passion and self worth amongst human beings.

In this context, Babette's winning of the lottery, and her decision to create a

banquet for her benefactors, becomes large enough to sustain a 105-minute narrative. The conflict which arises from her decision is very real for the elderly men and women, who see such extravagance as going against their value system. The outcome is comic for the audience but the emotion for the characters is not.

The style is expressive, with the bitter winter conditions and the sumptuousness of the final meal being created with equal veracity. The colours are muted and cold at first, and only warm as the feast becomes more imminent. The costumes are simple and basic, the houses spartan, and the landscape windswept. However, this is offset by the key emotional moments, especially the climactic scene, when everyone walks out into the moonlit night.

Babette fulfils her dream, to re-create a meal worthy of her own skills and passion, and in so doing affects all those present, who until this moment had denied themselves access to their own dreams and simple pleasures.

*Babette's Feast* concentrates on a stranger, with a hidden desire, who encounters familiar characters in an unfamiliar setting, and in so doing produces a dramatic narrative of warmth and understanding. The power of the narrative arises from the unity of characterisation and dramatic conflict in revealing Babette's passion and the thematic value of doing something brilliantly, even if you can only do it once.

These three films from different cultures contain the same story and thematic concerns and have similar plot devices, but the tone of the narratives support radically different dramatic developments. This, I hope, illustrates the overall impact of tone in the creation of a screenplay and, ultimately, a screenwork.

I do not know when the screenwriters of the above works knew the overall tone they wished to work with. It may have arisen from the original source material. It may have been part of the overall style discussions. However, no matter at what point it arose, for it to work, it had to be integrated into the development of every aspect of the narrative.

Tone is reflected in every element of narrative representation in the finished screenwork, and you have to ensure that the screenplay provides enough clear information and direction to allow this to come off the page and into the imagination of the reader, if it is to reach your audience.

### Problems with Style

Having seen the various ways in which style can impact on a narrative, it is worth noting some of the basic problems associated with developing a style for a particular narrative.

1. *Most initial style concerns are very broad*, i.e. comedic, tragic or dramatic, but the realisation is about the particular and therefore cannot be fully assessed until at least a draft screenplay exists.
2. *A conflict often arises between various elements of the narrative which belong to different styles*. A decision then has to be taken as to which style will dominate the narrative. This may lead to favourite scenes and characters being lost, but it is necessary for the narrative as a whole.

3. *The overall tone does not match the dramatic conclusion of the plot.* The classic mistake is to have a climax which is by its very nature dramatic, tragic or comic, but the rest of the narrative does not reflect this tone in the same way.
4. *There is no discernible pattern to the rhythm or tempo.*
5. *The dialogue could be reproduced on radio with no significant loss to the narrative.*
6. *Characterisation varies too much from the overall tone of the narrative.*
7. *There is no effective use of setting, time and place, or colour and sound to enhance the style of the narrative.*
8. *There is little or no sense of imagery and editing within scenes.*
9. *Descriptions are over elaborate and provide detail rather than evoke a situation or character.*
10. *There is no sense of the shots and the visual development of the narrative on the page.*

## Working with Style

Given all the possible variations on style it would be impossible here to illustrate all the options and ways of capturing them within a screenplay. Therefore, I have chosen to illustrate how a style is established within an opening. My main reason for doing this is that the opening – as with genre – is the place where if the style is not clearly signposted then the rest of the narrative will struggle to keep up with the audience's confusion. Here is the opening scene from *Shooting Fish*, a contemporary romantic comedy, written by Stefan Schwartz and Richard Holmes.[1]

```
INT. U.K. ORPHANAGE. CLASS ROOM - DAY

The voice over is spoken by an American in his twenties, his
voice is relaxed and confident - this is DYLAN.

                    DYLAN(VO)
        I guess it all began when we were about...
        eight years old. Right from the start we both
        wanted exactly the same thing.

CAPTION : ST MARY'S ORPHANAGE OF THE TORTURED SOULS. LONDON 18
YEARS AGO.

A few children aged about eight are sat on the floor painting
and drawing. A teacher looking stern and strained is walking
around the room.

                    TEACHER
        And Samuel, show the class where you'd most
        like to grow up.
```

                          SAMUEL
              (holding up a messy scrawl of a cottage
              with a picket fence etc.)
        A small house in fields with trees and
        flowers.

                          TEACHER
        And what about you Anna?

                          ANNA
              (presenting a picture of a giant boot, a
              chimney coming out the top)
        I want to live in a big trainer.

                          TEACHER
        Oh right, like the lady in the nursery rhyme.
        I see. Now what about you ...eh, Jeremiah?

JEZ(Jeremiah) has his back turned to the teacher and is sat on
his own away from the other kids. He is an awkward looking boy
with a strange haircut.

                          DYLAN(VO)
        Now Jez, that's my business partner, has
        always put in that extra 10%.

                          TEACHER
        Show us all where you'd like to live when
        you're grown up.

Jez hesitates, then pulls up a large paper and card
construction. It is an intricate-looking model of a stately
home.

                          TEACHER
              (slightly taken aback)
        Where... er did you get this Jeremiah?

                          JEZ
        Made it.

                          TEACHER
              (looking closer)
        Are you sure you didn't steal it?

                          JEZ
    No.

                        TEACHER
    Who made this Jeremiah?

                          JEZ
    I did, and I made the lights.

Jez reaches round behind for something. The model of the house
instantly lights up. The children gasp, it's beautiful.

                        TEACHER
            (starting to sweat a bit)
    How did you..?

                          JEZ
    And I made the people.

Tiny paper figures inside the house start to vibrate and move
about. The other kids are delighted. Jez starts to take
pleasure in their interest.

                        TEACHER
            (now genuinely spooked)
    But how did you....?

                          JEZ
    I used the electric hole.

The teacher rushes round behind Jez. The socket in the wall is
primitively jammed with wires and bits of cable, all leading
to Jez's model house. Electric sparks are spitting
intermittently from the socket.

                        TEACHER
    Oh shit.

She faints. The other kids look into his house, mesmerised. We
freeze on Jez's face, smiling.

    This one scene contains all the key elements of style. The general comedic tone
is set by the comic moment at the end of the scene and the slightly exaggerated
style of Dylan's voiceover. The absurdist aspect of the comedy is established by the

*Georgie (Kate Beckinsale) in* Shooting Fish, *a contemporary romantic comedy.*

scale of Jez's model and the way in which he has made it work. This latter point is also a major part of Jez's characterisation.

The expressionist way in which this is shot, which in the finished film involves an obvious colour distortion, establishes this as an element of the film's style. In fact, the film is shot in a generally naturalist style with the use of expressionist moments to capture people's thoughts or points of view. Moving quickly from one child to the next and the clipped dialogue also establish a fast tempo within the scene, thus creating an expectation of pace.

This expectation is then followed by the next short scene, which introduces the second of the main characters. This is also shot in an expressionist style. It is the third scene which brings in the naturalist style of the rest of the narrative and starts the sequence which forms the establishing sequence for the rest of the narrative.

This opening illustrates the presence of style in every moment but also the freedom of openings. It is possible to use the very opening of a narrative to establish some aspect of the narrative which will not be returned to for some time. This not only provides variety, and raises a certain level of active question, but also means that when this style or narrative information is referred to later in the narrative, it does not feel out of place.

Style informs every single line of a screenplay and when a screenwriter knows the style of narrative they are working with it shows, not only in the choice of characterisation and plot, but also in the use of dialogue, locations and editing.

One of the great contradictory aspects of creating a screenplay is the fact that the style elements of the matrix are the ones which audiences register first and are most likely to remember, yet the actual power of these elements rests upon all the other aspects of the matrix working. Therefore, style on its own, except in very short narratives, will, at best, only fascinate and, at its worst, obscure the underlying work.

The point at which the balance is struck between all the elements is in the rewrite process.

## Notes

1.   This unpublished extract is reproduced by kind permission of Stefan Schwartz and Richard Holmes.

# 8. The Rewrite

Does anyone ever write a first version of a screenplay which does not need a rewrite? In all the thousands of accounts I have read of screenplays and writers' work and the hundreds of writers I have worked with, I have not come across one single instance of it happening. The level of complexity involved in writing a screenplay and the numerous judgement calls which have to be made in each scene, mean that it is inevitable that some parts of the first draft work better than others.

There are many myths, tall stories and ruined projects surrounding the ideas and practices of rewriting. Fortunately, I do not have the space or the time to deal with all of them here. However, I do wish to commiserate with all those writers, directors, producers and development people who have seen a potentially great project slip away from them in the rewriting process.

It is in the light of the latter situation that this chapter attempts to set out a framework for tackling a rewrite. I hope this will provide some insight into how and why screenplays are sometimes seen to be better in drafts two or three than they are in draft nine to twenty-five.

There are two fundamentally different types of rewrite. The first is the one in which a screenwriter either decides to write a speculative screenplay or, on being commissioned, is allowed to develop it on their own. The second is when people who decide which screenwork will reach the screen engage a screenwriter to achieve what they want or need.

Most film projects pass through both stages but most television and corporate projects only exist in the second form. The crucial thing here is to realise that in the second version of the rewrite process it is a discussion amongst human beings, who often have radically different relationships with the process, different levels of screen knowledge, and often next to no knowledge of the writing process. The impact of this will be discussed in greater detail in the next chapter. The purpose of this chapter is to provide a set of reference points to ensure that the screenplay achieves its full potential, regardless of the limitations placed upon it by the people involved in its creation.

In this context there is one hard and fast rule for the screenwriter. *Do not give a screenplay to someone who will be involved in its translation to the screen until it is as good as you can make it*. The only exception to this rule is if the person you are showing it to is someone you trust and you know will stick with you through the rewrite process. It is also worth remembering that all writing is, in essence, rewriting, as even the first words on the page are merely one version of what you thought you might write.

The beginning of the rewrite process is probably best undertaken as you write the screenplay. I know that some screenwriting teachers and authors advise against reviewing the material as you write for fear that you will become bogged down in

sorting out a scene or think that it is just not good enough and will abandon a project before it has had time to breathe. However, there is a real gain to be made from a certain type of review. This is the process of re-reading the previous writing session's output.

This approach allows you to do several things at once. It provides you with a way emotionally to engage with the work again before you have to write a word. This is important because several things, people and thoughts will have passed through your life since you last wrote. These now stand between you and the work when you left it. You need to be back to the same place with the work in order for it to have some emotional unity guiding it. The importance of this cannot be over-stated.

Every writer writes in a particular way at a particular time. A screenplay reflects this in small ways, from the choice of words to the sense of a character. This is why some parts of rewritten screenplays feel so different from other parts.

There needs to be a consistency throughout the screenplay for it to deliver to its full potential. The only way this consistency can easily be maintained is to ensure that at all the major rewrite stages you re-read before you write the changes. In addition, reading the last session's work on the first draft also allows you to improve the dialogue and visuals in the last few scenes before moving on to the new ones. Finally, it reconnects you with the characters and the setting and the state they are in at this stage of the screenplay.

All of this knowledge will inform what you then write and ensures that the first rewrite has already occurred before the screenplay has been finished. Throughout all this initial stage of getting it down on the page, it is crucial to keep going. Even if a scene does not work or a line of dialogue is clearly not good enough, let it be. You are going to rewrite this screenplay anyway. Having finished this first version of the screenplay, the rewrite process proper begins.

The first thing you must do is read the whole screenplay in one sitting without making notes. Actually, this is in fact the second thing you must do – the first is to take a break from the screenplay. This comes to the heart of the rewrite process. Yes, it is a writing process but it is also a reflective process and this requires time and some emotional distance. Having invested days, weeks, months, perhaps years in a screenplay, you need to be able to stand back from it in order to assess it and start the necessary process of solving its problems.

So having read it, what do you think? That it is dreadful and you wish you had never started on this idea. This is undoubtedly a common reaction. Perhaps you think it's great and just needs a few minor adjustments. However, the reality of the screenplay's worth almost certainly lies somewhere in between.

The biggest problem is to realise that it has become something which you did not think you were writing. This normally arises from one of the central character's stories taking on a different aspect as the screenplay was written, or the ending of the screenplay is not the one envisaged at the earlier stages of development.

Characters only truly come alive in the writing of the screenplay and it is at this point that their stories, attitudes and attractiveness as characters really come

into their own. However, they may not be the characters you thought they were going to be or the stories you have given them may not really work together.

The important thing is, however, that the particular version of the more general theme will now be present. At this stage you will have a fairly good idea of 'What this is really about' and this understanding becomes the yardstick by which you can judge what to keep in and what to take out in later rewrites.

At this stage you will need to make some difficult choices as you come to realise that some of your characters' stories are not necessary or do not complement the theme, and to make the screenplay more effective you will need to adjust the stories accordingly.

Another difficult problem which often arises is the realisation that the overall dramatic structure is not really working. Either the beginning is too slow or the action at each climax is not different or dramatic enough to create a strong rhythm, or there is not a strong enough sense of dramatic development.

These two problems point to the first major stage of the rewrite – the structural rewrite. Before this stage can be undertaken, though, it is worth asking if this is still the best way to tell these stories or tackle this theme.

In the writing of a first version, especially of original material, all sorts of new dramatic questions present themselves. There is always the possibility of constructing the narrative from a different point of view. Therefore, you need to assess the potential of a radically different approach. The reason that this is so important is that the rewrite process is long and tiring and you need to have faith that this is the best dramatic version to address the things you want to address within the narrative.

Central to this appraisal is the degree of originality present within the narrative. How different is it from previous screenworks and is it different enough to capture the attention of an audience?

Most of this area should have been tackled at the earlier stages of the project's development but treatment and step outlines can leave undeveloped aspects of action sequences, characterisation and style which are only exposed in the first version of the screenplay.

The point to remember at this stage is that nothing is wholly original and that so long as you know why an audience will be captivated by the screenwork, what it is really about and why you are telling it the way you are, then it will work and it will find its audience.

If you decide to reject the current version and proceed with a different narrative development, then clearly all the earlier questions about plotting, genre, etc. apply to the development of the new screenplay. At this stage it is probably best to go back to stating what the narrative is really about, then create a simple step outline and proceed from there.

This leaves the question of a rewrite of the first version. A word of warning: do not start on page one and just rewrite as you go. This method often leads to umpteen versions of a potential screenwork, all of which have something good in them but none containing all the good bits and all having major weaknesses.

The strategy for making the rewrite work, and be as straightforward as

possible, is to look at different aspects of the screenplay at each stage of the rewrite. The aim is to solve the bigger questions of structure, genre and plotting first and the finer questions of editing, dialogue and visual moments last.

## Stage One – The Structural Rewrite

On reaching the point where the structural rewrite is appropriate, the following basic questions can be asked:

1.   *Who are the main characters and how do their stories dominate the narrative?* If a large sequence of the narrative is dominated by a secondary character, adjust the storytelling aspect of this character to fit one of the major characters.

Are the characters' stories fully developed and are they placed within the narrative to create the best dramatic tension and resolution? Is the basis of the protagonist's problem, clearly placing them in conflict with the other characters? Are the forces of antagonism strong and distinctive enough for the narrative?

2.   *How is the dramatic form reflected within the overall plotting of the stories?* Does it need adjustment to ensure some parts of the narrative are not overcrowded with action, dialogue, too many new characters or too much exposition?

Are the climaxes in the right places and in the right order? Are all the stories properly developed with a satisfying sense of closure?

3.   *Are the basic genre expectations fulfilled?* If they are being developed in an original way, how is this being done? Are the elements of the genre which remain unchanged strong enough to carry the changes or has the narrative moved into a genre other than the one initially intended?

4.   *Are the central active questions clearly present throughout the narrative and are they answered in the right dramatic order?* Are all the sequences clearly developed and the uses of the three-act structure fully realised?

5.   *Does each character have a distinct dramatic function and are they all necessary?*

6.   *What is the nature of the dramatic conflict and is this fully realised in the action?*

7.   *What is the film really about?* How do the stories of each character relate to this theme and how are they different from each other?

In a narrative without distinct characters, how are the strands of narrative information developed and is the theme approached in a sufficiently oblique way to stop the narrative being predictable?

The aim of this rewrite is to arrive at a version which contains all the major stories in the right dramatic order, and uses the full potential of the dramatic conflict, sequences and the overall three-act structure. Obviously, scenes, sequences, visuals, dialogue and characters will be rewritten during this rewrite but the focus is on making the dramatic structures work.

## Stage Two – The Character Rewrite

Having arrived at a solid dramatic structure, the next rewrite addresses the characters and their motivations.

1. *Is each character clearly motivated?* This does not mean simply in terms of solving their major problem/s but in terms of how they respond in each scene, and why they relate in the way that they do to each of the other characters.
2. *Is each major character introduced and defined clearly enough?* It is necessary at some point in the narrative to ensure that all the major characters have at least one scene which they dominate and which can be seen as a defining scene for them.
3. *Are the characters emotionally believable?* This is about ensuring that at all the key points where the character/s have to make a choice a moment is given over to that decision. By the end of the narrative the audience needs enough information to understand why a character did what they did.
4. *Are they engaging enough?* Ensure that all the sympathy, curiosity, fear, wonder and / or empathy is established early enough to engage the audience.

The aim of this rewrite is to ensure all the characters are credible within the parameters of this narrative and engaging enough to make them worth watching. As with the structural rewrite, several scenes, sequences, and characters may change substantially.

## Stage Three – The Scene/Sequence Rewrite

With the overall dramatic structure and the characters in place, it is now time to look at the smaller building blocks of the screenplay. When you are considering *sequences*, the following questions will help:

1. What are the active questions which help define each sequence?Are there too many or two few at some points within the narrative, and are they varied enough in terms of their dramatic weight?
2. Are the sequences written in such a way as to generate a distinct and effective rhythm?
3. Does the dramatic nature of each sequence reflect the overall tone of the narrative and its genre expectations?
4. Are there enough visual sequences to break up any dialogue based parts of the screenplay?
5. Are there enough pauses after each major dramatic development and are they long or short enough?

With respect to each scene, the following questions will help focus attention on their *dramatic structure*:

1. Does it have at least one clear dramatic purpose?
2. Who is driving the scene?
3. Does it vary in length, tempo and dramatic content from the scenes on either side of it?
4. What are the opening and closing moments and why?
5. Does the scene have a clear dramatic structure?

6. What does it contribute to the overall style and tone of the narrative?

Within this rewrite a number of scenes may be rewritten and some scenes added or taken away to provide a stronger sense of rhythm and tempo.

## Stage Four – The Dialogue Rewrite

In essence, this is about ensuring that all the dialogue is necessary and character specific.

This can most easily be checked by reading the dialogue aloud to yourself, or by asking friends or actors to read it. However, it is also useful to go through the screenplay just reading one character's dialogue at a time. This will expose any inconsistency in how each character speaks and how the characters express their emotional changes through dialogue as their stories progress.

## Stage Five – The Polish

This is the version which concentrates on the specific descriptions of shots, cuts between scenes, all the visual moments and how the screenplay reads from moment to moment.

This is the final version of the rewrite and should put you in the position of having a strong first draft.

## The First Draft

Why is having such a well worked first draft necessary? To anyone who has been rejected out of hand or has had their work pulled apart in a workshop or reader's report, there is a fairly obvious answer – to avoid any of these consequences.

Many hundreds of screenplays are rejected by companies and producers around the world every day, mostly because they are very poorly written. Being rejected because a company cannot make your film or is not looking for a children's series or an animation short is far easier to live with – especially if they compliment you on your work – than if they reject it because it is badly written.

Do not give your work over to other people – who may not have a clear understanding of how screen narratives work – until you are clear what each moment of the screenplay is doing. The reasons for this are:

a. You will have to defend it in meetings.
b. It has to be read and understood by several different people before it will be successfully translated onto the screen.
c. You may not have a chance to meet the director or actors and if it is approved for shooting they need all the help the screenplay can give them.
d. It demonstrates your professionalism.

No one can predict how long it will take to rewrite a particular screenplay, though once a commission has been accepted, there is a deadline to be met. It is important to allow for a reasonable length of time in planning your writing regime for the rewrites.

It is also important to have good readers read your work. These are people who like the sort of screenplay you are writing, have some knowledge of screenwriting, and are prepared to have a conversation which goes beyond 'I did' or 'I did not' like this aspect of the screenplay.

Unfortunately, people who have to read it as part of their job may not be the best people to give notes. Therefore, it is advisable, as you build up a portfolio of screenplays, that you also build up a group of people whom you trust to read the work before it is shown to producers, etc.

Finding people with these skills, attitudes and interests is obviously easier in big cities or where a local television or film production company is based. However, you can watch screenworks anywhere and if you analyse appropriate ones together with someone – even someone who may have no interest in screenwriting – they will be able to discuss what is missing, or what works, in your screenplay.

The point of rewriting is to improve the work. If people give you conflicting suggestions, which is very common, choose to respond to the ones which help you convey what you want to say. Remember that you have invested a great deal in this piece of work and are therefore emotionally very close to it. A reader and the eventual audience have not made this investment and if they say it is not working for them, no amount of pleading or tales of effort will change this.

On a more optimistic note, it is also worth remembering that many screenplays which have been rejected for all sorts of reasons go on to be great screenworks. If you want to know where you are with a particular screenplay in terms of its need for a rewrite, compare it with completed great works. Then you will understand why people are rejecting it.

This brings us to the next stage in a screenplay's development – the point at which the screenplay is shown to someone else with a view to getting it made: the art and science of screen business.

# 9. Screen Business

It is impossible in the modern world to attempt to keep up with the constant changes in screenwork production, as new distribution forms come into existence, new companies come and go, and new deals are struck every day. All this may mean it is more likely, or less likely, that your favourite project will get made.

It is equally impossible for a lone writer to be aware of all the opportunities that are available for new and experienced writers at any one time, even within their own country, leave alone in a global or regional marketplace.

This is where agents come in, why networking is so crucial and where the trade magazines and directories become invaluable resources for screenwriters.

In the USA the standard phrase is 'We will not look at your work unless you are represented by an agent' (or are related to someone we know, or have just won a recognised award). In the UK, most English-language speaking countries, Europe and, I suspect, the rest of the world, this attitude is not so prevalent. However, it is becoming more so as the screenplays arrive in an ever-increasing deluge on people's desks.

I wish to look at the art and science of screen business from a screenwriter's perspective. This perspective is largely restricted to the English-speaking world and a European context, owing to my own experience and knowledge. However, I suspect that the lessons that can be applied in the UK and Europe may well apply elsewhere.

## Becoming a Paid Screenwriter

The following sections address the vital areas of obtaining the first commission from a broadcaster, or a first film credit.

There are three distinct routes into film and television in the UK for a screenwriter. They are almost identical to the routes in the US, Australia and many other countries.

1. D.I.Y. – the 'Do-It-Yourself' route
2. Agents – the gatekeepers
3. Contacts – the 'by-any-means-necessary' route

Choosing which route to follow depends very much on what you want to achieve and what sort of screenwriter you want to be in the near future and in the long term.

If you want to be a film writer, then the D.I.Y. approach – which is essentially a director's approach – is still the quickest way to get recognised and to start to be paid for writing feature length screenworks.

If you want to be a television writer, then getting an agent is probably the quickest route to success.

However, the contacts approach gives you the opportunity to obtain that first commission without an agent in both TV and film.

## 1. D.I.Y.

This is the little or no money route, the home of the low-budget film-maker, the video artist and the director.

It involves writing a short or feature-length drama which can be performed or shot for little or no money. The performance or tape of the shoot is used to promote the writer's work.

This approach has been the starting point for many directors in America, less so in the UK as there is less money. For the writer, the major appeal of this approach is that you can see your work on the screen and therefore learn from it as well as have something which can be shown to people, instead of asking them to read a script.

Another tactic is to approach a worthy cause and offer to write a screenplay which will promote it, then offer to help make the film. The result is the same as above, plus you have helped an organisation you wish to support.

To whom do you show the finished work?

- Agents, script editors, development personnel – anyone who can help you with your career.
- Film schools – most of these now require a submission of a finished screenwork, but are still heavily director/writer oriented.
- Festivals – the range of these is now enormous, with new film and video festivals being created by almost every major city and town.
  It is impossible to list all the festivals and their criteria here but an annual list is published in the *BFI Film and Television Handbook* and regular updates are listed in *Screen International*.
- Development agencies – this is a growing body of organisations within Europe as MEDIA II monies and regional funds support the work of 'new' screenwriters. Again, it is impossible to list here all monies available and the criteria used, but they are listed in the *BFI Film and Television Handbook* and can be found through regional film groups, which you can contact through your national Media II desk.

### Problems with D.I.Y.

- This is essentially the same route that a director takes, and just as most directors cannot write, so most writers cannot direct. Therefore, before you choose to do both jobs, you should think about it very carefully. A solution may be to team up with someone and work on the screenplay together, discovering what you are good at and what works as you collaborate on the project.
- This is essentially a film route. Television series writers are not currently commissioned on the back of short films or videos.
- Making a short film or video takes a lot of time and energy which could be spent writing. If you are essentially a screenwriter, this may mean you are not improving your work or writing any new material. A poor short film will do you no more good than a poor short screenplay but will take a great deal of time and energy to produce. Make sure you have a distinctive and achievable screenplay before committing to this option.

### The advantages of D.I.Y.

- If it is good then people will support you in your next effort.
- If you do not want to direct the next project, the chances are there will be directors who will want to work with you as you will be able to attract money.
- It prevents your career from stalling just because no one has the time to find a director to make the screenplay or it is just lost in the 'to-be-read' pile.

## 2. Agents

To many people agents have a terrible reputation and they are often seen as a necessary evil. This is in part thanks to the actions of some agents and the myths which have become part of our culture. However, it is also because many people have little idea of how agents work, what they can and cannot do, and what their ten per cent is for. First, a few basic points:

### a. Agents are not all the same.

Some agents work as one-person companies or with only an assistant. Some agents are part of a large international collective with a global network. Even within the larger agencies, however, all agents work for themselves. By this I do not mean they are selfish but that their reputation, client base and skills are their own and just because the agent is part of a large organisation does not detract from the simple fact that a screenwriter has a relationship with an individual agent not with the agency.

In addition, agents vary enormously in background, temperament and approach. Although the negotiating positions are in principle the same, how individual agents tackle a problem differs widely.

Agents cannot know everyone and everything within the film and television industries. They specialise – some are great television soap or sitcom agents, others film agents, others are good directors' agents, others are cross-over agents who look for talent within the theatre or radio and find them work in television or film.

### b. Having an agent will not make you a good screenwriter.

Agents cannot turn a bad screenplay into a good screenplay, nor can they turn a bad screenwriter into a good one. Some agents act as script editors on their clients' work. Other agents refuse even to discuss a writer's work with them in detail. You will need to find out what level of feedback an agent is prepared to give you and whether or not this is what you want.

In essence, the agent is there to represent the screenplays you write and your skills as a screenwriter. In order for this to be a fruitful activity, you have to write new material all the time and develop your skills to match the challenges presented by each new project.

### c. Agents are human too.

Contrary to the mythology, agents are dependent on their skills as human beings to be effective in creating and maintaining relationships.

The relationships agents have with heads of studios or drama departments,

commissioning editors, development personnel, directors and producers are the key elements which agents bring to their relationship with you, the screenwriter. Sometimes they have bad periods when their working life is disrupted, when they fall out with people, or just lose the desire to fight for new clients or make the next deal. It is important, therefore, for you to be aware of an agent's priorities and their limitations.

### So what does an agent do?

The first role an agent plays is not in relation to screenwriters but in relation to producers. Agents are seen to be the 'gate-keepers' of the industry.

There are several thousand individuals aiming to be screenwriters at any one time and only limited resources available to read the screenplays they write. Therefore, producers see the agent as the person who has sifted the good from the bad and whose reputation rests on putting forward only those people who can deliver good writing.

This means that if an agent represents your work it will move from the unsolicited and probably unread pile to the 'must-be-read' pile. It is also the case that most series writing in television is commissioned at such short notice that producers call only agents to find out which screenwriters are available. By the time anyone else knows the opportunity exists it is already filled by an agent's client.

The second role of the agent is to develop screenwriters. This is achieved by finding them commissions which will help them and advising them against commissions which will not help them. This means pushing them towards some projects and not others, and matching them up with directors or producers with whom they think the screenwriter will get along.

However, this does not mean that these opportunities will work. It is still down to you to make things happen by writing well and developing an understanding with the people with whom you will collaborate on your work.

The level of script editing an agent will undertake on a screenwriter's work varies enormously from agent to agent. Some agents will read the material and then either send it out without comment or send it back to the writer merely saying it is not ready yet. Other agents will provide extensive notes on a new proposal or the first draft. The level of support you want as a writer from your agent is one of the critical factors in choosing an agent and staying with them.

The third role of an agent is dealing with contracts. This means not only the legal aspect of the written agreements but also the negotiations. Although this may be a role which a good media lawyer can handle, the essence of the job is the same no matter who does it.

### How do you get an agent?

Do not send an agent a screenplay and ask for an opinion! This is a simple mistake made by far too many would-be screenwriters. The first thing you have to do is ensure the agent actually reads your work. The easiest way to achieve this is to be recommended to them by someone the agent trusts or has a good working relationship with. The problem is that most new screenwriters do not have these

relationships either, and so a recommendation may be as hard to come by as the agent. Therefore, a simpler and more direct method needs to be applied.

## Preparation

- *Write one sample screenplay, preferably in the form in which you would like to write,* e.g. sit-com, feature film, thriller, romance. Write a good sharp premise of the work.
- *Write a second sample project.* This can be shorter and may perhaps only be a treatment. Write a good sharp premise of this work.
- *Research which agents are interested in reading material and representing new screenwriters.* Lists of agents are published in various directories (see 'Useful Directories' in Appendix A).

## The Approach

- *Ring the agents who appear to be working in your area of specialism and ask if they are prepared to read your work.*

Avoid agents who only do screenplays as an extra to novels or plays, unless this is the mix of work you intend to undertake. If the agent's answer is no because their client list is closed at the moment, accept this with grace and contact them again in six months. If the answer is yes, they will ask what you have written. This is when you tell them your premise for the work you have finished. They will then probably ask what else have you written. This is when the second project's premise is required.

They may also ask you what your background is and why you want to be a screenwriter. The reply does not have to be profound. What is required is a clear desire to write and a solid professional approach. If you attend courses, submit material to competitions, obtain development funds and the like, your case will be considerably stronger.

At the end of this short telephone conversation the agent will suggest you do or do not send your material in. If they do not want to see it, ask why not. It is probably not their sort of thing, i.e. the agent does not have the contacts to sell this sort of material and you would be better off with another agent.

- *Submit your material with a letter.*

Include the following information.

   a. A reminder that you rang and they have asked for the material. Many agents receive tens of letters a day with material and may not have made a note of your name when you spoke.

   b. State that you are looking for representation and why you have chosen them. This could be because they represent writers you like, or they are a specialist in certain types of work, or because someone recommended them to you.

   c. The premise of the work you are submitting.

   d. The premise of the second work. You will not include the second sample with this letter unless it has been asked for.

e. A brief description of your background and the sort of screenwriting you hope to do.

f. The point at which you will call them – usually a few days later to check that the material has been received. If they acknowledge the material but do not give a time frame for when they will get back to you, call them after four to six weeks.

- *Assuming they have not called you, call them.*
They will probably not have read the material. Ask for some indication of when they may read it.

- *Call them again after the date by which they said they would have read it.*
They still may not have read it and you have learned one of the early lessons of getting your work noticed: be persistent without being obnoxious.

- *If they reject the work, either in letter or over the phone, make sure you know why.*
If it is not their sort of project after all, then ask who they think might like to see it, and move on. If they think it is not good enough yet, review the work on the basis of their comments. Rewrite it only if you agree with their views or if three or more agents have said the same thing about it.

- *If the agent likes the work, they will invite you in for a meeting.*

## The Meeting

- *Before going to the meeting, plan the next screenplay and have some idea when you are going to finish it.*
The meeting is about discovering whether or not you and the agent can get on with each other and whether or not you are a potential source of income for the agent. They will ask to see other work and what other ideas you have. They need to know how long you took to write the material you have already submitted. If it took you three years to produce one screenplay, they will want to have some sense of whether this time scale will become shorter.

You need to have a sense of what sort of work the agent thinks they could get you and where they think you should be in a year's time. Both of you need to have a sense of the other. Do you trust them? How much guidance will they give you about projects and about who to work with?

Make sure you are clear about what you want from the agent and why you want to be a screenwriter, rather than another type of writer or a director. It is highly probable the agent will ask to read something else before they make a commitment.

## The Follow-Up

- *Send in the new material within the time frame agreed with the agent.*
Enclose a covering letter stating again your desire to be represented by them and why.

## The Agreement

• *If the agent wants to represent you, ask yourself if you think they are right for you.*
It is no good having an agent you have no faith in or feel uncomfortable with. They are representing you and your work. Therefore, they must reflect the values and desires you have for it and yourself.

Make sure you know in which areas they are prepared to represent you. Some agents want to represent you in all areas of writing while others do not. Some want to represent you worldwide, others only in their own country.

Note that it is still common in the UK for the agreement to be verbal and nothing to be put in writing. However, if there is a contract, make sure you have it checked over by a lawyer or someone who knows about the business to see whether it is fair. Do not be afraid to amend the contract if there is something you are not happy with.

Despite all the reasons given above, many new screenwriters obtain their first commissions and actually see their first screenplays made without the involvement of an agent. This is primarily because many agents are not interested in a writer until they have clear proven ability. This is why the majority of new screenwriters being represented by agents are in fact playwrights, novelists or copy-writers.

## 3. Contacts

This section is about obtaining a commission or sale without a short film or an agent but through people who will pay attention if you come with the right approach.

### *TV Commissioning Editors*

Interestingly, there is one area of production where a direct approach is still effective. On-going television series, e.g. soaps, sketch shows, episodic drama, have a very high turnover of writers. The more times a week the show is on the air, the more writers it needs each year. There is a constant demand for new writers which is not always being met by agents.

This gap in provision allows for the persistent screenwriter to break down the resistance of development personnel and be given the chance to join a series. To do this, first discover who is currently in charge of reading new submissions to the show and send them a sample of your work, asking to be taken on as a writer. Follow this with a series of polite but persistent phone calls to see if your work has been read.

If the reader likes the work, they will probably ask for a meeting or to see another sample. If they do not like it, then keep sending the show a series of good screenplays as samples of your work. These should be staggered over a period of time and matched with polite but persistent phone calls asking if the material has been read.

You may find that the person in charge changes over the course of your

submissions; but the point is, you will be seen as a committed and capable screenwriter, who is really interested in the show. These are qualities which are essential for a good screenwriter in series television and they will eventually get you the break you need.

It goes without saying that the material has to be consistently good and that you must remain friendly, despite the delays and frustration of waiting for the system to respond. This approach is not really successful with film companies, which are so inundated with screenplays and are so understaffed that unsolicited and in some cases solicited material can take anything up to a year to read.

There are numerous tales of runners, script editors, assistant directors and actors who have written a screenplay for a series or for a particular actor or director which has been the launch of their screenwriting career. This points to the importance of knowing something about the industry and the people who work in it. One of the traditional means to the first commission within UK television is in fact to work as a script editor on a series, a role which in America is normally held by a writer. However, this job is usually seen to be the first step into a producer's job and obtaining one as a writer will need some effort. The route which has become favoured in recent years is to start off as a reader and then to progress to script-editing or to development work.

Obtaining a job in a production company or an agent's office will provide you with insights and contacts which, while you still develop your skills, make sure you have people to show your work to when it is ready. These people can provide recommendations and advise you about what you should do next.

### Producers, Directors and Actors

The whole of the contact approach is about people and these are the key individuals who can ensure a project is made. The value of having a good producer attached to a project is inestimable – it is their passion and commitment to raising the finance, finding the right people and protecting the screenplay which will ensure the quality of the screenplay will eventually reach the screen.

Directors, especially in film, will unlock doors to production finance and bring insights to the realisation of a screenplay which the writer may only have half seen or dreamed of. Actors are often the means by which projects are financed and good screenplays, in whatever form, are hard to come by. If you think your project really is made for a particular actor, then try to have them read it, provided they have the influence to get it made.

How do you reach any of these people if they are not already friends or you do not have a mutual contact? Research and not being afraid to try the obvious.

Check that the person to whom you are thinking of sending your screenplay is actually in a position to do something with it. A producer who has a full slate for the next three years, the director who has just made a similar project, the actor who has just signed a contract tying them into a show for the foreseeable future are all unlikely to be able to help you.

Telephone the company or agent to whom they are attached and ask if they are

in a position to respond to new material. This is essentially the same approach as when finding an agent. If the person is attending a seminar or working on a project near you, go along, listen to what they have to say and give them a copy of your project. At the end of the day, people can only say 'yes' or 'no'. However, if you never approach them, it is already a 'no'.

## Rejections

With all these problems associated with even getting your screenplay read, leave alone made, the last thing you need is a string of rejections, and yet rejections are part of the process. There are three distinct types of rejection and you need to respond differently to each one.

### The Outright Rejection

This normally takes the form of a very brief letter which runs something like this:

```
Thank you for sending us your screenplay which we have now read.
Unfortunately, we are unable to do anything with it at this
time, and therefore we are going to have to pass on this
project.
```

```
Thank you for thinking of us and we wish you well with
developing the project elsewhere.
```

This means one of two things:
• The screenplay has major faults and needs a substantial rewrite, or
• You chose the wrong type of company or person for this project.
    The latter problem can be solved by making sure you only send your screenplays to companies and individuals who are looking for this sort of material. The first problem can only really be assessed by independent eyes going over the screenplay. If you receive five or more rejections on a project like this, then it is probably time to rethink the project or move on to the next one.

### The Encouraging Rejection

This takes the form of a slightly longer letter.

```
Thank you for sending us your screenplay which we have now
read. Unfortunately, we are not in a position to develop it in
its current form.
```

Or

```
We enjoyed the basic story but feel the character motivation/
action/some other element needs further development.
```

The next part of the letter may be very specific and even provide suggestions as to how it may be improved. It will conclude:

```
We wish you well with your writing and please do not hesitate
to send us any future projects.
```

This means someone in the company liked it but that there are major problems with the screenplay.

Unfortunately, the common response to this letter is to send in another project which is lying in a drawer for fear the company's enthusiasm for seeing future work will evaporate. Following this course of action will almost certainly ensure it does. The best response is to re-read the screenplay and address what is wrong with it. It might also be useful to call the person who wrote the letter and ask what particular problems they saw in the writing.

Having seen the problems, write another screenplay, making sure you do not make the same mistakes, and send this to the person who wrote to you when it is ready. All you have to do is remind them of their suggestion that you send in future work and it will be given a different priority from all the other works being submitted.

### The Totally Frustrating Rejection
This is a longer letter which runs roughly like this:

```
Thank you for sending us your screenplay, which we have now
read. This is by far the best example of this type of work I
have read in the last five (or ten/fifteen) years of my life
within the industry.

I found the story well told, the characters fascinating and
that the overall tone worked extremely well. I have shown it
to everyone in the company but unfortunately we are unable to
do anything with it at this time.
```

The detail in the last paragraph varies enormously and may include some minor criticism, suggestions as to who else to show it to, and a detailed reason about why the company/individual cannot do anything. It will conclude:

```
I wish you every success in developing it elsewhere and with
any future projects.
```

This means this is a great screenplay, these were the right people but this was the wrong time.

The response to this kind of letter depends on the detail of the letter but clearly the screenplay should be shown to other people. You should try to talk with

the person who wrote the letter to see if a meeting is possible to discuss with them other projects you have in development.

When you have received four or more letters of this kind on the same project you might begin to wonder if it is the wrong time full stop, not just for individual companies. The thing to remember, though, is that great screenplays and good ideas do last. Many of the best film and television projects have been resurrected when the screenwriter had almost given up hope.

Given the emotional damage rejections can and do produce, how do you know who is the best agent/producer/director, etc., and the appropriate one for your work? Again, it is back to the basics – research. The vast majority of submissions are rejected because they are badly flawed pieces of work. However, the next major reason a writer is rejected is because they have sent their work to the wrong person or place.

If you want your short film or low-budget feature to be seen and responded to favourably, then it has to be seen by people who are in a position to do something with it. Therefore, check that the agents you are thinking of actually represent screenwriters like you. Check that the producer is often interested in your type of project. Choose a director who you really believe can make your screenplay work.

All the basic information is contained in the various directories listed at the back of this book. However, it is the simple phone call that checks details and the current position with respect to submissions and probable outcomes which will save you a great deal of time and numerous unnecessary rejections.

Handling rejection is part of being a screenwriter; avoiding unnecessary ones is part of the art of surviving as one.

## Pitching

Meeting with people who want to hear your ideas is part of the process of being a screenwriter. This is generally referred to as pitching.

Much has been made of the American experience of 'cold pitching', i.e. talking to someone about your idea/s, when they have no idea who you are or what sort of screenwriter you are. Fortunately, outside of the American industries, and even within some parts of it, this experience is relatively rare.

The reason this practice arose was a stipulation by the Writers' Guild of America that a writer should be paid for whatever they were requested to put on paper by a producer. Given that even a one page premise can take over a week to get right, and this is a freelance business, this does not appear to be an unreasonable request. However, producers keen to keep their development budgets under control and avoid paying for writing they cannot use have opted for verbal pitches.

The problems inherent in this situation are enormous, and I suspect lead to a far greater waste of development monies than written premises. The initial problem is fairly obvious. The ability to pitch a project verbally has no bearing on the ability to write a good screenplay. This means not only that monies will be spent on projects that cannot be delivered by the pitcher, but that good screenwriters, who are not good verbally, will be ignored.

To overcome this problem, certain points should be considered. The first point is to make sure that all verbal pitches are heard in the context of a screenwriter's existing screenplays. This means development people have to read material before they become involved in a meeting. This is in fact the standard practice in most UK companies. The problem is that many prospective screenwriters are in fact novelists or playwrights and there is no screenplay to read.

The second point is to realise that the style of the screenplay will radically affect the cost and dramatic development of the idea. This aspect is often overlooked in pitching. Therefore, if people have particular financial parameters, they need to discuss the development of an idea in a way which will reflect their needs.

The third point about pitching is that development personnel often are not fully briefed on the needs of the company, or producers will state they are not clear what they are looking for in a new idea.

At the surface this appears fairly reasonable. If a producer knew exactly what they wanted, they would never be surprised by new material and would miss all the great original screenplays. However, it is highly unlikely that a development person or a producer would not have a list of subjects, genres, forms and themes in which they were either interested or not interested.

The failure to express these creative parameters leads many screenwriters to submit pitches which never had a chance in the first place. This often leads a producer to think that this screenwriter is not for them, when in reality all it means is that the writer did not know what the producer was not prepared to consider. This is a disaster for the writer as an idea which they believed to be good has just been rejected when, in fact, it was a very good idea.

This illustrates the need for the screenwriter to research the person or company they are pitching to in advance of the meeting. This may mean calling them and asking what type of projects they are definitely interested in or, alternatively, what they will never make.

The fourth point about the pitch meeting is to recognise that a screenwriter does not have to be a producer and have their verbal skills to be a good screenwriter. Anyone developing screenplays needs to be able to read work, understand it and communicate what they need from a project to any screenwriter. Equally, screenwriters must understand the position and conditions under which the development team is working and be able to help it to sell the screenplay to other people in the company and to the wider industry.

This underscores the crucial need for a flexible time frame within a development programme; time not only to write, read and think about the screenplay itself but time also to establish an understanding among all the people involved in developing it. Time may be money in many people's minds but it is also the difference between success and failure when creating a screenwork.

Given all these problems, what *can* you convey in a meeting about new ideas? There are three basic points:

1. *What it is – not the story, but the story type or the subject.* A sense of the central characters, the genre, the reason why this is a different version of the standard story type and what attracted you to it.
2. *Why it will appeal to an audience.* The theme and/or the contemporary context of the narrative. What other screenworks it is like and how you think it will affect its audience/s.
3. *What makes this project/storyline uniquely yours.* What research you have already undertaken, the contacts you have, your personal relationship with the material.

All of these contribute significantly to making the idea appear to be sound and well worked out. However, the key factor is your own enthusiasm for the project. The greatest inhibitor to your enthusiasm is the fear of rejection, which stops many writers from committing publicly to a project until someone encourages them to do so.

Therefore, before going into a meeting about ideas/storylines, check the following points:

- *Be absolutely clear why this story/idea/programme must be made.*
- *Select your arguments and organise them into an effective order.*
- *Anticipate the rejection/problems from the other side.*
- *Decide on the method of working which will best help you in the meeting* (memory, notes, visual aids). Do not take too much into a meeting as you may end up dealing with your visual aids more than with the person you are talking to.
- *How does your voice sound, what is your body language?* This aspect applies to the person/people you are meeting as well as yourself. When you are in the meeting, be aware of others' body language and how focused they are on your material.
- *Have material to back up the pitch.* This could be some of the research material or a short proposal document. However, hand over written material only if nothing said in the meeting has affected its possible content.
- *Be enthusiastic.* Never underestimate the power of energy and your commitment to a project.
- *Try to pitch to someone who can say 'Yes'.* This can prove extremely difficult when dealing with large companies, but the fewer people between you and the decision-maker – or makers – the better.

    Three final points:
- *Keep it short.* You need to let them see the story/programme in a few brief sentences or phrases.
- *Have a back-up in case the first pitch is not suitable.* Be prepared to amend the idea on the basis of the discussion.
- *Remember you are selling the work, not yourself.* Despite this, nearly all producers, agents and development personnel will tell you that it is you they are interested in.[1]

Having come this far in the screenwriting process, it is interesting to note that at this point not a single penny has yet entered your pocket. You can have a good agent, numerous meetings, people who love your work, and still not actually earn anything.

There is some truth in the saying – at least with respect to screenwriters – that this is an industry in which you can die from encouragement. However, assuming

you survive all of this encouragement and are successful in having a premise, treatment, format or screenplay taken up by a producer or production company, what sort of deal can you expect?

## Deals

The level of money a screenwriter can expect for a project varies from country to country, from company to company, and from the lucky break to the latest regular payment. It is impossible to say what you should expect for your work, other than it should at least meet the Writer's Guild minimum for the country in which you are working, or an equivalent. The sorts of deals on offer are essentially the same wherever you are.

1.    *The Option*. When someone, usually a producer, pays the writer a small sum of money to have the exclusive rights to develop a particular piece of work for a set period of time.

This is a common practice within film development, less so in television. The length of time covered by the option deal depends on the project and the amount of money involved in the option.

Nearly all options have an automatic renewal period, at which point the producer has to pay another sum of money in order to exercise the rights for the second period of the option.

The advantage for the producer is that the screenplay is not being shown to anyone else while they have it. The advantage to the screenwriter is that the producer is committed to the work, having spent money to acquire it.

The difficulty is if the producer does nothing with it. It is this problem which has led to buy-back clauses in deals, or an automatic reversion of rights to the writer if the option is not acted upon. However, this has to be in the initial agreement if it is to be easily dealt with at a later stage.

2.    *The Purchase*. When a screenplay, treatment or format is bought outright.

In these circumstances the writer often loses any rights with respect to the screenplay's further development. However, there are two highly significant aspects to the purchase agreement. The first of these is the development deal attached to the purchase. This is dealt with below. The second is the ancillary and residual rights which are inherent in the screenplay. In most cases, merchandising and other rights are attached to the producer. However, all writers are usually given additional payments for residuals and sequel rights.

All these separate rights have to be negotiated on every separate contract.

3.    *The Development Deal*. When a writer is paid to work a screenplay from one stage to the next (outline or treatment to first draft, through to the last polish).

This is the most common feature of screenplay deals both for film and television. Essentially, the writer's initial document is accepted by the producer, who then pays them to both write the screenplay and to rewrite it until it is made.

At each stage of the development deal the producer generally has the right to end the deal and any work they have paid for up to this point remains their property. It is at this point that other writers are usually brought into the project.

Note that if the original idea was the writer's, they may have some underlying rights in the work but these will usually have been bought out in the initial contract.

4.    *The Staff Writer*. When a writer is contracted to a television series to write a number of episodes and usually to oversee a number of others.

This is very common in the USA, less so in the UK and elsewhere. This is the outcome of screenwriters realising that they are the best script editors, and by becoming the creative part of the production team they can keep control of the series' dramatic development. A writer in this position is paid not only for what they write but also for what they oversee, and sometimes receives a producer's fee on top of this as well.

Apart from pursuing your career as suggested above, there are other things you need to make a success out of screenwriting.

## Some Useful Steps to Becoming a Screenwriter

Having read this far, you may have already decided that writing screenplays is not for you. Assuming this is not the case, the following advice is offered in the light of what has worked for many of the screenwriters I know and have taught.

1   *Establish a writing regime*. A set number of hours during which you write.
2.  *Set up a continuous viewing programme*. Watch the type of programmes, films or videos which you are trying to write.
3.  *Get to know the industry*. It helps to know where significant people are, what new series of dramas and the like are being produced, and what types of programmes particular people are interested in. Do not over-do this. Writing is more important at the end of the day.
4.  *Find a critical review group*. Workshops or effective notes from a small group of informed readers will ensure your screenplay does not make any fundamental errors. The review group will also provide you with the necessary confidence to pursue particular stories and abandon others. However, it is you who has to make the final choices and it is your knowledge and judgement which will make your work a good screenplay.
5.  *Ensure the original elements within the narrative are balanced by familiar elements.*
6.  *Learn persistence and the ability to handle rejection*. This is a small industry and you need to be able to handle the pressure of failure and criticism to survive.
7.  *Make contacts*. They will help you find the right producer/agent/director/reader, etc. Contacts also help to ensure writing does not become the isolating experience it can be on a day-to-day basis.
8.  *At the end of the day, believe in yourself*. You have to believe you will make it eventually, even though there are no guarantees.

## Notes

1.   For an agent's view of pitching, see Chapter 7 in Julian Friedmann, *How to make Money from Scriptwriting*. Boxtree.

# 10. A Few Final Words

If you have read this book all the way through you will, I hope, have realised that the art and science of screenwriting is still in its relatively early days. I have attempted in this book to redefine some terms, to help you understand how complex the process of writing a good screenplay is and to give you some tips on how to write a good screenplay.

I have also attempted to place this process in its wider human context and in so doing to explain not only why screenplays work but also why it is so difficult to get one right.

Just as it is impossible to capture the diversity of humanity in one simple statement, so it is impossible to express the totality of what screenplays are capable of.

Every screenwriter is unique and every screenplay is unique. Even so, the power of the matrix to provide the means for one person's concerns to be translated onto a screen so that they can be understood and emotionally appreciated by millions of people cannot be overestimated.

However, just as at the beginning of this process the question was asked, so it is at the end: What is this really about?

Many writers, producers and directors avoid addressing this question for fear of shutting off their audience or revealing too much of themselves. Others involved in the process start with this question and then discover the narrative provides its own unique answer/s.

The point is, the screenwork will be about something if it works, and you will be better able to address the problems within in it if you know what the answer to this question is.

This is because, in the end, screenwriting, like all forms of creativity, is about communicating with other human beings and with yourself. In order for this process to work and be sustained, there has to be something to communicate and you need to know what it is to make the screenplay work.

I stated in the introduction that this book is a celebration of screenwriting, a celebration of an art form which emerged this century and will continue to grow and develop. Each generation will ultimately create more great screenworks which we can all enjoy and which will challenge us as we struggle with the mess of life, the leftover coffees, and our desire to discover our own humanity.

I wish you well in whatever way you participate in this process of communication and sharing – a complex combination of science and art.

# Appendix A – Further Reading

## Some Useful Books

*Screenwriting for Narrative Film & Television* – William Miller. Columbus
    A general introduction to both film and television writing.

*Successful Scriptwriting* – J.Wolff & K.Cox. Writers Digest Books*
    A good general introduction to film and television writing with detailed breakdowns of television as well as film structures and formats.

*Film Scriptwriting* – Dwight Swain. Focal
    A craft-based book which is strong on treatments and contains numerous extracts as examples of produced work.

*Writing Screenplays that Sell* – Michael Hauge. Elm Tree Books*
    A solid introduction to the craft of feature-film writing based on a linear narrative. It contains a detailed discussion of the function of characters.

*The Tools of Screenwriting* – D.Howard & Edward Mabley. St.Martin's Press*
    A good all-round craft book which has the added benefit of the detailed analysis of over a dozen films.

*Alternative Scriptwriting* – Dancyger & Rush. Focal Press*
    A good analysis of different approaches to character and structure. It also contains the first serious attempt to look at how genre can be used, with numerous examples.

*Lew Hunter's Screenwriting 434* – Lew Hunter. Perigee*
    A written version of a course run at the University of California, which takes you step-by-step through the creation of a screenplay.

    *Any one of the above titles will provide you with a solid introduction to writing a feature film screenplay.*

*How to Make a Good Script Great* – Linda Seger.*
    A very good approach to rewriting linear, single protagonist film narratives.

*Writing the Character Centered Screenplay* – Andrew Horton. University of California Press*
    A strongly argued and well-presented development of character-centered screenplays with contemporary examples.

*How Scripts are Made* – I. Karetnikova. Southern Illinois University Press*
    Similar to *Tools of Screenwriting* but with more emphasis on individual aspects of the films under discussion.

*The Understructure of Writing for Film and Television* – Brady & Lee. Texas University Press*
    Good on character and scene development.

*Image, Sound and Story* – Cherry Potter. Secker and Warburg
> A detailed look at images and montage with respect to a series of films, plus a look at different dramatic structures.

*The Art of Creative Writing* – Lajos Egri. Citadel Press*
*The Art of Dramatic Writing* – Lajos Egri. Citadel Press*
> These two books cover much the same ground and both are very strong on character development and the essentials of conflict, even if it is written about the theatre!

*Screenplay* – Syd Field. Dell
*The Screenwriter's Workbook* – Syd Field. Dell
> The two books which brought screenwriting into focus in the 1980s and set out the paradigm model of the three-act feature film.

*Writing Short Scripts* – Phillips. Syracuse University Press
> A good comprehensive introduction to the short-film screenplay.

*Writing Short Films* – Linda J Cowgill. Lone Eagle
> A good introduction to short-film form.

*Successful Sitcom Writing* – Jurgen Wolff. St Martin's Press
> The most comprehensive approach to this specialist genre.

*Writing, Directing and Producing Documentary Film and Video*
> The most comprehensive approach to documentary-making.

*Screen Adaptation* – Portnoy. Focal Press
> A comprehensive handbook on adapting for the screen.

*American or Canadian imports in the UK

## Useful Directories

*BFI Film and Television Handbook* (Annual)
> Provide a list of all courses, sources of finding some production-companies and an overview of UK Films & Television Industries.

*PACT Directory* (Annual)
> A comprehensive listing of UK Production companies and personnel.

*Writers' and Artists' Yearbook* (Annual). A & C Black
> A general artists guide to agents, publications and some production companies.

*The Writers' Handbook* (Annual). Macmillan
> A writers guide to agents, publications and some production companies.

# Appendix B – Contacts

Arts Council of Great Britain
14 Great Peter Street,
London SW1P 3NQ.
Tel: 0171 973 6443

British Film Institute (& MEDIA 2)
21 Stephen Street,
London W1P 2LN
Tel: 0171 255 1444

British Screen Finance,
14-17 Wells Mews,
London W1P 3FL.
Tel: 0171 323 9080

Directors Guild of Great Britain,
15-19 Great Titchfield Street,
London W1P 7FB.
Tel: 0171 436 8626

London Film and Video Development
Agency/London Production Fund
114 Whitfield Street,
London W1P 5RW.
Tel: 0171 383 7755

London Screenwriters Workshop
Holborn Arts Centre,
Three Cups Yard,
Sandland Street,
London WC1R 4PZ
Tel: 0171 242 2134

New Producers Alliance (NPA),
9 Bourlet Close,
London W1RP 7PJ
Tel: 0171 580 2480

Producers Alliance for Cinema and
Television (PACT),
45 Mortimer Street,
London W1N 7TD.
Tel: 0171 331 6000

Scottish Screen
Dowan Hill
74 Victoria Crescent Rd.
Glasgow G12 9JN
Tel: 0141 334 4445

The Writers Guild of Great Britain
430 Edgware Road,
London W2 1EH
Tel: 0171- 723 8074

# Index